MODERN CHINESE ART

The Khoan and Michael Sullivan Collection

D1581806

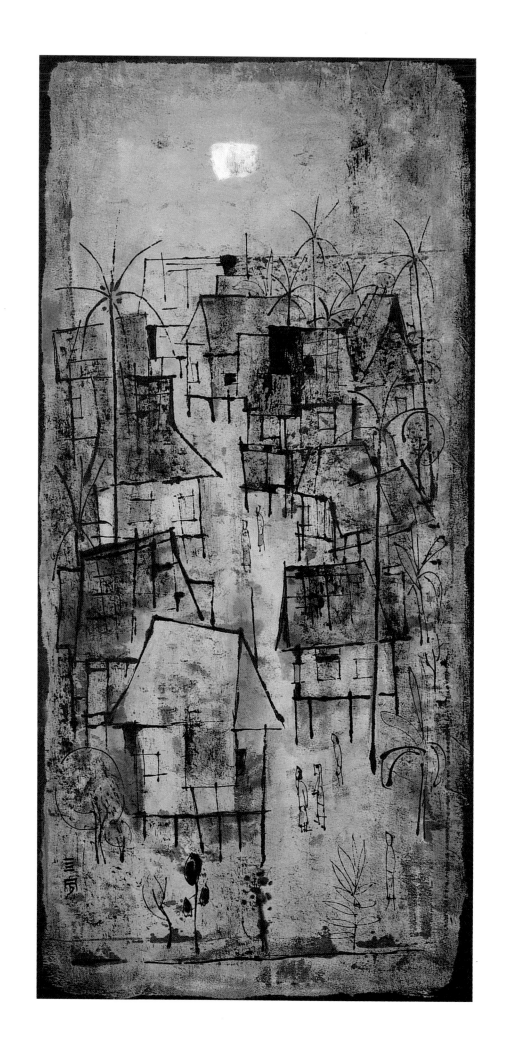

MODERN CHINESE ART

The Khoan and Michael Sullivan Collection

REVISED AND EXPANDED

Ashmolean Museum

Oxford

© Text copyright jointly Michael Sullivan and the University of
Oxford: Ashmolean Museum, Oxford, 2009

British Library Cataloguing in Publication Data
A catalogue record for this book is available from
the British Library

ISBN 1 85444 233 3 (EAN 978-1-85444-233-8)

Cover illustration: Catalogue Number V. 41
SHAO FEI: *Creatures from the Shanhai jing*

Designed and set in Monotype Plantin Light by Behram Kapadia

Printed and bound in Singapore by
Craft Print International Ltd, 2009

CONTENTS

FOREWORD

This is the catalogue of a unique collection of modern Chinese painting formed by the great scholar and connoisseur of Chinese painting in the West, Michael Sullivan, and his wife Khoan who began collecting in the province of Sichuan in Western China in the 1940s and have continued until today. What makes this such a fascinating collection is not just the Sullivans' great taste and discrimination but the fact that many of the artists represented here were or are friends of Michael and Khoan and so the collection is also the record of many friendships.

The Sullivan collection is being exhibited, very appropriately, in the Khoan and Michael Sullivan Gallery of Chinese Painting at the Ashmolean Museum in Oxford during 2001 and 2002. This is the only gallery in the United Kingdom to have been built specifically for the display of Chinese paintings, funded by the Christensen Foundation and an anonymous American benefactor. It was opened in 2000, and along with the generous gift of the Reyes collection, has made the Ashmolean Museum a centre of international repute for the study of twentieth century Chinese paintings.

Michael Sullivan is the world authority on twentieth century Chinese painting. His book *Chinese Art in the Twentieth Century* (1959) was the first ever on the subject, while his *Art and Artists of Twentieth Century China* (1996) provides the most complete survey and includes biographies of the artists. In the present catalogue he gives a personal account of his engagement with Chinese painting and his meetings and friendships with the artists.

Michael and Khoans' move from Stanford to Oxford has been of lasting benefit to Oxford University, and to the Ashmolean Museum in particular, and we welcome the opportunity of publishing and exhibiting this remarkable collection for the first time.

CHRISTOPHER BROWN
Director

ACKNOWLEDGEMENTS

Khoan and I would like to express our warmest thanks to everyone who has been involved, in one way and another, in the making of our collection, and in the exhibition of selections from it at the Ashmolean Museum.

First of all, our gratitude goes to the artists without whose generosity we would never have formed our collection at all. Recently we have bought a few pictures, but most of them were given to us over nearly sixty years by the artists, as recorded in the following pages. Our debt to them is immeasurable.

We would like to express our thanks to Dr. Christopher Brown, Director of the Ashmolean Museum, for his support and for writing the Foreword to this catalogue, and in particular to thank Shelagh Vainker, Keeper of Chinese Art, for her great help in arranging the two exhibitions. It is a pleasure to work with her. Also our thanks go to David Gowers and his colleagues in the Photographic Department of the Museum, to Ian Charlton, Publications Officer, to Behram Kapadia, who designed this handsome catalogue, and to my conscientious copy editor Helen Kemp.

We would not have been able to build up our collection without the help of a number of gallery owners and friends of whom I can name but a few: Michael Goedhuis (London); In Hong Kong; Harold Wong, Alice King (Alisan Fine Arts) and Johnson Zhang (Hanart TZ); Mel Maggio (CourtYard Gallery, Beijing); Arnold Chang and L. J. and Carol Wender (New York). Our warm thanks go to them all.

I have had valuable help with the reading of inscriptions from David Hawkes, James McMullen and Wang Tao, while much work on the Catalogue has been done by Xiu Huajing Maske, Liling Hsiao and Lin Hsiaoting. Most recently, Hiromi Kinoshita has been involved with checking the illustrations and other valuable secretarial and editorial help. The hours we have spent with these young scholars have been among our happiest since we came to Oxford.

Finally, none of this would have happened if Khoan and I had not moved from Stanford to Oxford at the invitation of Alan Bullock, Founding Master of St. Catherine's College, with the generous backing of Allen and Carmen Christiansen and their family. So it is with deepest pleasure that Khoan and I acknowledge our debt to Alan, to his wife Nibby, and to the Fellows of St. Catherine's, whose hospitality have given us so much pleasure over the last twenty years and more.

Since the above was written eight years ago, Khoan has died, and the collection stands as a memorial to her. Over the years it has grown, chiefly through the generosity of the artists whose names are recorded with the works they gave us, and to whose friendship and generosity I owe so much.

In recent years, a selection of works from the collection has been exhibited in the Lakeside Art Centre, University of Nottingham (2005), the Oriental Museum, University of Durham (2006), Seattle Art Museum, and Asia House, London (2008).

To the list of those to whom I am indebted for work on this new edition, I am happy to add the names of D. Phil. students at Oxford, past and present. They include Dr Josh Yiu Sifu, now with the Seattle Art Museum, and Celine Lai, Deng Fei, Jiang Qiqi, Chen Xin and Chen Yi who, as I write, are still at Oxford. Additional photography has been done by Wang Ruohong, proof-reading by Dr. He Weimin, and the book has been designed, as before, by Behram Kapadia and seen through the Press by the Publications Officer, Declan McCarthy.

MICHAEL SULLIVAN
Oxford
March 2009

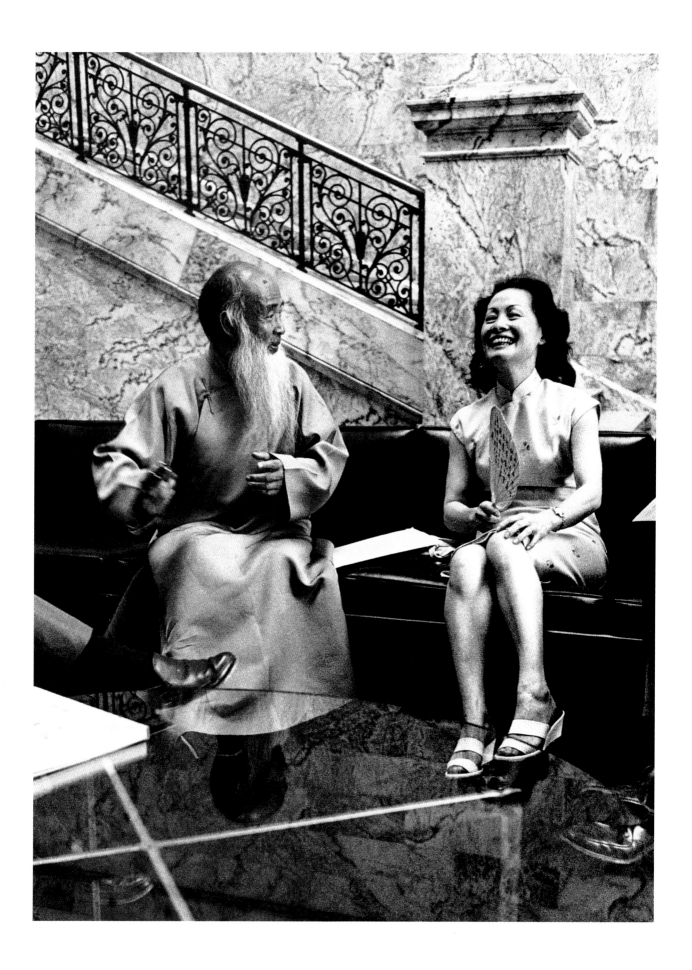

INTRODUCTION

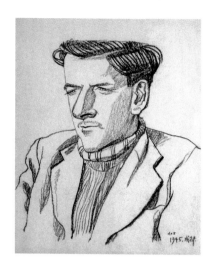

ABOVE: *Ding Cong.* Cartoon of Michael Sullivan, Chengdu, 1945.

OPPOSITE: Zhang Daqian with Khoan Sullivan at his exhibition in the Stanford University Art Museum, 1967. *Photo by Leo Holub.*

Khoan and I never set out to be collectors. In fact, it is only very recently that we have begun to consider ourselves as collectors at all – because other people said we were. We never planned our acquisitions. Over the years, paintings and prints, drawings, a few albums and fewer pieces of sculpture came to us, chiefly as gifts from the artists, with one valuable bequest. Only recently have we bought paintings, and our aim in buying will be made clear later on.

The Chinese tend to look on works of art not only as precious in themselves, but as symbols of friendship. In this respect, Khoan and I have been extraordinarily fortunate. Our friendship with artists began in Chengdu, Sichuan, in the mid-1940s. Chengdu, with its own two universities and five refugee ones from 'down river', was just out of range of the Japanese bombers (unlike the wartime capital Chongqing), and had become a haven for artists, writers, theatre people, scholars and teachers from the coastal cities. Guilin, 'the Paris of Free China', was another centre of cultivated life until it was overrun by the Japanese in 1944. In Chengdu, Khoan was working as a bacteriologist, making smallpox vaccines for the Public Health Service, while I was on the staff of West China University Museum, teaching and working in Sichuan archaeology under Cheng Te-k'un.

So it was in Chengdu that our collecting began, and it was there that Khoan in her own special way began to build bridges and open doors for me, who would otherwise always have been looked on as a foreigner. Some of the artists we came to know had already made adventurous journeys into the western borderlands – an activity that was to be taken up again after 'Liberation' by artists anxious to escape from the stifling conformity of Beijing and Shanghai. Wu Zuoren had travelled in Gansu, Qinghai and Xichang, and gave us an oil sketch of a local market scene from which he later, on our verandah, made the much larger painting now in the National Gallery, Beijing. Pang Xunqin had spent a year among the Miao Minority of western Guizhou and Yunnan; he gave the beautiful paintings of peasants and Miao people and his exquisite Tang dancers to us at that time; Ding Cong – Xiao 'little' Ding – had travelled among the Qiang and Lele minorities of western and south-western

Sichuan, and gave us a number of his drawings. Ye Qianyu had managed to get to India, where he made the drawing in our collection. The Cantonese artist Guan Shanyue, who gave us the landscape with a waterwheel, exchanged lessons with me: I taught him English, while he taught me to paint in the traditional technique using the standard *Painting Manual of the Mustard Seed Garden*. But I was a bad student. When I sat idly by watching while my teacher ground the ink, Khoan was horrified, and gave me a severe scolding.

Other artists had settled in Chongqing, where Geoffrey Hedley of the British Council had contact with several of them. Fu Baoshi, Zhang Anzhi and Lin Fengmian were painting and teaching at National Central University; Xu Beihong had gone on a fund-raising trip to Singapore, and managed to return to Chongqing ahead of the Japanese invasion of south-east Asia. Liu Haisu was not so lucky. On a fund-raising visit to Java he was caught by the Japanese invasion. There are conflicting accounts of how he fared under the Japanese.

Most famous of all, Zhang Daqian (Chang Dai Chien), had recently returned to Chengdu from his second long stay at Dunhuang, where, with a team of assistants, he had been copying the wall paintings in the caves. From these copies he made more finished versions for exhibition. Although I visited him in Chengdu and was impressed above all by the fact that he owned a private rickshaw, it was some years before we became friends, and Khoan and I acquired a number of his works, including one of the original copies he had made in the Dunhuang caves.

The refugee artists in Chengdu, led by Wu Zuoren, Xiao Ding, Pang Xunqin, the sculptor Liu Kaiqu and the cartoonist Zhang Guangyu, formed the Modern Art Society, (Xiandai meishu hui), which held its first exhibition in 1944 on the Campus of West China Union University. Among the works displayed was Xiao Ding's *Xianxiang tu*, a satire on the corruption of society under the Guomindang so devastating that it had to be hidden from the secret police. It was eventually bought by an American missionary, William Fenn and is now in the Art Gallery of the University of Kansas at Lawrence, Kansas. Even those artists who had a teaching position, such as Pang Xunqin, lived near the starvation level. Later, when senior officers from the RAF came to train officers at the Chinese Air Force Staff College, and later still, when the American 14th Air Force arrived to set up bases for the bombing of Japan by long-distance B29s, Khoan was able to help some of these artists by selling their paintings for precious American dollars, to scrounge painting materials for them, and medicines for their sick children. Among the American officers who were frequent visitors at our home was Marvin Bradley, from Chicago, who made the lively portrait drawing of Khoan illustrated here.

Lt Marvin Bradley, US Air Force. Portrait sketch of Khoan made in Chengdu in 1945.

So our collection began in a small way, with paintings and drawings given to us by these artists, who became our lifelong friends. In their mid-1940s exile in the western provinces, many of them dreamed of going home when peace returned, and of picking up where their comparatively good life had broken off in 1937. They could not have imagined what lay in store for them. Almost all of them were to suffer – some very severely – after 'Liberation', again in the 'Great Leap Forward' of 1958, and worst of all in the Cultural Revolution of 1966–76. But now they were full of hope for the future, while those who had been abroad, such as Liu Kaiqu, Wu Zuoren and Pang Xunqin, reminisced about their life in Paris. Pang lent me one of his most precious possessions – a book about Cézanne, which he carried everywhere with him. Oil paints had become almost unobtainable; but Pang drew on his precious store to paint the charming portrait of Khoan that is one of our treasures.

Pang Xunqin in Chengdu, about 1944. *Photo by MS.*

The war dragged on to its sudden end in August 1945, and soon the artists were packing up for the long, often roundabout, journey home to a new and better life. But their dreams were soon shattered, by galloping inflation and the gradually accelerating civil war. Early in 1946, Khoan and I went to England, where we continued to receive letters from our artist friends. Those from Pang Xunqin and his wife, the painter Qiu Ti, give a heart-rending picture of their growing despair as the Guomindang régime collapsed and chaos reigned. Reading these letters, it is not hard to see why in 1949 the great majority, even of the educated class, at first welcomed the Communists with open arms.

But before 'Liberation' shut off all communication with the outside world, several of these artists had learned from Pang Xunqin of my hope one day of writing a book about twentieth-century Chinese art. When all my research notes gathered in China were stolen from a train in England, Pang went to enormous trouble to provide me with essential information on the history of modern Chinese art, indicating the young artists to look out for – he said we should particularly watch out for a young student who looked promising, Zhao Wuji (Zao Wou-ki) – circulating his friends

Qi Baishi and Xu Beihong (in front) with Li Hua and Geoffrey Hedley. Beijing, 1948. *Photo by Wu Zuoren.*

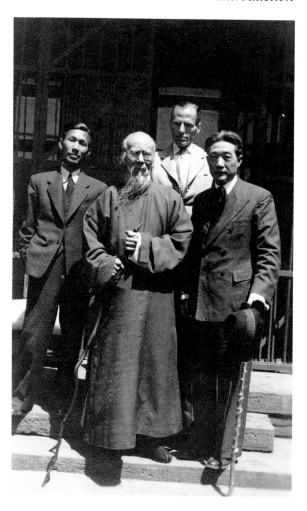

and soliciting their help. One result of this was the exquisite small landscape that Huang Binhong, doyen of the Jiangnan scholar painters – whom I had never met – painted for us and sent, folded up very small, in an airmail letter from Shanghai.

In 1948, Geoffrey Hedley organised an exhibition of woodcuts in Shanghai by the young Huang Yongyu and his friends that were refreshingly different from the heavily propagandist prints that had been produced in 'Free China' and the Communist base at Yan'an during the war. We never set out to collect prints; but many years later at the National Academy in Hangzhou, we met printmakers who were developing into an expressive art form the *shuiyin* (water-printing) technique – which had been revived by the Rongbaozhai studio in Beijing for making letter-paper and facsimiles of paintings. At the Academy two of the teachers, Lu Fang and Huang Xuanzhi, gave us fine examples of their *shuiyin* prints.

Geoffrey Hedley was also instrumental in sending four artists from Nanjing to study in Britain: Zhang Anzhi, who gave us two charming sketches of Hyde Park, the Cantonese painter Chen Xiaonan, and Fei

Chengwu and Zhang Qianying, who married and settled in London. By that time, I was a student at the School of Oriental and African Studies, Khoan supplementing my meagre scholarship by doing some teaching and lecturing (her audiences included Women's Institutes and the inmates of Holloway Prison). Our painter friends were far away, and although my interest in contemporary Chinese art was intense and growing, we were too poor to buy pictures. In the meantime, Geoffrey Hedley, moving between Nanjing, Beijing and Shanghai, was not only helping the struggling artists, but, with enormous difficulty, obtaining photographs of their work for the book I hoped to write, among them the now famous photograph which he took in Beijing of Qi Baishi, Xu Beihong, Wu Zuoren and the wood-engraver Li Hua, which was reproduced in *Chinese Art in the Twentieth Century*, and has since appeared in several books published in China.

In 1950 Khoan and I went to Harvard. My Rockefeller Foundation Fellowship seemed princely compared with my SOAS scholarship, but there was nothing left over for buying paintings. Yet we could not resist the temptation to acquire six early album-leaves by Huang Binhong. Chen Ch'i-k'uan, then studying Architecture at MIT, held his first painting exhibition there in 1953 and gave us the first of his works that we came to own, the still-life *Pickled Cabbage* which he had priced so high – $30.00! – because he didn't want anyone to buy it. At that time Zeng Youhe (Tseng Yu-ho, Betty Ecke) was already studying under Alexander Soper at New York University. She was later to give us several beautiful paintings.

In 1954 Khoan and I went – in the face of fierce opposition from our friends who said we would sink into obscurity – to Singapore, where the University of Malaya, as it then was, had offered me the post of Lecturer in the History of Art – a surprising new departure, considering that Singapore was widely looked on as a 'cultural desert'. But four Chinese artists who became our friends were working there – Choong Soo-pieng (Zhong Sibin), Liu Kang, Chen Wen-hsi and Ch'en Chong-swee (Chen Zhongrui) – while the small private Nanyang Academy of Art, run by Lim Hak-tai, was struggling to survive. To my eternal regret, I did not come to know Georgette Chen, an excellent oil painter who had trained in Paris, and was living very quietly in Singapore.

There were no collections in Singapore of the work of living artists. Khoan and I founded the University Art Museum with the blessing of two vice-chancellors and the support of Loke Wan-tho and Malcolm MacDonald, Commissioner General for south-east Asia. Khoan persuaded several wealthy Chinese businessmen – most notably the rubber tycoon Lee Kong-chien – to give funds, and the collection grew, to include not only Chinese ceramics and other works of art, but Indian

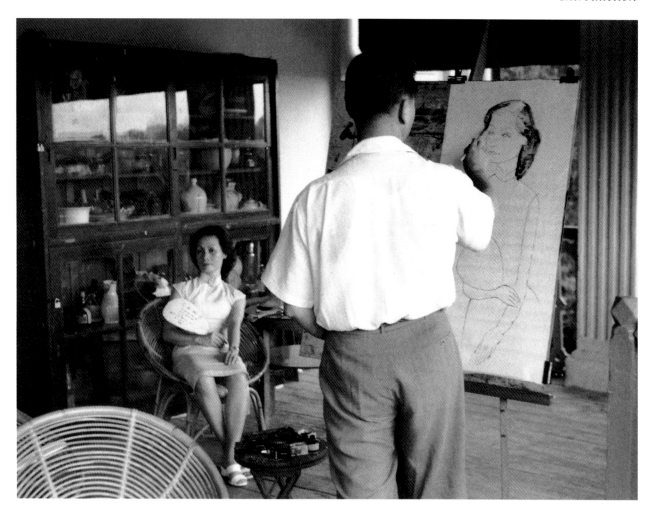

Zhong Sibin (Cheong Soo Pieng) in his studio in Singapore, painting his portrait of Khoan illustrated on page 158. *Photo by MS.*

sculpture and shards of Chinese, Siamese and Khmer ceramics that we collected from a number of sites in south-east Asia. We also collected works by Singapore artists for the Museum and were thus able to give them some encouragement. Cheong Soo Pieng gave us a number of his works, and painted a beautiful portrait of Khoan. One of the pioneers was Chhuah Tien Teng (Cai Tianding), former teacher and umbrella-maker, who was the first to create paintings, usually Malayan genre scenes, using the batik technique. Sadly, when, in 1965, Malaysia and Singapore separated, half the collection was sent to Kuala Lumpur. The rest was eventually absorbed into the collection of the National Museum of Singapore and eventually found its home in the re-established University Art Museum. During the years we were there, the modern art movement in Singapore, and indeed in the whole of south-east Asia, was in its infancy. It has since blossomed into a rich maturity.

We returned to London in 1960, when I took up a lectureship at the School of Oriental and African Studies. Geoffrey Hedley, after a difficult assignment in Dacca, was back in London; but that summer his exhausted heart gave out. In his will, to our astonishment, we found that he had

left all his Chinese paintings and woodcuts to us, with the exception of any five that the British Museum could choose. Fortunately for us, Soame Jenyns, who made the selection for the BM, was unsympathetic to modern Chinese painting, and chose safe nineteenth-century works. So it was that our collection was immensely enriched, with works by Ren Bonian, Xia Hui the Dowager Empress' ghost painter Miao Jiahui, painting under her own name, Fu Baoshi, Lin Fengmian, Pu Xinyu, Qi Baishi, Cheng Songwan, Walasse Ting, Fu Shuda, Tang Yun and other artists, and the interesting collection of post-World War II woodcuts by Huang Yongyu and his contemporaries.

The 1960s was a time when, if one had the resources, one could build up a rich collection of modern Chinese *guohua* (traditional-style painting in ink on paper or silk). The Communist authorities gave these artists no encouragement, and many of their works found their way to the dealers and auction houses in Hong Kong and the West. It was at that time that Charles Drenowatz in Zürich, Franco Vannotti in Lugano, and Arno Schüller in Prague formed their notable collections, while American collectors were still inhibited by the embargo on imports originating in Communist China. Khoan and I were not in a position to take advantage of this situation, and apart from a fine Li Keran, that we bought for forty pounds from Mrs Shen's gallery in London (and which thereafter she constantly tried to buy back) we made almost no additions to our collection during the mid-60s.

In 1966, we went to Stanford University, where I had been offered the Chair in Oriental Art which was subsequently endowed by Alan Christensen. We started to travel to the Far East once more. On our return visits to China in 1973 and 1975 the Cultural Revolution was still raging – it only ended with the death of Mao in 1976 – the museums were closed, although opened for our sole benefit (walking through the silent, deserted galleries of the huge Historical Museum in Beijing was a somewhat eerie experience) and we chiefly visited archaeological sites. When we asked to see our artist friends from Chengdu days, we were told they were sick, or 'in the country' (i.e. working as farm labourers as part of their 're-education', or in prison). In fact, several were in Beijing and knew of our arrival, but were forbidden to get in touch with us.

But when we returned in 1979, the climate had changed. Officials from the Artists' Association who met us at the airport told us that, if we were not too tired, there would be a dinner party for us that night, where we might see some people we knew. Arriving at the restaurant, there, seated round a large table, were Pang Xunqin, Wu Zuoren, Xiao Ding, Yu Feng and other old friends. Pang sat next to me, holding my hand much of the time. After some urging, and a few drinks, his French began to come back and we resumed the conversation about art that had been

Ding Cong in his house in Beijing in 1983. *Photo by MS.*

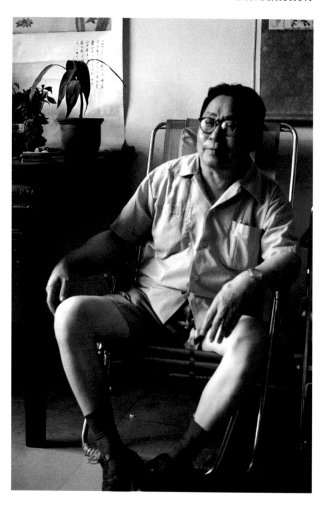

broken off in 1946. Before he left Chengdu that spring, he had given us a portfolio of his designs for modern crafts based on his profound knowledge of ancient Chinese art, hoping that we could have it published in the West. We were unsuccessful. But that evening, thirty-three years later, we were able, to his astonishment, to put it in his hands. It was subsequently published, with other of his designs, in Beijing, in a form worthy of this pioneering material.

At this time we renewed our friendship with many other artists, including the sculptor Liu Kaiqu, Cheng Shifa, who gave us two paintings, and Pang Xunqin's daughter Pang Tao, who was a beautiful ten-year-old when we last saw her, and was now a Professor of Oil Painting in the Central Academy, married to the painter Lin Gang. We now met for the first time Huang Yongyu, who had sent us a fine landscape two years earlier, and now gave us several more of his works, including a version in batik of the owl with one eye shut which, when shown to the paranoaic Jiang Qing (Madame Mao), had earned him four years detention. And we made many new friends among the younger artists who had emerged from the darkness of the Cultural Revolution, among them

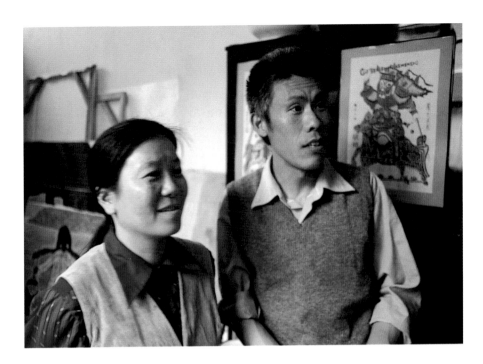

Wang Huaiqing and his wife Xu Qinghvi in their studio home in Beijing in 1983. *Photo by MS.*

Wang Huaiqing, who has since become a major figure in contemporary Chinese art.

We also visited Taipei, where we encountered the remarkable revolution against traditional orthodoxy launched, in the face of relentless official opposition, by Liu Guosong, Chuang Che and their friends in the Fifth Moon Group. In Hong Kong, we discovered the almost simultaneous movement away from orthodox *guohua* launched by Lü Shoukun and his friends in the Circle and In-Tao groups. These artists, who were to some degree under the influence of the New York School of Abstract Expressionism, represent the first major breakthrough in modern Chinese painting since the 1930s. Their achievement was in due course to have a great impact in mainland China.

Khoan and I were incredibly fortunate to become friends with so many of the artists in the modern groups in Hong Kong and Taipei. Not only did they give us paintings, but they circulated among themselves albums in which each artist made his or her contribution. Painting in an album can be a duty, and perfunctorily done. But these artists took enormous care with ours, and their albums are among our most treasured possessions, not only for the generosity of the sentiments they embody but for the quality of the works they contain.

But with all these new acquisitions, we still did not look on ourselves as collectors. Most of the works were too personal, and had too many levels of meaning for us to be regarded merely as items in our collection, while increasingly we were acquiring paintings in exchange for some help to the artist – generally in the form of writing a preface to their exhibition catalogues. This of course raises problems. Among Chinese

friends, it is hard to refuse such a request, and indeed many such prefaces are no more than conventional encomiums and carry no critical weight whatever. I find this impossible to do. I have only once, in gratitude to a friend, written about an artist about whom I was lukewarm (and was astonished when the gallery owner printed it!); while I have refused many such approaches, even from the highest quarter, generally by apologising that I did not appreciate the artist's work sufficiently to do it justice.

But, as the years went by, I found myself writing with a fully engaged heart and mind for artists whose work I did admire: Zhang Daqian, Lin Fengmian, Zhu Dequn, Liu Guosong, Ch'en Ch'i-k'uan, Pang Xunqin, Wucius Wong, Wu Guanzhong, Shao Fei, Li Huasheng, Ju Ming, Song Yugui, Harold Wong, Yu Chengyao, Wan Qingli, Wang Huaiqing, Gao Xingjian, and others, and in doing so came to understand something of their aims and approaches to art. So I gained far more than they did.

We had known the essayist and short-story writer Ling Shuhua for years – first in Singapore and later in London, until she left in 1989 to pass the last months of her life in her native Beijing. It was on one of our visits to her London flat that she showed us the tiny handscroll with pictures, poems and inscriptions which her friend the poet Xu Zhimo had first brought on his return visit to England in 1925 with her request that he get his friends in the Bloomsbury Group to contribute to it. In the event, being high summer, most of them were away, but the first two contributions are a landscape by Roger Fry and a quotation by Dora, wife of Bertrand Russell, from one of her own books. Over the years many other distinguished people made their little contributions to it, including Xu Beihong, Lin Fengmian, and Wen Yiduo. In a gesture of

Lin Fengmian with K and MS in the artist's home in Hong Kong, 1987. *Photo by Dr Mayching Kao.*

rare generosity, she gave the scroll to us a few months before she left London for the last time.

While we were at Stanford (1966–84), we renewed our old acquaintance with Zhang Daqian, who had settled at Carmel, surrounded by his family and friends, rocks and exotic trees. We organised an exhibition of his work at the Stanford University Art Museum in 1967, which drew huge crowds from the Chinese community in the Bay Area. When, selecting pictures to exhibit, we came to the tall scroll of an old flowering plum-tree, we exclaimed with such pleasure that he immediately said, 'It's yours!' Before leaving finally for Taiwan, he held an exhibition at the Laky Gallery in Carmel. The owner evidently told him of Khoan's love of a small landscape in the exhibition, for on the day he left, it arrived, with a letter, as a parting present to her. He also gave her a beautiful small scroll of lotus which, knowing her fondness for small things, he had painted for her.

During the 1970s and 1980s, several artists from mainland China arrived on the West Coast, refugees from the uncertainties of life at home, to make new careers in the States, among them Li Hua (who later changed his name to Li Huayi so as not to be confused with the famous wood-engraver); from his first exhibition at a gallery in San Francisco he gave us the beautiful pictographic abstraction illustrated here. His style has since become far more classical.

In the meantime, modern art in China had entered a new and more exciting phase, as the doors to the West were swinging open at last and, in spite of many setbacks, artists were embarking on a voyage of discovery. Much of the best work of the last two decades of the twentieth century has political resonances – overt or oblique – that give it a particular edge and vitality, while the range of forms of expression was vastly extended. Now, no longer was officially approved and sponsored art at the centre. New, if erratic, freedoms, the birth of free enterprise, commercialism and the interest of foreign critics and art galleries began to create an art world, chiefly in Beijing and Shanghai, that looked more and more international – in style, if not in content – while new forms of art, such as performances, installations, happenings, were a stimulus to hundreds of young artists clamouring for attention.

Many forces were at work in these exciting decades. The opening to the West created intense curiosity about every aspect of Western art and culture, which led inevitably to a good deal of confusion and imitation. But this was also a positive gesture, for it represented the repudiation of Party orthodoxy. The desire to be accepted in the international world of modern art was a spur to experiment. The blurring of the distinction between Chinese and Western methods of painting was aided by the mixing of media and techniques. Significantly, the indiscriminate

borrowings from abroad also produced a healthy reaction, when some more thoughtful artists, feeling that Westernisation had been carried too far, sought to rediscover their identity as Chinese. This could mean many things: painting the world they knew from their own experience; reaching down for ideas about the nature of art, and discovering formal images, in the deep well of Chinese culture and history; reviving and developing the technique of ink painting as a natural Chinese means of expression; reviving the art of calligraphy and experimenting with abstract calligraphy and invented characters ... the possibilities seemed endless.

How were we to respond to this challenge? Thanks entirely to Khoan's extraordinary management of our affairs, we were now in the fortunate position where we could begin, in a modest way, to buy pictures, and so to choose. The sheer volume of work being produced by the new generation of Chinese artists was so overwhelming that we clearly had to have a policy. With our limited resources and small space for storage we could not hope to create a 'representative' collection. As it looked likely, if all went well, that the ultimate home of our collection would be the new Gallery of Chinese Painting at the Ashmolean Museum, we decided to acquire works that would complement the Ashmolean's holdings, acquired over the years by the Keepers Peter Swann and Mary Tregear, and substantially augmented more recently, since Shelagh Vainker assumed that office, by the gifts from the Reyes family. Almost without exception, these holdings are traditional *guohua*. So, partly for this reason, and partly because it is our preference anyway, we have begun to acquire works of a more advanced kind, including abstractions – but nothing freakish or of mere transient interest – works that we hope a hundred, two hundred, years from now will still be as moving and as satisfying as they are to us today.

Sculpture has always been beyond our range. But in 1980 in Beijing we visited the second exhibition of the Stars – the heroic group of young dissident amateur artists who had hung their first, epoch-making and unauthorised, exhibition on the railings of the Beihai Park in the previous year. We met several of the leaders, including Wang Keping, Ma Desheng, Huang Rui and Shao Fei. Wang Keping had incurred the wrath of the authorities with his satirical *Idol* – clearly a caricature of Mao Zedong. Later, from his crowded studio, he selected two less controversial works, and gave them to us.

When Wang Keping and his French wife Catherine settled in Paris, refusing to compromise with current art fashions, he had a long, and ultimately successful, struggle for recognition. To the Taiwanese sculptor Ju Ming, fame came more quickly, when his colossal figures of *taiji* boxers, cast in bronze, were shown in many public places across the

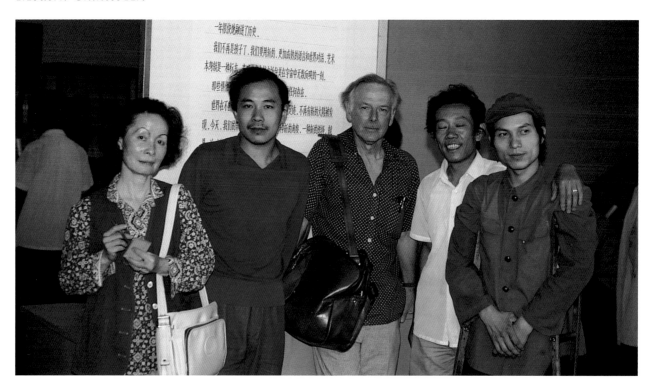

At the second Stars Exhibition, Beijing, 1980. Khoan, Wang Keping, MS, unidentified person, Ma Desheng.

world including the terrace of the Festival Hall in London and the Place Vendôme in Paris. These powerful figures, only one aspect of his astonishing creative range, are represented in miniature in our collection by the group he gave us in 1991.

But our chief interest has always been in painting. Since we felt that the overriding criterion must be quality, we could not resist the temptation to acquire a few paintings in a purely traditional style. So it was that we acquired a charming view of the Yangzi Gorges by Yuan Songnian, and two fine paintings by the Shanghai master Zhu Qizhan, a still life and a landscape, painted six years before his death at the age of a hundred and four. Subtle variations on classical styles are revealed in a landscape by Li Shubai, in a beautiful flower painting by Cai Xiaoli and the sumptuous landscape decorating the cover of this catalogue, by her husband Wang Jia'nan which illustrates the rediscovery at the end of the century of Northern Song monumentalism, reinterpreted in a modern idiom.

Yu Chengyao is unique: a Guomindang general who retired to Taipei and there took up painting as a hobby. Declaring that he had nothing to learn from the old masters, or from the rules of brushwork laid down in *The Painting Manual of the Mustard Seed Garden*, he set out to create a dense, monumental style of landscape painting enlivened by bright and fresh colour. Although his brushwork is full of technical mistakes, he succeeded by the sheer force of his artistic personality in creating something both traditional and new. The same, in a different way (and without the

mistakes), can be said of Wan Qingli, art historian and author of the definitive work on Li Keran and of seminal studies of Chinese nineteenth-century painting. The landscape he gave us in 1990 is brilliant both in its unusual composition and in its striking use of colour.

For many Chinese artists, settling in the West has created its own problems and challenges. When, after a rigorous classical training in Beijing under Pu Quan, Zeng Youhe (Tseng Yu-ho, Betty Ecke) came to live in Honolulu, she was brought through her husband Gustav's many contacts to confront Western modernism. An artist of rare intelligence, Zeng Youhe created out of this confrontation a range of works in which the Western elements sit lightly on the surface of pictures that have deep resonances in the Chinese tradition: the landscape in plate II.139, for instance, is evocative of the Northern Song, while, in more meditative mood, the cluster of trees seems to take us back to the Southern Song Chan master Muqi and to an echo of his famous *Five Persimmons*.

In the early 1960s, Zhang Daqian and the collector and connoisseur CC Wang, meeting as old friends in New York, discussed how they could answer the challenge of Abstract Expressionism, and bring *guohua* to life again. CC Wang's way was to create a new kind of composition completely filling the picture space, emphasising the structure of rocks and mountains with brushwork and restrained colour; while Zhang Daqian, ever receptive to new trends, met the challenge of the New York school by floating his ink and mineral colours over the surface, then, creating out of the lovely chaos of ink and colour, by a few deftly placed details, a living landscape.

There is much talk in China nowadays about the *xin wenrenhua*, the new literary men's painting. For many of its practitioners this is a misnomer, for with their meagre educational background, they hardly qualify as literati, while, lacking the rigorous training with the brush, their apparent spontaneity is often a mask for sheer incompetence. But the best of these artists, heirs to the style of the seventeenth-century Individualist Bada Shanren, are fully the equal of their predecessors, among them the Sichuan painter Li Huasheng, whose playful exuberance with the brush and intricate interweaving of painting and calligraphy are well displayed in his *Cockcrow at Dawn*, while we see him in more relaxed and lyrical mode in his charming imaginary evocation of the native village of the poet Li Bai. Perhaps the purest example of the literary tradition from the younger generation is the sensitive handscroll by Harold Wong, whose style and technique seem to take no account of current trends.

The creative freedom of modern Chinese artists in the Chinese medium is shown in less traditional vein in a number of works in our collection, acquired in the 1980s and 1990s: in Yang Yanping's *Fishing*

Yang Yanping and her husband
Zeng Shanquing in their studio
flat in Beijing in 1983.
Photo by MS.

Net, an early experimental work done in Beijing, more freely in her lotus paintings and landscapes and in the powerful peasant's head by her husband Zeng Shanqing. Yu Peng whimsically evokes life in his Taipei garden with his little son; Shao Fei, in her compositions of children, uses rich colour to create pictures that are a little disturbing beneath their apparent playfulness; Wucius Wong paints dreamy landscapes of great textural intricacy and beauty.

The New Ink Painting movement is an expression of the resistance that some artists feel to the overpowering influence of Western art, and the need to re-establish Chinese values. Some of these artists set out to explore the fullest possibilities of brush and ink. Lyrical, if somewhat conventional examples of this trend are the northern landscapes of Song Yugui; while in his evocation of a southern farmhouse against a hillside Gao Xingjian conveys the same poetic feeling that he expressed in his book *Soul Mountain* of 1982, which, with other writings, earned him the Nobel Prize for Literature in 2000. Many of the new ink paintings only seem, at first sight, to be Abstractions, for often there is a hint of a landscape there too. A close examination of Leung Kui Ting's *Cliff* reveals rocks, trees, waterfalls. It seems that for the Chinese artist there is no such thing as pure abstraction. When once I asked Huang Yongyu what he thought of the abstract paintings that he had seen in the Whitney

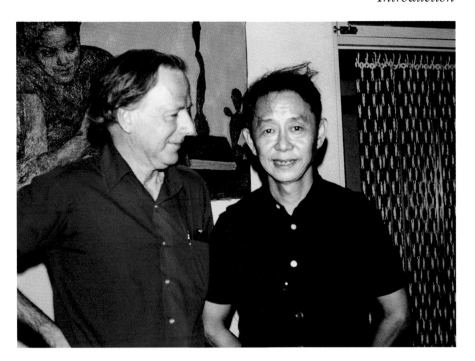

Huang Yongyu with MS in the artist's home in Beijing, 1979. *Photo by KS.*

Museum in New York, he replied 'Meiyou yisi' – they have no meaning.

But for many modern Chinese artists today the question of *guohua* versus *xihua* (Western painting), so long the subject of hot debate, is no longer an issue. They naturally combine elements of both in an infinite variety of ways. Each artist of real integrity finds his or her own answer to this challenge. There are a number of examples of this synthesis in our small collection, among them the delightful *Eiffel Tower Park* by Chu Hing-wah and Qiu Deshu's landscapes and rocks, evolved from almost pure ink into solid, exhilarating colour, now at last an expressive element in Chinese painting. Chu Ko, like many of his more thoughtful contemporaries, has found inspiration in the archaic Chinese script – one of his most striking designs was used for the cover of my book *Art and Artists of Twentieth Century China* – and has become fascinated by knots, which he weaves in the air, in bronze, or sets down in ink and colour on paper. These knots, which straddle the boundary between figurative and abstract art, seem to epitomise both the energy and the complexity of modern Chinese culture.

Calligraphy, the supreme art form in China, is the hardest for the foreigner to appreciate, and we have never sought to acquire the works of leading calligraphers of today. That we have a few precious examples is entirely due to the generosity of our friends: to Yang Chaoxian who wrote the quotation from Qu Yuan for us in Singapore at the age of one hundred and eighteen; to the philosopher and poet Pat Hui in Minneapolis; to Yu Chengyao in Taipei; to Cheng Enyuan, whom we encountered again on the slopes of Huangshan in 1984 forty years after our last meeting in Chengdu; to the great Dutch Sinologist, lutanist and

diplomat Robert van Gulik; to Zhuang Yan, Curator of Painting at the Palace Museum in Taipei and father of Zhuang Zhe, who wrote out for my book *The Arts of China* exquisite examples of all the main styles of calligraphy.

Modern Chinese artists' rediscovery of the art of calligraphy as an aspect of their repudiation both of Soviet influence and excessive Westernisation has been one of the most fruitful and exciting aspects of the art of the last two decades, exploring both its formal and semantic values. While she was still in Beijing Yang Yanping was experimenting with pictorial yet readable compositions of ancient seal characters. Since then other artists have exploited the infinite possibilities of abstract and quasi-abstract calligraphy, notably the Beijing calligrapher Gu Gan; while Fung Ming Chip managed in a delightful conceptual composition to convey the sense of moving, as a Chinese, from the West back to his native Taipei. Some artists carry the calligraphic line into the realm of pure form – notably Jiang Baolin, whose *baimiao* (plain line) works might be considered a Chinese counterpart to Mark Tobey's 'white writing', while by contrast Qu Leilei, in one phase of his work, assembles passages of writing in various styles to produce collages in rich colour of rare beauty.

For the rebels of the Avant-Garde movement of the 1980s, calligraphy was a powerful weapon. Gu Wenda mocked the 'big character poster' of the Cultural Revolution by deliberately miswriting the characters, crossing them out, omitting strokes. He went on to demonstrate the meaningless of the written word in an authoritarian society by inventing his own meaningless characters, combining them in monumental compositions, which for exhibition he mounted as spectacular installations enlivened with performance. His friend and fellow dissident Xu Bing went even further, creating with immense labour over a period of several years a text in which thousands of imaginary characters, printed by hand, was displayed as an installation in Beijing, and made into a book in traditional form, an exercise in the futility of human endeavour of monumental and heroic dimensions. His *Tianshu*, 'A Book from Heaven', as it has come to be called, is one of the most remarkable achievements in contemporary Chinese art.

Finally comes oil painting, an art whose position in Chinese culture has been hotly debated since it was first taught in Chinese art schools around 1915. It was not a natural Chinese mode of expression, but it was modern, while it allowed the depiction of things, and the expression of emotions, beyond the range of traditional *guohua*. Some modern artists, notably Yan Wenliang, were most comfortable in the Western medium, as is Chen Wenji in his exquisitely painted small works in our collection, but others were able to move freely between the two. Wu Zuoren, for

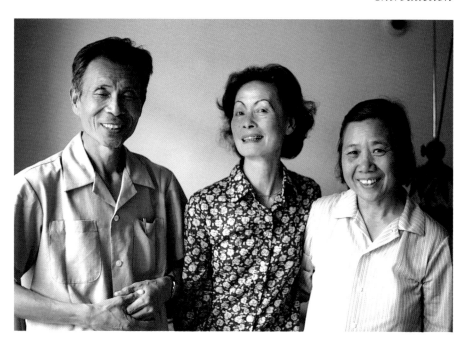

Wu Guanzhong and his wife
Zhu Biqin with KS in the artist's
home in Beijing, 1983.
Photo by MS.

example and Pang Xunqin, who painted the Miao people and lovely
Tang dancers with the Chinese brush, but who, for other subjects, and
for his portraits of his wife and daughter, and of Khoan, turned to oils.
Wu Guanzhong, when asked which medium he preferred to work in,
replied 'When I take up a brush to paint, I paint a Chinese picture.' His
mastery of both media, and the ease with which he moves between them,
is shown in works that he gave us when we first visited his Beijing studio
in 1980.

Modern Chinese artists who settled in the West (although now their
return visits to China are becoming more and more frequent, while some
have gone home for good) seem to have found it easier to work in a
world of *almost* pure Abstraction. Chuang Che's powerful work painted
in New York is entitled *Boulder;* the blue picture that Chu Teh Chun
painted for Khoan in Paris in 1988 is a cosmic landscape with Daoist
undertones. Zao Wou-ki, whose fifty years in France have confirmed him
as a modern master of the School of Paris, when I said to him in his
studio that his pictures looked like landscapes, exclaimed 'But of course
they're landscapes!'. The references in his work to nature are not always
so obvious, although in his wonderful *Triptych* of 1995, the feeling for
atmosphere, and the rhythmic movement of the brush through space,
express a sense both of visible nature and of the reality 'beyond the
image,' as the Chinese put it, that lies at the heart of Chinese painting.

MICHAEL SULLIVAN
Oxford
August 2009

KHOAN AND MICHAEL SULLIVAN
COLLECTION OF
MODERN CHINESE ART

I. Albums

ALBUM A

This album was circulated among artists of the younger generation whom we met during our visit to Hong Kong in 1968. All were painters, except for the sculptors Cheung Yee and Van Lau. Their contributions give a hint of the fascinating range of media, styles and techniques, from the purely classical to abstractions and collages, being practised at this time of the Colony's artistic awakening. Van Lau's etched and coloured aluminium plate must be unique in a Chinese album.

OVERALL DIMENSIONS 26.5 × 37.2 CM.

Zhang Yi (Cheung Yee) 張義
(b. 1936)

1 *Images from oracle bones (double spread)*

> Ink and colour on paper.
> Signed and dated 1968.

Han Zhixun (Hon Chi-fun) 韓志勳
(b. 1922)

2 *Composition with classical text in red on green with blue*

> Signed and dated 1968.

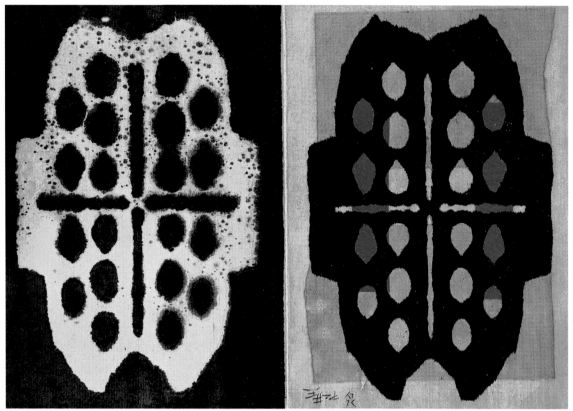

I. A. 1

I. A. 2

I. A. 3

Wen Lou (Van Lau) 文樓
(b. 1933)

3 *Abstraction*

Aluminium plate engraved and partly coloured.
Signed and dated 1968 in Shatin, Hong Kong.

Liu Guosong 劉國松
(b. 1932)

4 *Abstract landscape*

Ink and collage on paper (double spread).
Signed and dated 1968.

I. A. 4

I. A. 5

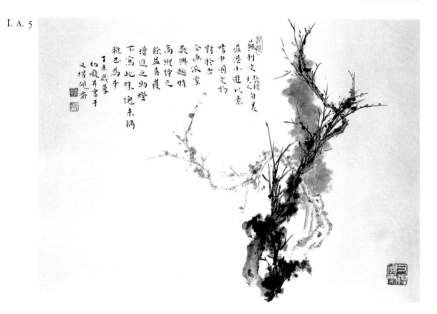

Huang Zhongfang (Harold Wong) 黃仲方
(b. 1943)

5 *Trees*

Ink and colour on paper (double spread).

Inscribed to K and MS by the artist. Signed and dated 1968, with three artist's seals.

Feng Zhongrui 馮鍾睿
(b. 1933)

6 *Abstraction*

Ink on paper (double spread).

Signed and dated 1968.

I. A. 6

Chen Tingshi 陳庭詩
(1915–2002, Fuzhou)

7 *Abstraction*

Made by pressing inked fibre-board over loosely coiled string.
Signed and dated 1968 with one artist's seal.

Xu Zixiong (Chui Tze-hung) 徐子雄
(b. 1936)

8 *Three part abstraction*

Ink and colour (double spread).
Signed 'Chui'.

Unidentified artist

9 *Abstraction*

Ink on paper (double spread).

Wang Wuxie (Wucius Wang) 王無邪
(b. 1936)

10 *Page from a newspaper with ink, a long inscription by the artist, and dedication to MS*

Dated 1968.
(*not illustrated*).

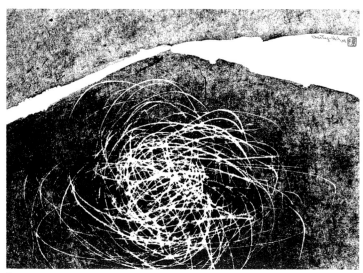

I. A. 7

I. A. 8

I. A. 9

ALBUM B

This album was circulated among Hong Kong artists during and after our visits of 1970 and 1971. Like Album A, it reveals something of the variety of styles and techniques of the less conventional Hong Kong artists, and it too is a witness to the birth of friendships that still flourish today.

OVERALL DIMENSIONS 31.1 X 22.2 CM

Tan Manyu (Tan Doen) 譚曼于
(b. 1908)

1 *Right page: A Mountain Path (on Huangshan?)*
Left page: calligraphic inscription and dedication to
MS

Signed with two seals of the artist.

Zhang Jiahui (Beatrice Ts'o) 章家慧
(b. 1914)

2 *Chrysanthemums and vine stems*

Ink and colour on paper (double spread).
Signed and dated 1971 with one artist's seal.

Zhou Luyun (Irene Zhou) 周綠雲
(b. 1924)

3 *Tree branches and ghostly shape*

Ink and colour on paper (double spread).
Signed by the artist with one seal.

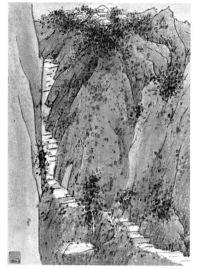

I. B. 1

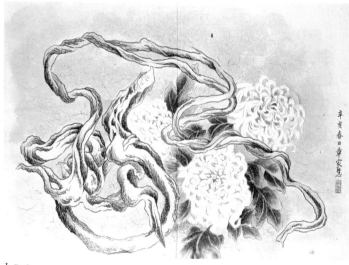

I. B. 2

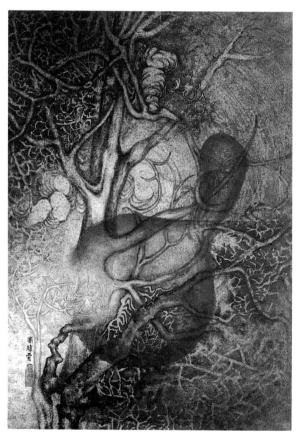

I. B. 3

Tan Zhicheng (Lawrence Tam) 譚志成
(b. 1933)

4 *Mountain landscape*

Ink on paper (double spread).
Signed and dated 1970 with one artist's seal.

Ng Yiu-chung (Wu Yaozhong) 吳耀中
(b. 1935)

5 *Landscape with red sun*

Ink and colour on paper.
Signed with two artist's seals (double spread).

Wang Honghui (Wong Wangfui) 汪弘輝
(b. 1940)

6 *Landscape*

Signed with one artist's seal.

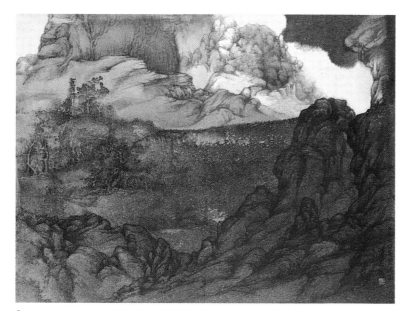

I. B. 4

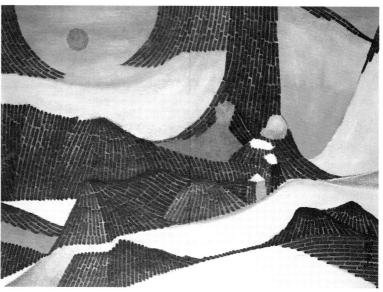

I. B. 5

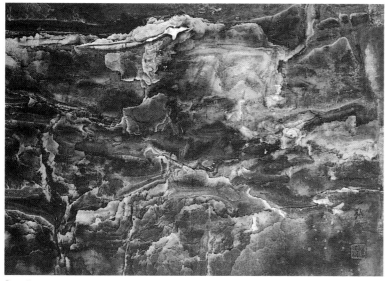

I. B. 6

Li Wei'an (Lee Wai-on) 李維安
(b. 1937)

7 *Collage*

Ink, colour, photo, printed text.
One artist's seal.

ALBUM C
Title written by Pu Xinyu.

Painted for Geoffrey Hedley. As British Council representative in China from 1944 to 1950, Geoffrey Hedley made contact with artists chiefly in Chongqing, Beijing, Nanjing and Shanghai, whom he helped and encouraged in a number of ways. In return, several of them contributed to this album for him. This album was a bequest by Geoffrey Hedley to K & MS in 1960. Not all the works in this album show the artists at their best.

OVERALL DIMENSIONS 35.5 × 47.6 CM

Fu Shuda 傅叔達
(?–1960)

1 *Bamboo*

Ink on paper.
Signed with one artist's seal.

Pu Xinyu 溥心畬
(1896–1964)

2 *Landscape in ink*

Ink and colour on paper.
Dated autumn 1949. Signed with one artist's seal.

I. B. 7

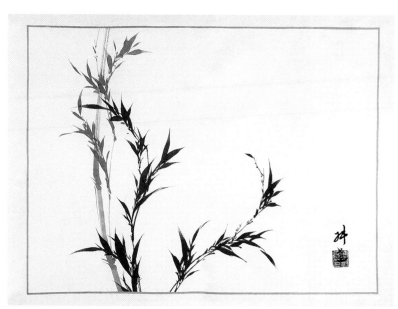

I. C. 1

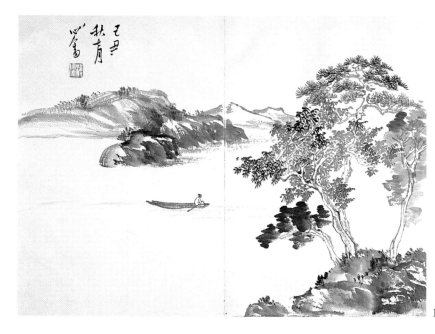

I. C. 2

Lin Fengmian 林風眠
(1900–1991)

3 *Birds on branch*

Ink and colour on paper.
Signed, one seal.
(*not illustrated*).

Zhang Yuguang 張聿光
(1884–1968)

4 *Cranes, pine and plum*

Ink and colour on paper.
Two artist's seals.
This artist was better known as a cartoonist.

Fu Baoshi 傅抱石
(1904–1965)

5 *Gentlemen by the Lake Shore*

Ink and colour on paper.
Signed and dated to 1950 with two artist's seals.
Painted in Nanjing.
Fu Baoshi was incapable of painting a bad picture.

Qi Baishi 齊白石
(1864–1957)

6 *Grapes*

Ink and colour on paper.
Dedication to Geoffrey Hedley.
(*not illustrated*).

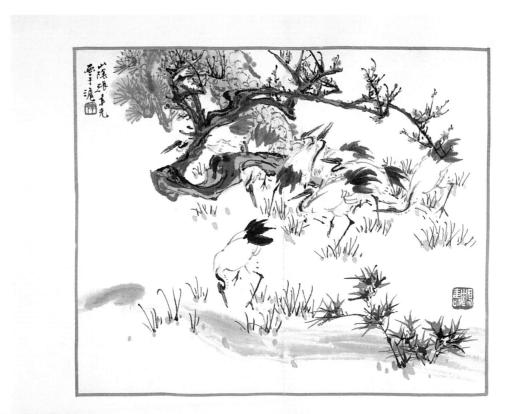

I. C. 4

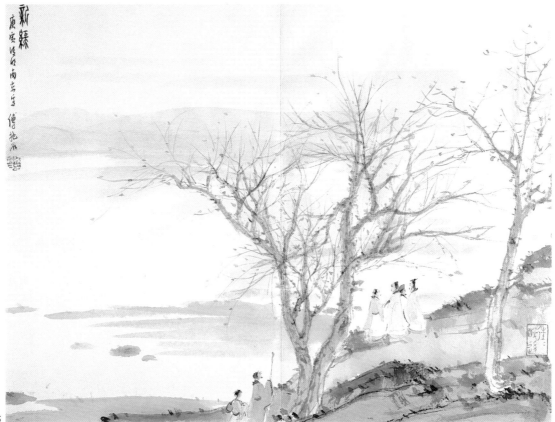

I. C. 5

Ding Xiongquan (Walasse Ting) 丁雄泉
(b. 1929)

7 *Landscape*

Ink and colour on paper.
Signed W Ting, and dated '51.
(*not illustrated*).

Huang Binhong 黃濱虹
(1865–1955)

8 *Landscape sketch*

Ink and colour.
One artist's seal.
(*not illustrated*).

Huang Binhong 黃濱虹
(1865–1955)

9 *Landscape sketch*

Ink and colour.
One artist's seal.
(*not illustrated*).

Hu Ruosi 胡若思
(b. 1916)

10 *Lotus*

Ink and colour.
Artist's inscription to Geoffrey Hedley.

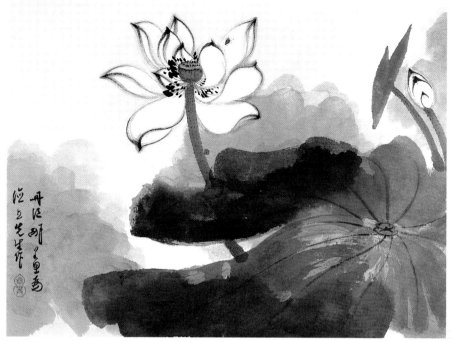

I. C. 10

ALBUM D

ASSEMBLED IN HONG KONG IN 1999.
OVERALL DIMENSIONS 38.8 x 21.5 CM.

Zhuang Yan (Chuang Yen) 莊嚴
(1899–1980)

1 *Sixteen examples of different styles of Chinese epigraphy and calligraphy*

These were specially written in 1968 for inclusion in *A Short History of Chinese Art,* and included in all editions of *The Arts of China.*

Zhuang Yan (father of the painter Zhuang Zhe, Nos. II. 69–173) was then Curator of Painting at the Palace Museum, Taizhong.

I. D. 1(a) I. D. 1(b)

Fu Baoshi 傅抱石
(1904–1965)

2 *Letter from Fu Baoshi to Geoffrey Hedley, with self-portrait*

Dated 29 December 1950.

29 × 15.8 cm.

ALBUM E

Xia Hui (Xia Yugu, Yunshan waishi etc) 夏翚
Early 19th century, native of Kunshan, Jiangsu, lived in Suzhou.

1 *Orchids and bamboo*

Ten leaves, 27.3 × 33.5 cm.

Last leaf signed and dated 1801. Each leaf bears artist's seal.

Title *Jin de feng liu* written by Chao Li in 1844 at the request of a previous owner, Xiaofeng.

Formerly in the collection of Cheng Erxiang in Suzhou.

Bequeathed by Geoffrey Hedley to K & MS in 1960.

I. E. 1(a)

48

賀德之先生：月中曾託敝友罪時穿先生造訪

承 惠予延見甚慰之榉

揚明並望稱 先生保護榉作毋微不至尤限

拜謝 諸項作點不全部叔託敬怀

釋念 時鍚 教言昌勝在峯當冬明坫

眹中諸兄

道綏祥祝

年釐

弟 傅抱石 一九五〇. 十二. 廿九。

I. D. 2

I. E. 1(b)

I. E. 1(c)

49

ALBUM F

Fu Baoshi 傅抱石
(1904–1965)

I *Landscapes of the Four Seasons*

Ink and colour on paper. 28 × 34.3 cm.

Each leaf has an inscription by the author and two seals.

The last (winter) inscribed to Geoffrey Hedley, signed and dated 1950.

Bequeathed by Geoffrey Hedley to K & MS in 1960.

I. F. I(a)

I. F. I(b)

I. F. I(c)

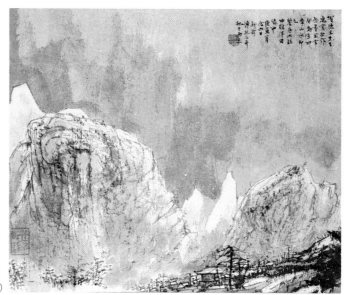

I. F. I(d)

II. Paintings and Graphics

Cai Tianding (Chuah Tian-teng) 蔡天定 (b. 1914)

Batik designer and decorative artist who, after studying in the Xiamen Art Academy, settled in Penang in 1932. He learned the batik technique in Java and was one of the first artists in south east Asia to use it for genre subjects.

1 *Rice-husking season*

Batik 'painting' on cotton, 44 × 37.1 cm.

Made in Penang or Singapore.

Given by the artist to K & MS in about 1958.

Publ. *Chinese Art in the Twentieth Century*, Fig. 65.

II. 1

Cai Xiaoli 蔡小麗
(b.1956, Xi'an, China)

In 1982 graduated from the Central Academy of Fine Art, Beijing, where she taught *guohua* till 1988. She lives in London and Beijing with her husband, the landscape painter Wang Jia'nan. (No. II. 117 and front cover)

2 *Summer flowers*

Ink and colour on paper, mounted and framed, 79.5 × 81.2 cm.

Mounted and framed.

1997, signed Xiaoli.

Acquired from Kaikodo, New York, *Two Dimensions* Exhibition, 1999.

Ch'en Ch'i-k'uan (Chen Qikuan) 陳其寬
(b. 1921, Beijing)

Architect and amateur painter. In 1944 gained his BS in architecture at the National Central University, Chongqing; in 1949 MA, University of Illinois; from 1952–54 instructor in architecture, MIT, Boston; 1980 Dean of Engineering, Donghai University, Taiwan. Although an active architect Ch'en Ch'i-k'uan is known world-wide as an artist of great imagination and precision of technique. He has been a friend of ours for fifty years.

3 *Reflections (landscape)* 山麓漁影

Light ink and colour on paper, mounted and framed, 22 × 92 cm.

Title and one seal of artist. No signature, n.d.

Acquired by gift from owner of Mi Chou Gallery, 801 Madison Ave, New York in 1960.

II. 2

II. 3

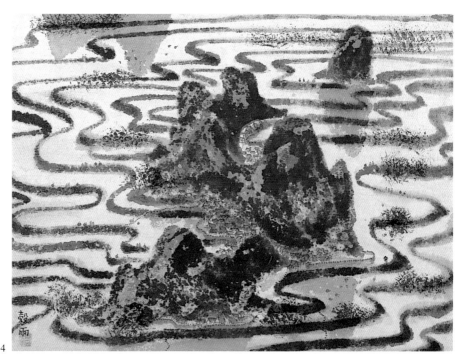

II. 4

4 *Landscape with hills rising out of rice fields*

Ink and colour on paper, mounted and framed, 22.2 × 29.8 cm.

No signature, one seal of the artist.

Acquired by gift from owner of Mi Chou Gallery, 801 Madison Ave, New York in 1960.

5 *Monkeys (mother with baby monkeys)*

Hanging scroll, ink and slight colour on paper, 33.7 × 45.6 cm.

Signed with one seal of the artist, n.d.

Given by the artist to K & MS in 1990.

6 *Paocai (Pickled Cabbage)*

Ink on paper, 29.8 × 48 cm.

Signed with one seal of the artist, n.d.

Given by the artist to K & MS after his first exhibition at MIT, Cambridge, MA in 1953.

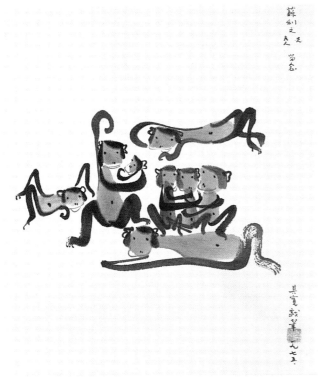

II. 5

II. 6

Chen Tingshi 陳庭詩

He lost his speech and hearing at the age of eight; at thirteen he studied *guohua* and was self-taught in Western media. In 1949 he moved to Taiwan, where he was a founding member of the Fifth Moon Group. He is noted for his abstract compositions printed from cut-out fibre-board.

II. 7

7 *Abstract composition*

Hanging scroll, printed in ink on paper from cut-outs of coarse fibre-board, 60.5 × 61.4 cm.

Signed, with one artist's seal, and dated 1967.

No. 3 of an issue of 10.

Given by the artist to K & MS in 1968.

Chen Wenji 陳文驥
(b. 1954, Shanghai)

Printmaker and oil painter. In 1978 he graduated from the Central Academy, Beijing. From 1985 he was a teacher of *nianhua*, then worked in the Wall-Painting Department. In the 1990s he developed as an oil painter with a miniaturist technique that is both atmospheric and subtle.

8 *Unbalanced View (from the train)*

1999, oil on canvas, 25 × 30 cm.

Those who know present-day Beijing will recognize the yellow smog that envelops the city for much of the year.

Acquired from CourtYard Gallery, Beijing, in November 1999.

II. 8

9 *Lonely Glory – Series of Supremacy*

1999, oil on canvas, 30 × 25 cm.
Acquired from CourtYard Gallery, Beijing, in November 1999.

10 *Lonely Master – Series of Supremacy*

1999, oil on canvas, 30 × 23 cm.
Acquired from the CourtYard Gallery, Beijing, in November 1999.

II. 9

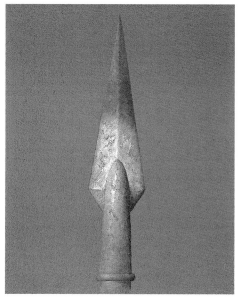

II. 10

II. 11

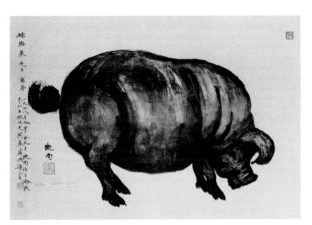

II. 12

Chen Wenxi 陳文希
(1906–91)

Born in Guangdong and trained in the Xinhua Academy, Shanghai, Chen Wenxi was, with Zhong Sibin, Liu Kang and Chen Chongswee, one of the four leading artists active in Singapore in the 1950s and 1960s.

11 *Garden in Guangzhou*

Pastel on paper, 33 × 39.7 cm.
Mounted and framed.
Two small seals of the artist.
Given by the artist to K & MS in Singapore in about 1955/56.

Chen Xiaonan 陳曉南
(b. 1909)

Native of Lixian, Jiangsu. After World War II, he became a pupil of Xu Beihong in Nanjing. One of four artists from Nanjing who came to London in 1948 with the support of the British Council.

12 *Sow*

Lithograph on paper.

Mounted.

Dated New Year 1948(?).

Gift of the artist.

Cheng Shifa 程十髪
(1921–2007, b. Songjiangxian, Jiangsu)

Guohua painter, illustrator and calligrapher.

After studying in the Shanghai College of Art he worked for many years, chiefly as an illustrator, for the People's Art Publishing House.

13 *Peasant girls on a buffalo amid flowers*

Hanging scroll, ink and colour on paper, 82 × 51.4 cm

Signed with one artist's seal and dated 1964.

Purchased by K & MS. Probably from Mrs Shen's gallery in London in 1960s.

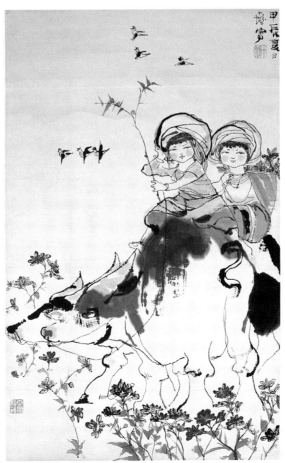

II. 13

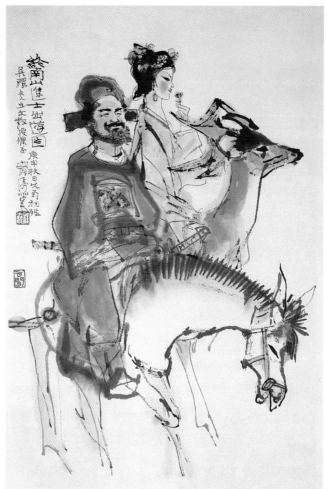

II. 14

14 *Zhong Kui out on an excursion with his sister*

Hanging scroll, ink and colour on paper, 70 × 48.5 cm.

Title, signature and two artist's seals.

Inscribed by the artist to K & MS in 1980, when we visited his home in Shanghai.

Zhong Kui was a Tang Dynasty official who in Chinese folklore became a legendary ghost-buster. He is often depicted taking his favourite sister out riding, or marrying her off.

Cheng Songwan 程頌萬
(1865–1932)

Active in Shanghai at the turn of the 20th century, Cheng Songwan (*zi* Shifa jushi 十髮居士) established the Guangyixing Gongsi, which produced paper, seals, bamboo and wood products, lacquer and embroidery; he had a wide circle of friends among the Shanghai literati.

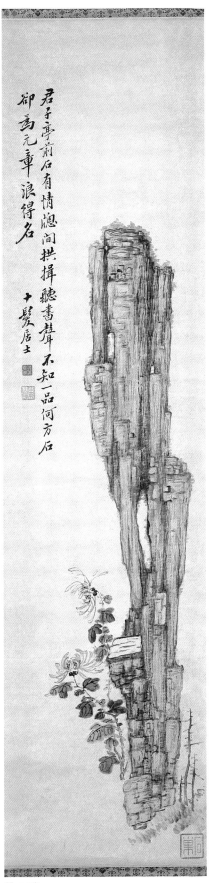

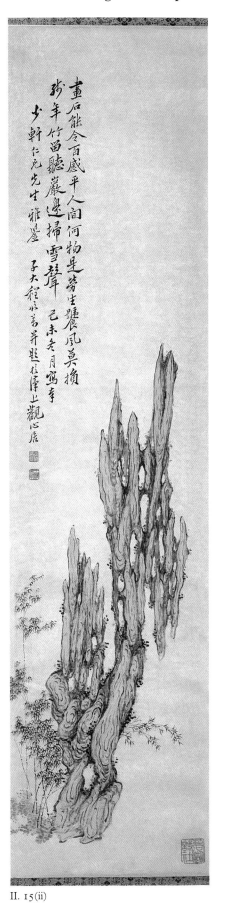

II. 15(i)

II. 15(ii)

15 *Fancy garden rocks*

Pair of hanging scrolls, ink on paper, 125.4 × 31.4 cm each.

Dated winter, 1919, painted and inscribed for his friend Shaoxuan:

Inscriptions:

(1)
The rock in front of the Pavilion of Gentlemen has feelings.
It stands respectfully between the windows and listens to the sound of
 reading.
I wonder how a piece of unknown rock,
Made the reputation of Yuanzhang (Mi Fu).

(2)
Painting rocks can ease a hundred feelings of distress.
What is there in the world to burden life?
Gluttonous custom! – Do not damage the remaining bamboo,
Spare some to hear the sound of snow sweeping by the rock.
Painted in the winter season, 1919, for the appreciation of my friend
 Mr Shaoxuan. 少軒仁兄

(Translated by Hsiao Li-ling 蕭麗玲)

Chu Ko (Yuan Dexing) 袁德星
(b. 1931, Hunan)

Painter, poet and art critic. He joined the Guomindang army during
World War II, and in 1949 went to Taiwan. In 1967, he became curator
in the bronze section of the National Palace Museum, Taipei, when he
made a deep study of epigraphy and bronze décor. Since 1985 he has
visited the US and Europe.

16 *Knots*

Ink and colour on canvas, framed, 44.8 × 52.3 cm.
Given to K & MS by the artist in 1998.

17 *Landscape*

Ink and colour on canvas, 49 × 59.2 cm.
Given to K & MS by the artist in 1998.

II. 16

II. 17

Ding Cong (Xiao Ding) 丁聰
(b. 1916, Shanghai)

Cartoonist, illustrator and graphic artist. Son of the cartoonist Ding Song. Before World War II and after 'Liberation' he edited pictorial magazines; during World War II he travelled widely in 'Free China'. We became friends in Chengdu where he gave us a number of his drawings. Today he is still living and working in Beijing.

18 *Old woman*

Chinese ink on paper, 31.4×24 cm.

Drawn and signed in Chengdu in 1944.

Xiao Ding gave this drawing to a friend in Chengdu in 1944. This person threw it away. Xiao Ding recovered it and gave it to K & MS in Chengdu in, I think, 1945.

Publ. *Art and Artists of Twentieth Century China*, Fig. 9.14.

19 *Self-portrait*

Ink on paper.

Drawn in Chengdu in 1943.

Gift of the artist to K & MS.

Publ. *Art and Artists of Twentieth Century China*, Fig. 9.13.

(*not illustrated*).

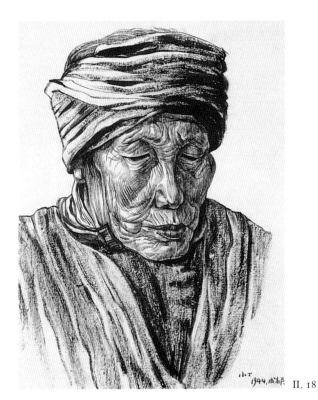

II. 18

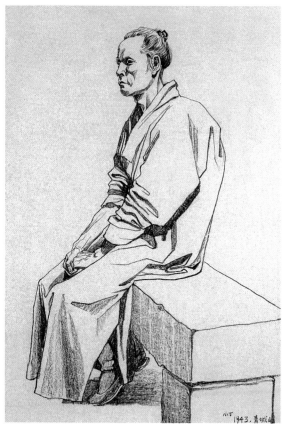

II. 20

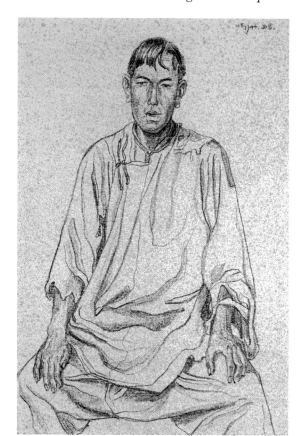

II. 21

20 *Daoist priest on Jingchengshan*

Pencil drawing on paper, mounted, 30.5 × 20.6 cm.

Drawn on Jingchengshan, near Guanxian, Sichuan in 1943.

Given by the artist to K & MS in Chengdu in 1944 or 1945.

Publ. *Art and Artists of Twentieth Century China*, Fig. 9.15.

Jingchengshan in the foothills northwest of Chengdu is famous for its Daoist temples and a welcome retreat from the humid climate of Chengdu.

21 *Lele man*

Pencil and slight colour on paper, mounted, 37.5 × 22 cm.

Signed and dated Xichang 1944.

Given by the artist to K & MS in Chengdu in 1945 or 1946.

Publ. *Art and Artists of Twentieth Century China*, Fig. 42.

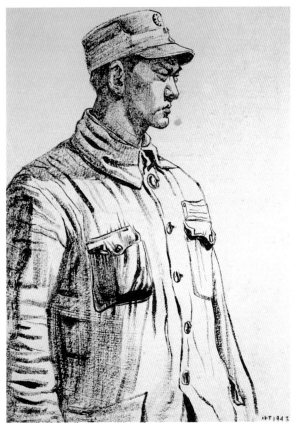

II. 22

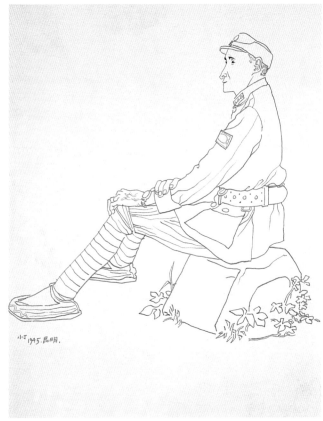

II. 23

22 *Guomindang soldier*

Chinese brush and dry ink on paper, mounted, 33 × 24.2 cm.
Signed Xiao Ding 1943.
Given by the artist to K & MS in 1945 or 1946.
Publ. *Chinese Art in the Twentieth Century*, Fig. 68.

23 *Seated soldier*

Ink line drawing, 22.7 × 7.6 cm.
Done in Kunming in 1945.
Gift of the artist in Chengdu.

24 *Peasant with carrying pole*

Ink line drawing, 30.5 × 22.8 cm.

Done in Kunming in 1945.

Gift of the artist in Chengdu.

25 *Lu Xun*

Ink on paper, 31.3 × 20 cm.

Dated 1977.

Inscribed in October 1979 to his old friends Lao Mai (Michael) and Khoan in Beijing.

Publ. *Art and Artists of Twentieth Century China*, Fig. 8.1.

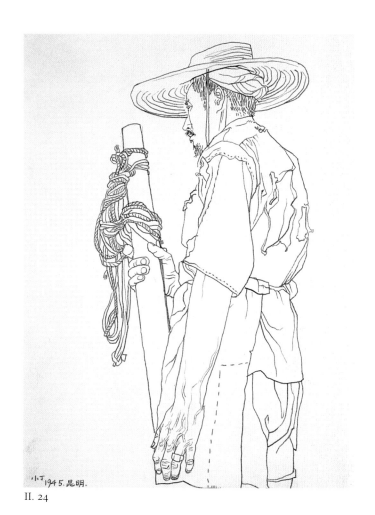

II. 24

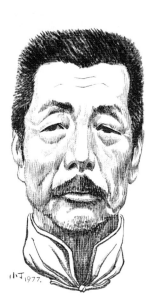

II. 25

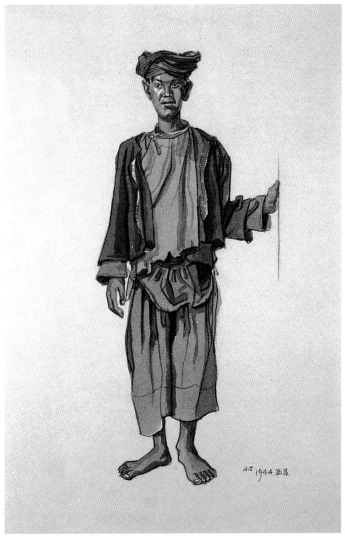

II. 26

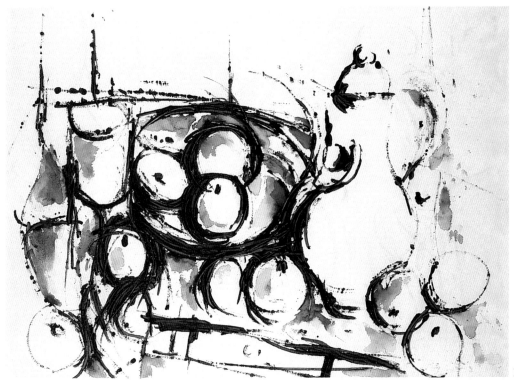

II. 27

26 *Borderland tribesman*

Watercolour on paper, 33 × 22 cm.

Signed and dated 1944 in Xichang 西昌.

Gift of the artist in Chengdu.

Ding Xiongquan (Walasse Ting) 丁雄泉
(b. 1929, Shanghai)

In 1953 he went to Paris to study and paint; in 1963 he settled in the USA. An abstract painter in the 1960s, he later developed an expressionist figurative style.

27 *Still life*

Ink and slight colour on paper, 36.2 × 75.3 cm.

Signed 'W Ting', probably painted about 1948 in Shanghai.

Bequeathed to K & MS by Geoffrey Hedley in 1960.

28 *Grotesque figures*

Ink and colour on paper, mounted.

Bequeathed to K & MS by Geoffrey Hedley in 1960.

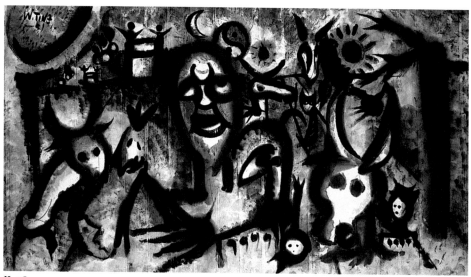

II. 28

71

Fang Jizhong 方濟眾
(1923–87, Shaanxi)

Guohua painter who studied under Zhao Wangyun. Celebrated for his portrayals of goats. He lived and worked in Xi'an.

29 *Deer in an autumn forest*

Ink and colour on paper, mounted, 68 × 44.3 cm.

Painted in the autumn of 1979 and inscribed by the artist to K & MS in Xi'an.

Feng Mingqiu (Fung Ming-chip) 馮明秋
(b. 1951, Guangdong)

Painter, calligrapher and seal-carver, playwright and director. Moved to New York in 1977; from 1986 he has been living between New York and Taiwan.

30 *Accidental Passing B, 1998*
堅強區域字 , which the artist translates as 'Zone script'.

Ink on paper, 83.2 × 69.5 cm

The artist told me that the idea for this work came to him on a long flight from New York to Taipei, during which he gradually left the West behind and became more and more conscious of his Chinese identity. This is a vivid and unusually successful example of modern conceptual art that is also profoundly Chinese.

Acquired from his exhibition at Michael Goedhuis' Gallery, London, November 2000.

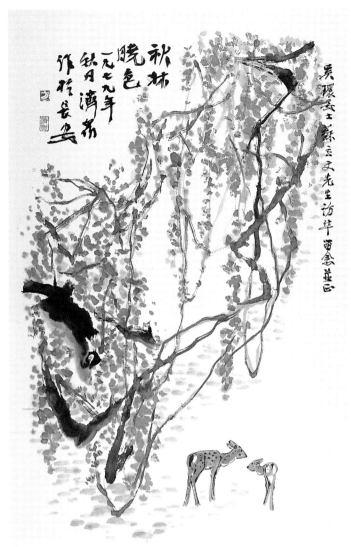

II. 29

II. 30

Feng Zhongrui (Fong Chung-ray) 馮鍾睿
(b. 1933, Henan)

Abstract painter. In 1949 he moved to Taiwan, where in 1956 he joined Liu Guosong in the Fifth Moon Group.

31 *Abstraction*

Ink and colour on paper, circular painting, mounted and framed, diam. 56.5 cm.

Signed and dated May, 1970.

Given by the artist to K & MS in Hong Kong in 1970.

Fu Baoshi 傅抱石
(1904–1965)

Guohua painter, born in Nanchang, Jiangsi. After studying and teaching in Nanchang, he went to the Tokyo Academy of Art (1933–35). In 1949 he became head of the Jiangsu Academy of Art in Nanjing. Although he was in west China during World War II, we never met him, but he was a good friend of Geoffrey Hedley.

32 *Landscape*

Hanging scroll, ink and colour on paper, 109.2 × 61 cm.

Painted in the suburbs of Chongqing in about 1944.

Bequeathed to K & MS by Geoffrey Hedley in 1960.

33 *Landscape*

Hanging scroll, ink and colour on paper, 69.8 × 34.5 cm.

Painted in Chongqing, dated 1944.

Inscription.

Bequeathed to K & MS by Geoffrey Hedley in 1960.

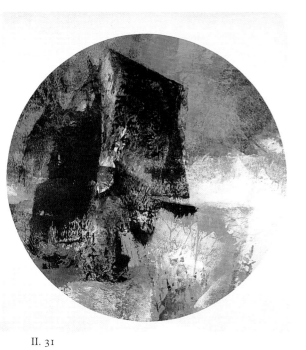

II. 31

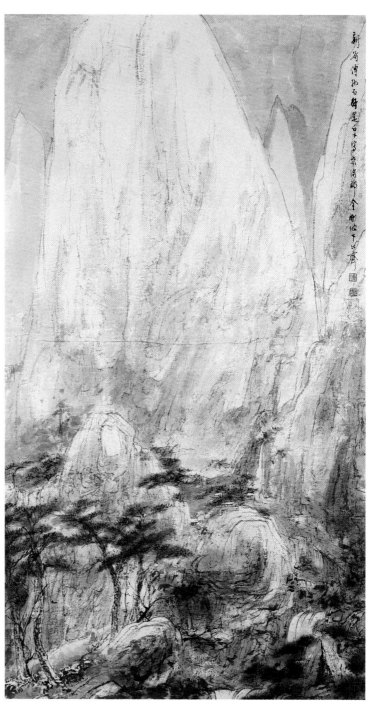

II. 32

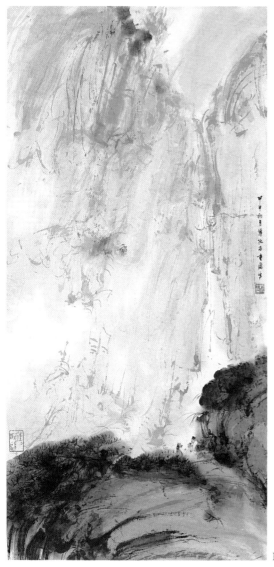

II. 33

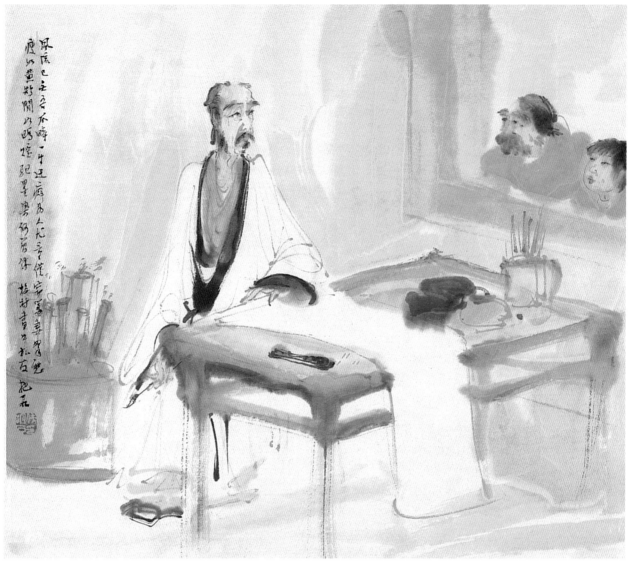

II. 34

34 *The scholar artist in his studio*

Album-leaf, ink on paper, mounted and framed, 30 × 34 cm.

N.d., about 1948.

Bequeathed to K & MS by Geoffrey Hedley in 1960.

Another almost identical version is in the collection of the Musée Cernuschi, Paris.

Publ. *Chinese Art in the Twentieth Century*, Fig. 18; *Art and Artists of Twentieth Century China*, Fig. 1.18.

Fu Shuda 傅叔達
(d. 1960)

Guohua painter, who trained in *guohua* in Beijing. From 1937–41 he lived in the USA doing book illustration. In Chongqing in 1941, he then worked for the British Government in India and Singapore. In 1948 he returned to China, where he was a friend of Geoffrey Hedley. He died in 1960 of cancer during (or after) a long term in prison. His wife was also imprisoned. If it were not for his friendship with Geoffrey Hedley, his work would be almost unknown in the West.

35 *Bamboo and rock*

Ink on paper, mounted, 62.3 × 45.3 cm.

Signed Shuda, one seal.

Bequeathed to K & MS by Geoffrey Hedley in 1960.

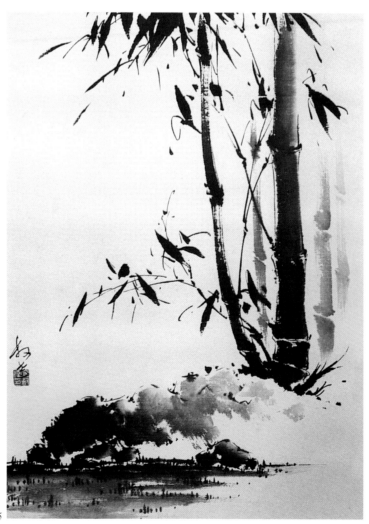

II. 35

36 *and* 37 *Lotus*

Two hanging scrolls, ink on paper, 131.5×67.4 cm and 86×50 cm.
Signed with one artist's seal, n.d.
Bequeathed to K & MS by Geoffrey Hedley in 1960.

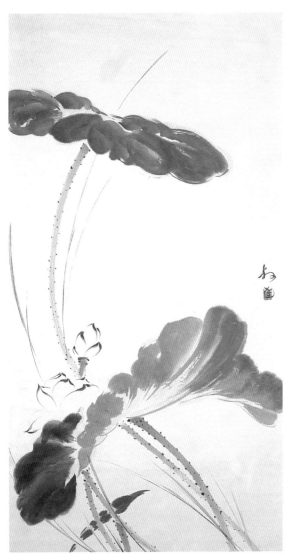

II. 36

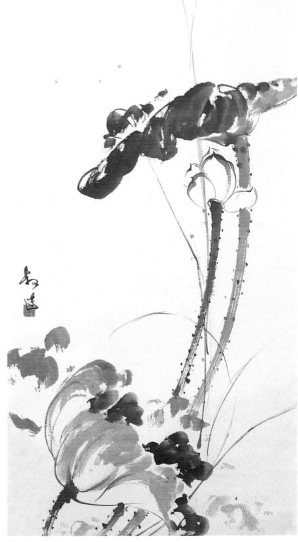

II. 37

38, 39, 40 *and* 41 *Four paintings of actors*

Ink and colour on paper, 43.5×39.2 cm, 47×35 cm, 41.2×32 cm, 41×32 cm.
Each with one artist's seal, no signature. About 1949.
Bequeathed to K & MS by Geoffrey Hedley in 1960.

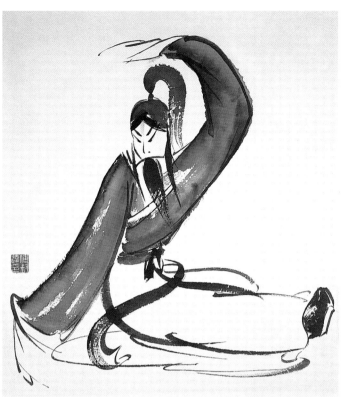

II. 38

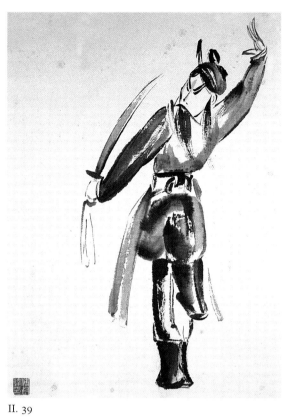

II. 39

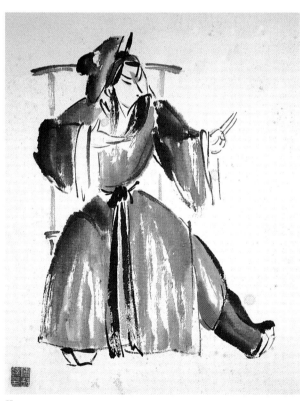

II. 40

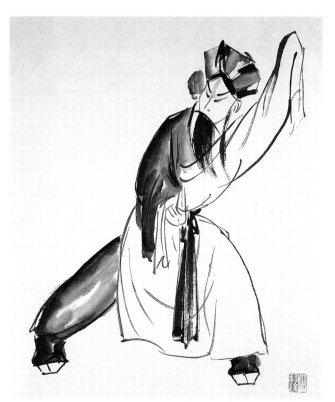

II. 41

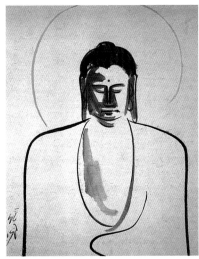

II. 42

42 *Buddha*

Ink on paper, mounted, 64.5 × 50.8 cm.

Signed Shuda, no seal. Painted about 1949.

Bequeathed to K & MS by Geoffrey Hedley in 1960.

43 *River landscape*

Ink and colour on paper, 10 × 43.3 cm.

About 1950.

This painting was evidently sent to Geoffrey Hedley after he left China. On the back Fu Shuda has written:

> My dear Geoffrey,
>
> You cannot imagine how happy we are hearing from you, Millie, Fred and Muriel Garner.
>
> Please don't forget that your friends are always think of you and remember you from far away, special in Christmas day.
>
> With all the best wishes for this coming New Year
>
> from
>
> Chung-ching & Shuta

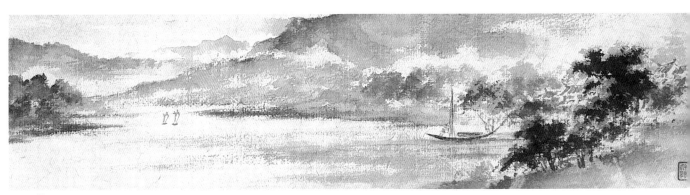

II. 43

Gao Xingjian 高行健
(b. 1940, Jiangxi Province)

Playwright, novelist, critic and amateur painter. He took a university degree in French in Beijing and in 1987 settled in Paris. There in 1989 he completed *Soul Mountain*, which in 2000 earned him the Nobel Prize for literature. His ink landscapes convey with haunting beauty the atmosphere of the Chinese countryside that he evokes so vividly in *Soul Mountain*.

44 *Farmhouse in the evening*

Ink on paper, mounted and framed, 87 × 74 cm.

1998.

Acquired from Alice King's Alisan Gallery, Hong Kong, in November 1999.

II. 44

Gu Gan 古干
(b. 1942, Changsha, Hunan)

Painter and calligrapher, who studied under Ye Qianyu, Huang Miaozi and Zhang Zhengyu. In 1985 he became Chairman of the Society of Modern Chinese Calligraphy, Beijing. From 1987–93 he lectured in the University of Bonn and the Fine Arts Institute, Hamburg and has held exhibitions in Germany, London, New York and elsewhere.

45 *Longevity*

Ink and colour on paper, mounted and framed, 93 × 98 cm.

1990.

Acquired from his 1998 exhibition at Michael Goedhuis' Gallery in London.

Guan Shanyue 關山月
(1912–2000, Canton)

Guohua painter, Lingnan School. After studying under Gao Jianfu, he became a teacher in the Painting Department of Canton Municipal Art Academy. During World War II he lived in west China. After a stay in Hong Kong, he returned to China where he became active in Party cultural politics.

46 *River with waterwheel and cranes*

Ink and watercolour on paper, mounted and framed, 82.4 × 40.8 cm.

Signed by the artist, with two artist's seals.

Painted and given to MS by the artist in 1945 in Chengdu, and inscribed to him.

Guan had been exchanging lessons with MS, teaching MS painting while MS taught him English. MS had seen another version of this painting and admired it. The artist could not part with it, and painted this version to give to him.

Publ. *Chinese Art in the Twentieth Century*, Fig. 35; *Art and Artists of Twentieth Century China*, Fig. 5.4.

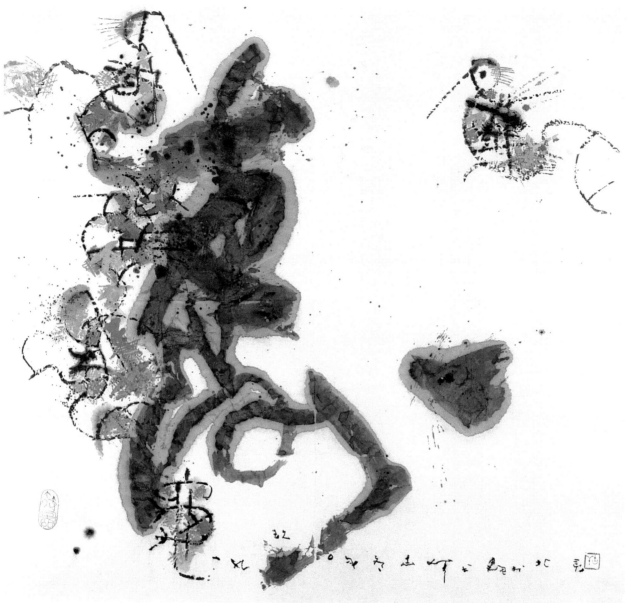

II. 45

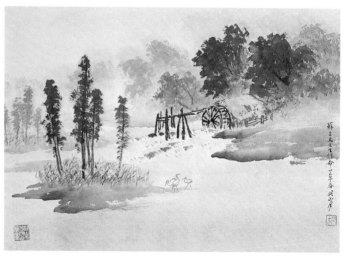

II. 46

Gu Wenda (Wenda Gu) 谷文達
(b. 1955, Shanghai)

Painter, performance artist and creator of Installations, trained in Shanghai in wood-carving then in *guohua* at the National Academy, Hangzhou under Lu Yanshao and others. In the 1980s he became prominent in the Avant-Garde movement. In 1987 he went to Toronto and later settled in New York with return visits to China. His controversial Installations and Performances have earned him a world-wide reputation.

47 *Stele (Imaginary 'big seal', dazhuan characters)*

Ink on paper, mounted and framed, 96 × 89.8 cm.

One artist's seal.

Given by the artist to K & MS in February 2000, in recognition of MS's contribution to the Western understanding of modern Chinese art.

II. 47

84

Huang Binhong 黃濱虹
(1865-1955)

Guohua painter, connoisseur and editor. He grew up in Anhui where he studied at home with a private tutor. An active member of societies connected with painting, calligraphy and seal-engraving in Shanghai. Professor at the Xinhua Academy, Shanghai and, after a stay in Beijing, Professor in the Hangzhou Academy whence he sent us the small landscape. The dominant figure in the revived Anhui School of landscape painting, his influence on younger *guohua* painters was enormous.

48, 49, 50, 51 *and* 52 *Landscapes*

Leaves from an album, ink and colour on paper, 27.3 × 47.2 cm.
Inscribed with poems and the artist's signature and one seal on each.
(*One leaf not illustrated*).

Painted before about 1925, when he finally dropped the water radical from the *Bin* of his name. None of them are dated, but they were bought in New York or Boston by K & MS in about 1953. (Being very poor, in 1954 I consigned 6 leaves, keeping the best 6, to H. Medill Sarkisian in Denver for sale. He later said he had lost them. They must be in someone's collection, somewhere.) Although painted when he was a young man and had not yet perfected his mature style, these leaves show that he was already a master.

II. 48

85

II. 49

II. 51

II. 50

II. 52

II. 53

53 *Waiting for the Ferry in Sichuan*

Ink and colour on paper, mounted and framed, 35 × 26.3 cm.

Inscription, signature and one seal of the artist, n.d.

Sent by airmail, unmounted and folded up small, to K & MS in London in 1948 or early 1949. A perfect little example of the style of this artist's best period. Perhaps he chose this subject because he had heard that we had been living in Sichuan.

Huang Yongping 黄永砅
(b. 1954, Xiamen, Fujian)

Graduated from the Zhejiang Academy of Art to become a pioneer in the 'Non-Expressionist Painting' movement and a neo-Dadist follower of Marcel Duchamp. He moved to Paris in 1989, since when some of his work has beome more lyrical.

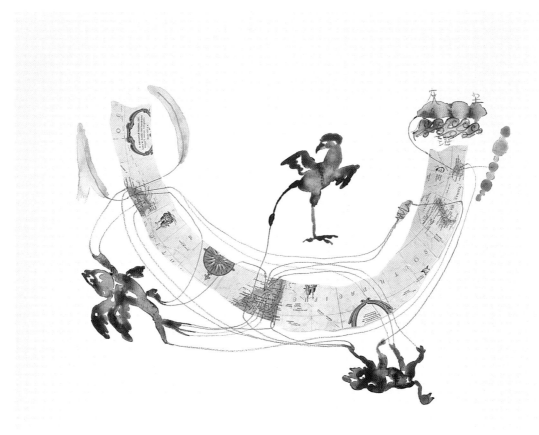

II. 54

54 *Sketch of the World Map No. 1. 2000*

Watercolour, collage, tape and graphite on paper, 64.5 × 50 cm.

Acquired from the CourtYard Gallery, Beijing, 2001.

This is one of the studies the artist made for an Installation mounted in the CourtYard Gallery, Beijing, consisting of a spiral map of the world with about four hundred prophesies stuck into the surface foretelling the end of the world, such as 'Oct. 2004, concentrated heavy snow', and 'Dec. 2018, obvious change in the substance of seawater'. For so pessimistic a message, the treatment seems somewhat light-hearted. Perhaps Huang Yongping was just having fun.

Huang Yongyu 黃永玉
(b. 1924, Fenghuang, Hunan)

Painter, graphic artist and wood-engraver. During World War II he studied with Lin Fengmian in Chongqing, then went to Shanghai. In 1948 he was art editor of *Dagongbao* in Hong Kong, then in 1953 returned to China where he taught graphic art at the Central Academy. He fell foul

of Jiang Qing during the Cultural Revolution and was imprisoned, being released on the death of Mao. In 1989 he settled in Hong Kong but in the late 1990s returned to live in comfort in the home he built outside Beijing. Geoffrey Hedley must have organised an exhibition of his woodcuts in 1948, for they came to us already mounted (see Section III of this catalogue).

55 *Village in South China*

Ink and gouache on paper, framed, 103 × 105.7 cm.

Painted in Beijing in 1976. Inscription, signature, and date, three seals of the artist.

Given by the artist in the winter 1976/77 to K & MS (sent to us in Oxford through a friend: he asked us to choose one of three).

三十六陂，春水白頭，相見江南。

丙辰歲尾　黃永玉作于北京京新巷。

The meaning is perhaps deliberately obscure, but here is a free translation:

'Thirty-six troubled years have passed, and my hair is white. We will meet in the South. Painted by Huang Yongyu in Beijing at the end of 1976.' Professor David Hawkes suggested that the phrase 春水, literally 'spring water', is borrowed from a famous poem written by Li Houzhu, 李後主, last emperor of Southern T'ang, who had been taken prisoner by the Northern Song Emperor and was dwelling upon his sorrow: '恰似一江春水向東流.'

Publ. *Symbols of Eternity*, pl. 115.

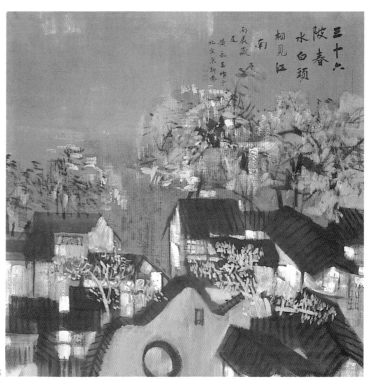

II. 55

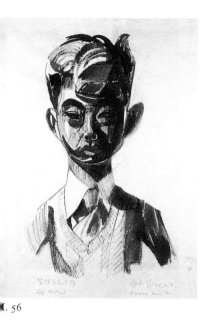

II. 56

56 *Self-portrait aged 24*

Ink and wash on paper, mounted, 38.2 × 29.3 cm.

Signed and dated 1948.

Bequeathed to K & MS by Geoffrey Hedley in 1960.

Publ. *Art and Artists of Twentieth Century China*, Fig. 10.3.

Jiang Baolin 姜寶林
(b. 1942, Penglaixian, Shandong)

Painter, from 1962–67 he studied under Lu Yanshao and Pan Tianshou at the National Academy, Hangzhou. In 1967 he was arrested as a counter-revolutionary and spent a month in prison with Pan Tianshou. In 1981 he graduated in *guohua* under Li Keran at the Central Academy, then became Professor in Hangzhou Academy; in 1996 he was given the title of Professor in the Central Academy.

57 *Baimiao*

Ink and colour on paper, 67 × 176 cm.

The artist calls his works in this tyle *baimiao* (plain line), although that term is usually reserved for paintings in a flowing linear technique.

Gift of the artist, 1999.

II. 57

91

Jin Zhen 金震

An obscure Anhui artist and poet of the late Qing period.

58 *Fairy of the White Cloud* 白雲仙女

Hanging scroll, ink and colour on paper, 97.8 × 28.6 cm.

Artist's inscription, signature and seal, one collector's seal.

Painted in mid-summer. Cyclical date equivalent to 1750, 1810, 1870…

From Geoffrey Hedley?

(*not illustrated*).

Leung Kui Ting (Liang Juting) 梁巨庭
(b. 1945, Canton)

Painter, designer and sculptor. After studying under Lü Shoukun he taught at the Hong Kong Polytechnic and in 1980 became Principal of the Hong Kong Institute of Visual Arts, of which he became Director.

59 *Cliff 1*

Hanging scroll, ink on paper, 137 × 70 cm.

2000.

Acquired 2001 from his exhibition at the Hanart TZ Gallery, Hong Kong.

A close examination of this 'abstraction' reveals rocks, trees, water falls – in fact, it is a landscape.

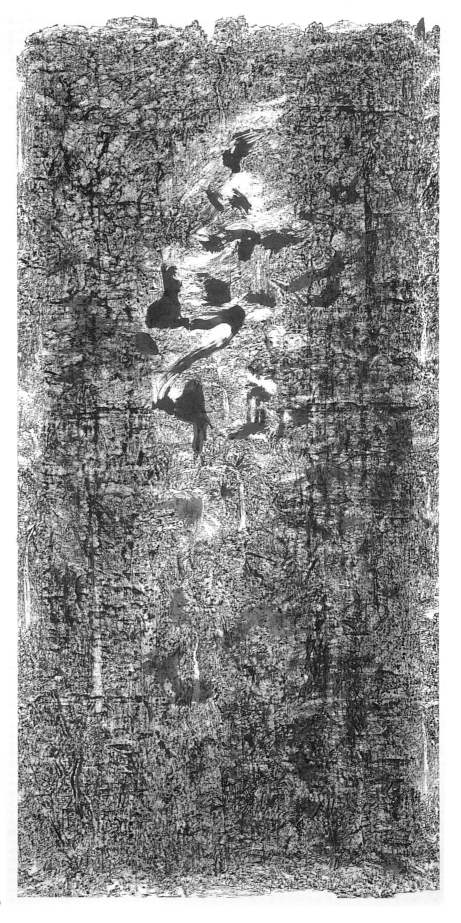

II. 59

Li Junyi 李君毅
(b. 1939, Kaohsiung, Taiwan)

Painter. In 1970 he moved with his family to Hong Kong where he was educated. At Hong Kong University, under the influence of Liu Guosong, he switched from Biochemistry to Fine Art. After graduating in 1988, he paid a visit to France on a French Cultural Ministry Scholarship. He now works as a professional artist in Taichung.

60 *Summer and Autumn*

Two leaves from a set of the Four Seasons.

Ink and colour on specially printed paper, 57 × 39 cm.

1965.

Acquired from his exhibition at the Hanart TZ Gallery, Hong Kong, in 2000.

Li Hua (Li Huayi) 李華弋
(b. 1948, Shanghai)

Painter. As a child in Shanghai he met Wang Jimei (son of the painter Wang Zhen) and later studied under Zhang Chongren. In 1982 he moved to San Francisco. Later he changed his name from Li Hua to Li Huayi. This painting reveals his eclectic concern with ancient Chinese cultural motifs, which later gave way to a more classical style of landscape painting.

61 *Composition with motifs derived from bronze décor and oracle bones*

Ink and colour on paper, mounted and framed, 62 × 67 cm.

One artist's seal, no signature, n.d.

Given to K & MS by the artist in San Francisco in 1984.

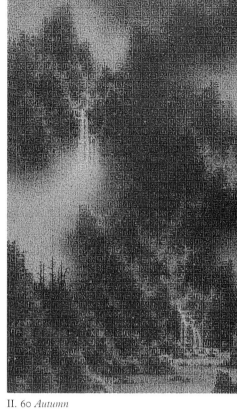

II. 60 *Summer*

II. 60 *Autumn*

II. 61

Li Huasheng 李華生
(b. 1944, Yibin, Sichuan)

Largely self-taught *guohua* painter who studied between 1972 and 1976 with the Sichuan eccentric artist Chen Zizhuang; later developing his own eccentric style. His five months spent in the US in 1987 were a very unsettling experience for him.

62 *Cockcrow at Dawn*

Hanging scroll, ink and colour on paper, 153.5 × 84 cm.

Artist's title, inscription, signature and date (1989), one artist's seal.

Given to MS by the artist in 1990.

Publ. Hanart 2 Gallery, Hong Kong, *Li Huasheng* (1990), and *Art and Artists of Twentieth Century China*, Fig. 81.

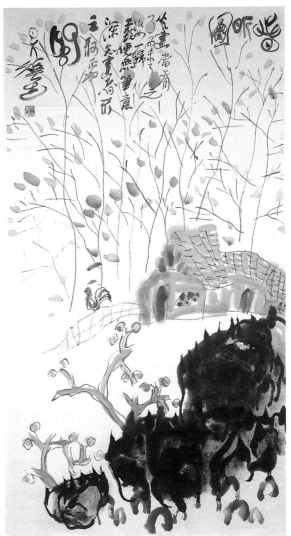

II. 62

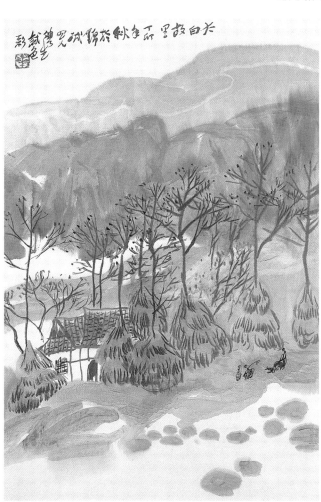

II. 63

63 *Home Village of Li Bai*

Ink and colour on paper, 66.5 × 44.5 cm.

Artist's inscription and one seal, dated 1987.

Acquired from Alice King in 1998.

No. 10 in Exhibition *Li Huasheng: An Individualist Artist*, Chinese Culture Center, San Francisco, and Alisan Gallery, Hong Kong, July/August and September 1998.

Li Keran 李可染
(1907–89)

Guohua painter. Native of Xuzhou, Jiangsu Province. He studied under Liu Haisu in the Shanghai Meizhuan, later with Qi Baishi, Huang Binhong and Lin Fengmian. In 1946 he joined Xu Beihong in the

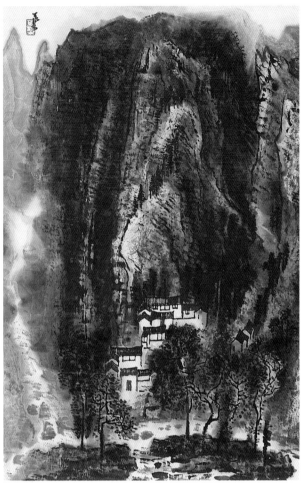

II. 64

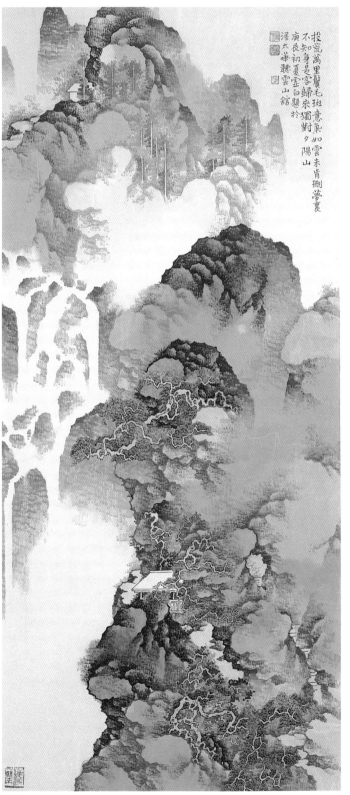

II. 65

National Art Academy, Beijing. From 1950 for many years he was a highly influential Professor in the Central Academy. Famous for his landscapes, herd boys and buffaloes.

64 *Mountain Landscape*

Hanging scroll, ink and colour on paper, 27.5 × 50.4 cm.
Signed, n.d.
Acquired by K & MS from Mrs Shen's Gallery, London, in 1960s.

Li Shubai 李虛白
(b. 1940, Fuzhou, Fujian)

Painter and poet. In 1979 he moved to Hong Kong, and in 1996 to Canada, where he lives in relative obscurity. He is one of a small group of contemporary Chinese artists who deliberately choose to paint in a very personal classical manner, and to write classical poetry on his paintings – partly, at least, to show that traditional Chinese modes of expression are still relevant today.

65 *Landscape No. 5*

Hanging scroll, ink and colour on paper, 115 × 52 cm.
With inscription and four seals of the artist. Dated 2000.
Acquired from the artist in August 2000.

Lin Fengmian 林風眠
(1900–91)

Painter and art teacher, born in Meixian, Guangdong. In 1919 he went to Shanghai and in December of that year left for France on the work-study programme. He spent six years in France, where he married Alice Vattant, returning to the National Art Academy in Beijing. In 1927 he was the founding principal of what became the National Art Academy in Hangzhou. There his influence as the most progressive art teacher in modern China was enormous: among his pupils were Wu Guanzhong,

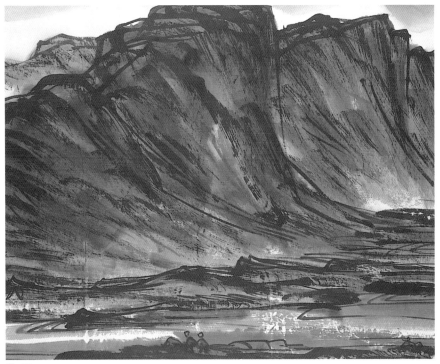

II. 66

Chu Teh-chun, and Zao Wou-ki. After 'Liberation' he was replaced as Principal of the Hangzhou Academy and suffered severely before he managed to get to Hong Kong in 1977. There he lived in deep seclusion. It was there that, after admiring him and his contribution to the development of modern Chinese art for many years, we finally met him in 1988.

66 *The Yangzi below Chongqing*

Ink and colour on paper, mounted and framed, 46.5 × 59 cm.
Signed.
Bequeathed to K & MS by Geoffrey Hedley, 1960.
Publ. *Chinese Art in the Twentieth Century*, Fig. 40.

67 *Cottage among the Trees*

Ink and gouache on paper, mounted and framed, 66.8 × 67.5 cm.
N.d., about 1948.
Bequeathed to K & MS by Geoffrey Hedley, 1960.
Publ. *Symbols of Eternity*, pl. 106.

II. 67

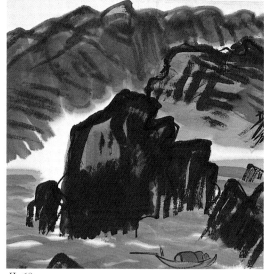

II. 68

68 *Rocks by the Seashore*

Ink and colour on paper, mounted, 33.4 × 34 cm.
Bequeathed to K & MS by Geoffrey Hedley in 1960.

69 *Reeds by a Riverbank*

Ink on paper, mounted.
Bequeathed to K & MS by Geoffrey Hedley in 1960.

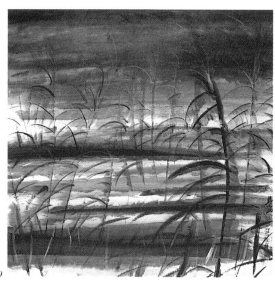

II. 69

70 *Hauling a boat upstream*

Ink and colour on paper, 26.7 × 33.3 cm.

1940s.

This little sketch was bought by Lowell Groves, US Air Force, at an art fair in Kunming in 1944. He gave it to K & MS in 2001.

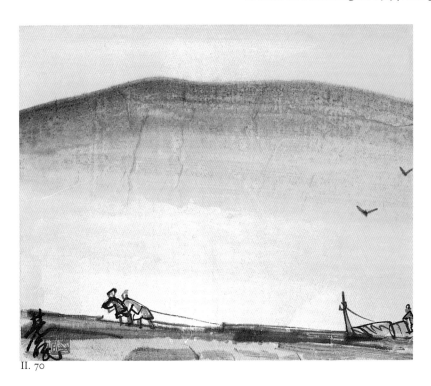

II. 70

Ling Shuhua 凌叔華
(1900–90)

Painter, essayist and collector. Born in Beijing, daughter of a Hanlin scholar and court official, she became in the 1920s an essayist and painter in the literary tradition. In 1947 she and her husband, the diplomat Chen Yuan, moved to the West, settling in London. In 1956 she taught at Nanyang University in Singapore. She returned to her native Beijing a few months before her death (see also the handscroll, IV. F. 2, for more about Shuhua).

II. 73

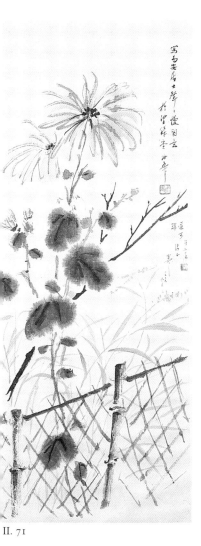

II. 71

71 *Chrysanthemums by a Bamboo Fence*

Ink and colour on paper, framed, 42.7 × 24 cm.

Painted in Singapore, and given by the artist to K & MS there in 1959.

Liu Kuo-sung (Liu Guosong) 劉國松
(b. 1932, Shandong Province)

Painter. In 1956 gained a BA from National Taiwan Normal University. Soon thereafter he was the prime member in founding the Fifth Moon Group of young artists, dedicated to breaking free from the rigid cultural conventions imposed by the Guomindang regime in Taiwan. He was on the faculty of the Chinese University of Hong Kong from 1971 to 1992, since when he has flourished as an independent artist. The influence of his semi-abstract style of ink landscape painting on young Chinese artists has been considerable.

72 *Flowers in a Basket-shaped Vase*

Ink line on paper, mounted, 56.8 × 40 cm.

No signature, one artist's seal.

A very early work in Taiwan, before 1968.

Given by the artist to K & MS in Taipei.

(*not illustrated*).

73 *Landscape*

Handscroll, ink and colour on paper, 9 × 94 cm.

Signed and dated 1970.

Given by the artist to K & MS in 1970.

74 *Abstract landscape*

Ink and colour on paper, mounted and framed, 59 × 91 cm.

Signed and dated 1966.

Acquired by K & MS from the artist in 1967 in San Francisco.

Publ. *The Meeting of Eastern and Western Art*, pl. 14; *Art and Artists of Twentieth Century China*, pl. 38.

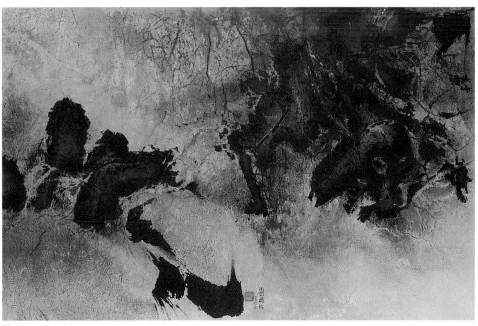

II. 74

Lü Shoukun (Lui Shou-Kwan) 呂壽琨
(1919–75)

Painter. A native of Guangdong Province, Lü Shoukun graduated in Economics and settled in Hong Kong where he worked for the Yaomati Ferry Company from 1949 to 1966. He was, however, devoted to art, developing in a short time from a conventional *guohua* artist to an experimentalist, who, with his associates in several art societies and his many pupils, did much to revolutionize *guohua* in Hong Kong. His later work became increasingly abstract.

75 *View of Hong Kong Island*

Ink and wash on paper, mounted and framed, 20.6 × 94 cm.

Signed and dated July 1961, one artist's seal, inscription in Chinese and English.

Acquired in about 1958 from the artist through Major Barker.

Published in *Art and Artists of Twentieth Century China*, fig. 19.4.

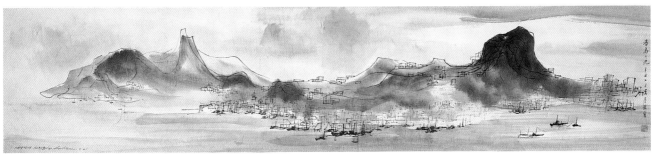

II. 75

76 *Landscape in Hong Kong*

Ink and wash on paper.
Signed with one seal of the artist, dated February 1973.
Acquired from the artist in 1973 or 1974 through Major Barker.
(*not illustrated*).

77 *Autumn Promontory*

Hanging scroll, ink and colour on paper, mounted, 83.5 × 59 cm.
Signed and dated winter 1961, with one artist's seal.

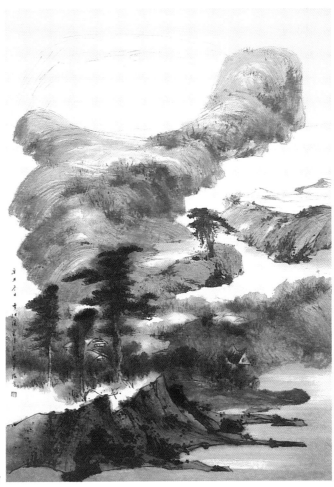

II. 77

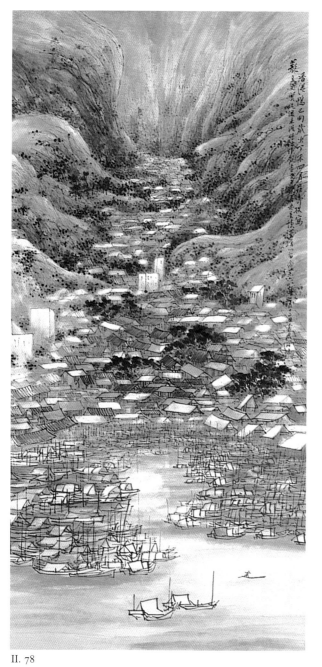

II. 78

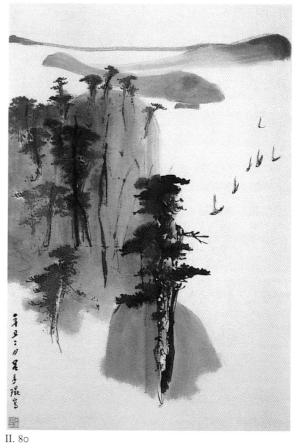

II. 80

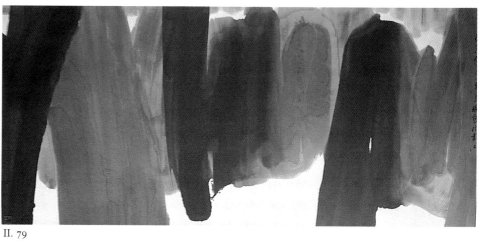

II. 79

78 *Houses and Squatters' Huts on Hong Kong*

Hanging scroll, ink and colour on paper, 141 × 65 cm.

Signed and dated April 1967.

A graphic impression of Hong Kong Island in the 1950s and 1960s, when a torrent of refugees from the PRC built their huts in any patch of land they could find. Before they were rehoused in the hundreds of tower blocks that are a feature of Hong Kong, fires and mud-slides created havoc in these squalid settlements.

Given by the artist to MS when he and KS visited him in Hong Kong in 1968.

79 *Abstract Landscape*

Ink and slight colour on paper, mounted, 43.3 × 95.3 cm.

Signed and dated 1962, with two artist's seals.

Given to K & MS by Major Barker in about 1963/64.

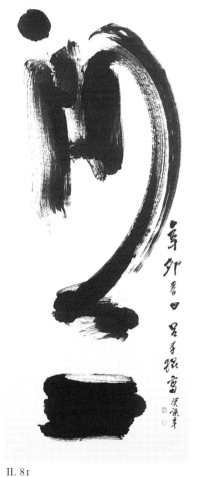

II. 81

80 *Landscape*

Ink on paper.

Signed and dated.

Given by the artist to K & MS.

Published in *Art and Artists of Twentieth Century China*, fig. 19.5.

81 *Abstraction*

Ink on paper, 93.5 × 37.5 cm.

Title and signature of artist, dated 1963 with two artist's seals.

Given by Major Barker to K & MS in 1960s.

Ma Desheng 馬德升
(b. 1952, Beijing)

A self-taught artist, he worked as an industrial draughtsman and was one of the three or four dominant figures in the Stars Group (Xingxing pai) who held their daring and controversial exhibitions in Beijing in 1979 and 1980. In 1985 he moved to Switzerland, and later settled in France.

82 *Mountain landscape*

Ink on paper, 79.2 × 52.2 cm.

One artist's seal.

Given by the artist to K & MS in 1980.

Miao Jiahui 繆嘉蕙
(1842–1918)?

A native of Kunming, she was recommended as 'ghost painter' to the Empress Dowager Ci Xi, being at her side 'from morning to night'. It was said that after her arrival at court all the flower paintings 'by' Ci Xi were her work. This one is an example of the work she did under her own name. Although it is said that she died at the age of seventy-six, the precise date of her death does not seem to be recorded.

83 *Bouquet of peonies*

Hanging scroll, ink and colour on paper, 116.8 × 57.1 cm.

N.d., one artist's seal.

The artist's inscription reads: 'The lady Suyun, Miao Jiahui, respectfully paints this and reverendly congratulates the imperially bestowed Noble lady, Aunt Luo, Grand Mistress Wu, on her eightieth birthday.'

Bequeathed by Geoffrey Hedley to K & MS in 1960.

Publ. and exhib., Marsha Weidner and others, *Views from Jade Terrace: Chinese Women Artists 1300–1912* (Indianapolis Museum of Art and Rizzoli, New York, 1988); *Art and Artists of Twentieth Century China*, pl. 1.

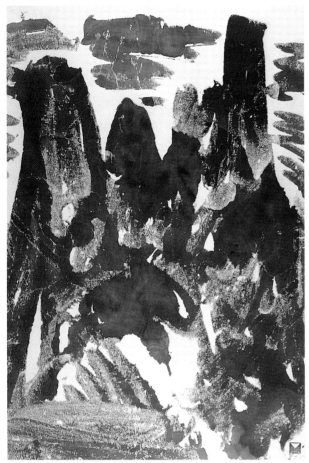

II. 82

II. 83

Pang Tao 龐濤
(b. 1934, Shanghai)

Oil painter, daughter of Pang Xunqin. She spent the war years chiefly in Chengdu; in 1984 graduated from the Central Academy in Beijing, where she later became a Professor of Oil Painting; married to the oil painter Lin Geng. In 1984–85 and 2000 she visited Europe, and in 1990 the USA.

84 *Copy of detail of a wall painting in the Yonglegong, Shanxi*

Oils and body colour on paper, 61.7 × 46 cm.
Painted in Paris in 1985.
Given to K & MS when she visited Oxford in that year.

Pang Xunqin 龐薰琹
(1906–85)

Oil and *guohua* painter and designer, native of Changshu, Jiangsu, where there is now an art gallery in his memory. After studying in Shanghai he spent the years 1925–30 in Paris, then returned to Shanghai where in 1931 he joined the Storm Society, Chuelanshe. He spent World War II in west China, among the Miao people, and teaching in Kunming and later in Chengdu. After the war he continued to teach in various academies, but he had long been interested in the history of decorative art in China and his most notable achievement was the founding in 1956, with the support of Zhou Enlai, of the Central Academy of Arts and Crafts, Beijing. Three years later, during the Great Leap Forward, he was branded a 'Rightist' and was not rehabilitated until after the death of Mao in 1976.

85 *The letter*

Ink and watercolour on paper, mounted and framed, 42.7 × 36.7 cm.
Signed, n.d.
She has read her husband's – or her brother's? – letter from the Front; his pipe hangs on the wall, and her thoughts are far away.
Painted about 1944/5 and given by the artist to K & MS in about 1945.
Publ. *Art and Artists of Twentieth Century China*, pl. 23.

II. 84

II. 85

86 *Suzhou (with pagoda)*

Hanging scroll, ink and colour on paper, 67.4 × 67.3 cm.
Signed and dated 1979.
Painted for 'Maike' (Michael) in Beijing and inscribed there.

87 *Riverside scene, Suzhou*

Hanging scroll, ink and colour on paper, 68.4 × 67 cm.
Signed and dated 1979.
Painted for KS in Beijing and inscribed there.

II. 86

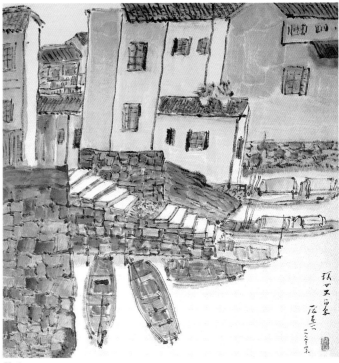

II. 87

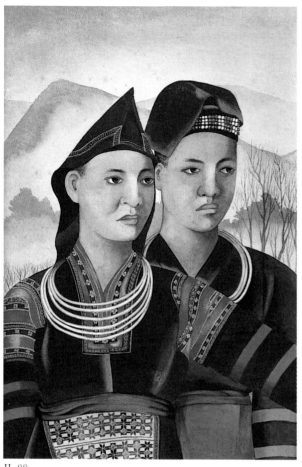

II. 88

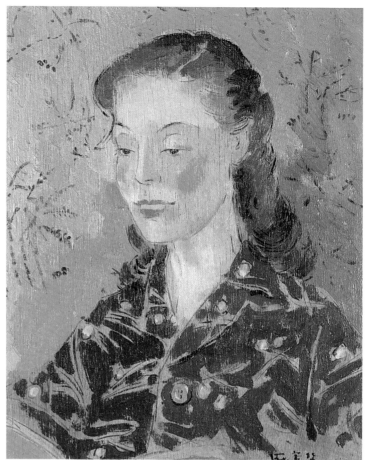

II. 89

88 *Two Miao Girls*

Ink and watercolour on paper, mounted, 36.5 × 24.5 cm.

Signed in lower border Hiunkin Pang. Painted about 1944, probably in Chengdu.

Given by the artist to K & MS in Chengdu in about 1945.

89 *Portrait of KS*

Oils on plywood 47.7 × 39.5 cm.

Signed in Chinese and 'Hiunkin Pang'.

Not a good likeness – Pang has made her look too foreign – but an exquisite painting.

Painted in Chengdu in 1945/6 and given by the artist to KS.

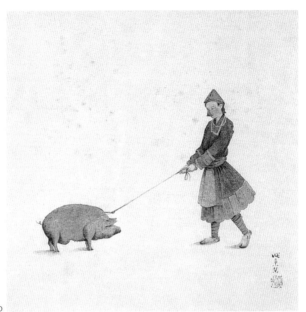

II. 90

90 *Miao girl with her pig*

Ink and colour on paper 29 × 29 cm.
Signed, n.d., painted in Chengdu about 1944/5.
Given by the artist to KS in Chengdu in about 1945.

91 *Tang dancing girl in blue costume*

Ink and colour on paper, mounted, 32.2 × 42 cm.
Signature and one seal by the artist.
Given to K & MS by the artist in about 1945.

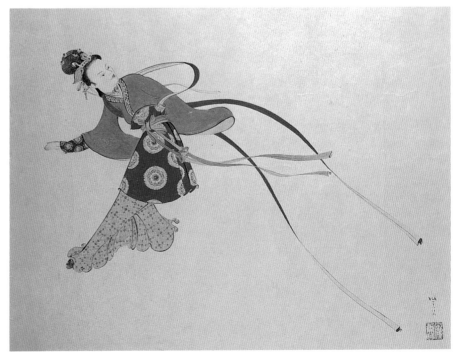

II. 91

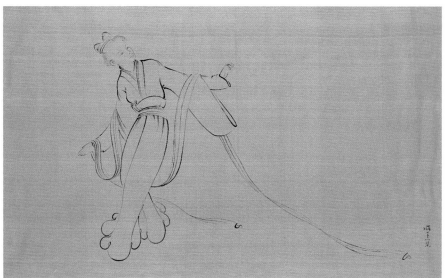

II. 92

92 *Tang dancing girl*

Ink line on silk, mounted and framed, 32 × 50.3 cm.

Signed, no seal.

Painted in Chengdu, and given by the artist to KS in Chengdu in about 1945.

93 *Tang dancing girl*

Ink line on paper, mounted, 45.6 × 41 cm.

Signed with one seal of the artist.

Given by the artist to K & MS in about 1945.

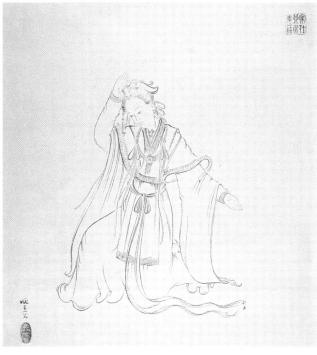

II. 93

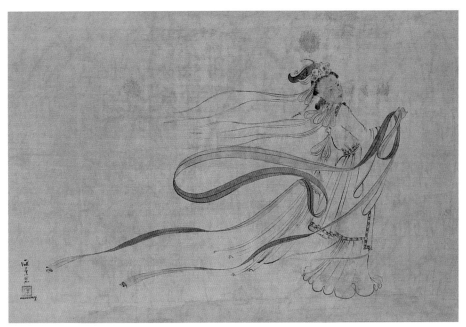

II. 94

94 *Tang dancing girl*

Hanging scroll, ink and colour on silk, 32.8 × 48.8 cm.
Signed in Chinese and 'Hiunkin Pang', with one seal of the artist.
Given by the artist to K & MS in Chengdu in 1945.

Pu Xinyu 溥心畬
(1896–1964)

Painter, born in Beijing, last grandchild of the emperor Xuanzong. In 1915 he entered the College of Political Science, studying at Berlin University in 1915–18 and 1919–22. In 1925 he began to study painting, taught briefly in the Imperial University in Tokyo, returning to teach in Beijing Normal University and the Academy of Art. After World War II he went to Nanjing and in 1949 to Taiwan, where apart from visits abroad he spent the rest of his life teaching and practicing orthodox academic and scholarly techniques of traditional painting.

95 *Landscape in the manner of a Song artist*

Hanging scroll, ink and colour on paper, 122.4 × 37 cm.
Inscribed and signed by the artist, two artist's seals, n.d.

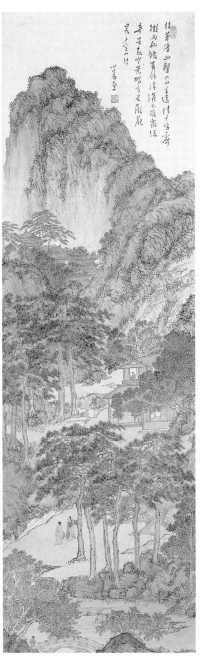

II. 95

Geoffrey Hedley bought it at Pu Xinyu's exhibition in Shanghai in 1949, when Pu wrote the label for him. GH bequeathed it to K & MS in 1960.

(Although the artist says this is in the manner of a Song artist, the style suggests the Yuan painter Wang Meng.)

Inscription:

結茅傍山壑，入山生遠情；千峰靄微雨，孤館有餘清。
灌木滋眾潤，奇芳袞空榮；駕言采薇蕨，晨夕空山行。

I have built a thatched cottage by the side of a gully.
Entering the mountains, I feel a surge of emotion.
Amid a thousand peaks the soft rain clears,
And my lonely cottage shares in this abundance of purity.
I bring water to nourish the trees, so all is green.
Marvellous fragrance pervades the clear air.
I declare that I'll pluck the young bracken,⋆
So at dawn and dusk I wander through these lonely mountains.

(translated by Hsiao Li-ling 蕭麗玲)

⋆ This is a reference to the brothers Boyi and Shuqi who, at the end of the Shang Dynasty, rather than serve the Zhou, chose to retreat into the mountains and subsist on the wild plants they found there.

96 *Landscape with pine in the manner of Shen Zhou*

Hanging scroll, ink and slight colour on paper.
Artist's inscription, signature and two seals, n.d. About 1949.
Bequeathed to K & MS by Geoffrey Hedley in 1960.
(not illustrated).

Qi Baishi 齊白石 (Qi Huang 齊璜)
(1864–1957)

Painter and seal-carver, native of Xiangtanxian, Hunan. After apprenticeship to a carpenter he became a professional painter, finally settling in Beijing in 1920. There he came under the strong influence of scholar painters, notably Chen Hengke, and developed his mature, vigorous style. He was a dominating figure in Beijing art circles until his death. In 1955 he was awarded the International Peace Prize by the World Peace Council.

97 *Frogs*

Hanging scroll, ink on paper, 103 × 34.5 cm.

Inscribed and signed by the artist, three artist's seals.

Painted at the age of 88.

Bequeathed to K & MS by Geoffrey Hedley in 1960.

98 *Shrimps*

Hanging scroll, ink on paper, 104.8 × 34.7 cm.

Inscribed by the artist at the age of 88. Three seals.

Bequeathed to K & MS by Geoffrey Hedley in 1960.

II. 97

II. 98

99 *Three Friends in Winter
(narcissus, bamboo, and plum)*

Ink and colour on paper, mounted, 36.7 × 57.1 cm.
Signed and dated at the age of 82, with two artist's seals.
Bequeathed to K & MS by Geoffrey Hedley in 1960.
(*not illustrated*)

100 *The thing to prolong life is wine!* 延年酒也

Hanging scroll, ink and colour on paper, 64 × 33 cm.
Signed, n.d., painted when the artist was 88.
Bequeathed to K & MS by Geoffrey Hedley in 1960.

II. 100

II. 101

101 *Landscape with Blue Mountain*

Hanging scroll, ink and colour on paper, 94.3 × 61.7 cm. 1949.

Inscribed with inscription, signature, and two seals. The artist painted this when he was 89 (Chinese count), i.e. in 1953.

Yang Xianyi and his wife Gladys, who had met at Oxford in the 1930s, became noted translators at the Foreign Language Press in Beijing. In 1968 they were both arrested and held for four years, Gladys in solitary confinement. When we visited them in 1973 after their release, Xianyi opened a cupboard that had been sealed through their imprisonment, selected this fine painting, and gave it to us.

Publ. *Art and Artists of Twentieth Century China*, Fig. 1.3.

102 *Wine for long life! Peaches (in tray) with chrysanthemums in jar.*

Hanging scroll, ink and colour on paper, 94 × 34.3 cm.
Title, dated 1948, signature and two seals of the artist.
Painted aged 88.
Bequeathed to K & MS by Geoffrey Hedley in 1960.

103 *Peaches (longevity)* 多壽

Hanging scroll, ink and colour on paper, 101 × 34 cm.
Title, dated 1948, signature and two seals.
Painted aged 88.
Bequeathed to K & MS by Geoffrey Hedley in 1960.

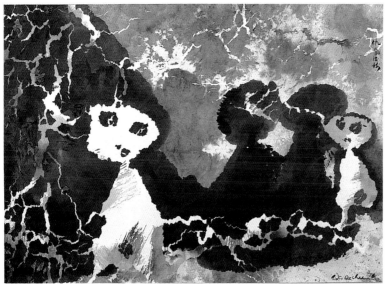

II. 104

Qiu Deshu 仇德樹
(b. 1948, Shanghai)

He did not study art professionally, but in 1977 served as resident artist in the Cultural Palace in Shanghai. In 1979 he organised the Grass Society (Caocao huashe 草草畫社), one of the first dissident groups. After a year in America (1985–86) he returned to Shanghai as a professional painter, developing his unique technique which he called 'transparent paper tear method', in which, in his own words, 'through a process of scraping, rubbing and wiping, a wide range of colours can penetrate through the surface from the underlying layer(s) of the paper.'

104 *Ghostly figures and cracks*

Ink and red colour on paper, backed and unmounted, 36.9 × 57.2 cm.
Signed in Chinese and English.
Given by the artist to K & MS on their visit to his studio in Shanghai on 7 May 1989.

105 *Blue No. 4*

Xuan paper and acrylic on canvas, framed, 84 × 180 cm.
1996.
Acquired from the CourtYard Gallery, Beijing, in June 2000.

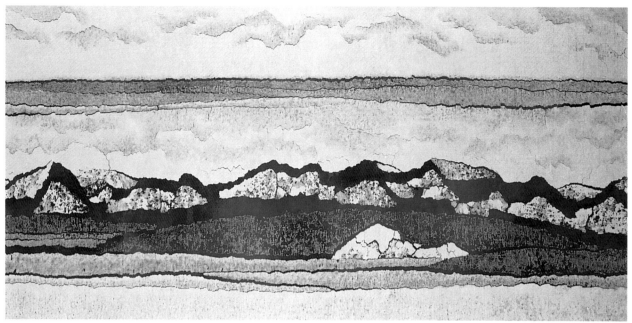

II. 105

106 *Silence Landscape No. 5*

Xuan paper and acrylic on canvas, framed, 120 × 60 cm.
1998/9.
Acquired from the CourtYard Gallery, Beijing, in June 2000.

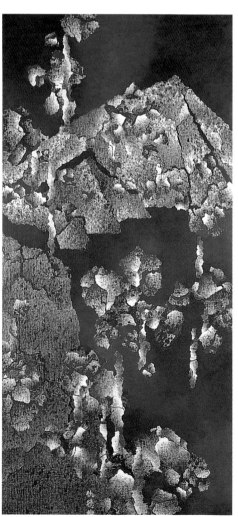

Qu Leilei 曲磊磊
(b. 1951, North China)

Painter. Brought up as an ardent revolutionary, he worked as a peasant, barefoot doctor, labourer and artist. He first encountered Western art in 1973 and in 1979 was a founder member of the dissident Stars Group (Xingxing pai). After secretly recording the trial of Wei Jingsheng and posting the proceedings on Democracy Wall, he left for the West, settling in London, where he has become recognized as a prominent figure among Chinese artists in the international movement of contemporary art.

107 *Collage*

Ink and colour on paper 1998, framed, 50 × 41.5 cm.

Inscription in several styles. The fragments of calligraphy in different styles are bits of an original poem, 'Where are you going to?' by the artist, which he translates as follows:

When you are facing a historical choice,
There are ninety-nine roads you can take, but
Maybe only one of them really belongs to you.
And on the one you choose,
There might be eighty-one disastrous events,
Any one of them could break you into pieces.
However, you must find that way, and go on with it firmly,
Otherwise you will regret it and waste your life in the end.
In this world there are very few who can achieve what they want to,
That is the reason.

Given to K & MS by the artist, May, 1998.

108 *I Know*

Mixed media collage on Chinese paper 38 × 35 cm.

Two seals.

1999.

Acquired from the artist during his 1999 exhibition in the Loading Bay Gallery in Brick Lane, London.

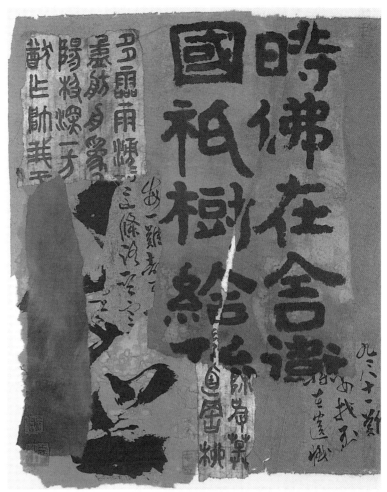

II. 107

II. 108

Ren Bonian 任伯年, (Ren Yi 任頤,), 1840–96

Painter, a native of Shaoxing, Zhejiang Province, he followed his father as a portraitist. Discovered by Ren Xiong (no relation) in Shanghai, who took him as his pupil. He became a very successful figure and portrait painter, with Ren Xiong, Ren Xun and Ren Yi famous as one of the 'Four Rens' of the Shanghai School.

109 *Saying Farewell*

Album-leaf, ink and colour on paper, mounted and framed, 31.1 × 41.8 cm.

Inscribed, signed and dated 1874.

Bequeathed to K & MS by Geoffrey Hedley in 1960.

II. 109

126

II. 110

Ren Xun (Ren Fuchang) 任薫 (阜長)
(1835–93)

Painter, younger brother of Ren Xiong 任熊 (1820–57) and father of Ren Yu 任預 (1853–1901). A well-known professional painter in Shanghai.

110 *Parrot in a Flowering Magnolia tree*

In the manner of Chen Hongshou (Chen Laolian 1599–1652).

Hanging scroll, hand-coloured woodblock print, ink and colour on paper, 146 × 36.8 cm.

Bequeathed to K & MS by Geoffrey Hedley in 1960.

Shao Fei 邵飛
(b. 1954, Beijing)

Studied *guohua* with her mother who was also an oil painter. From 1970–76, she served in the army, in 1976 she joined the Beijing Painting Academy, and in 1979 and 1980 was active in the dissident Stars Group (Xingxing pai) with Wang Keping, Ma Desheng and the poet Bei Dao, whom she later married and with whom she lived in Davis, California, before returning to settle in Beijing in 1999.

111 *Figures (children)*

Ink and colour on paper, mounted, 45.2 × 59.1 cm.

N.d.

Given by the artist to K & MS in Beijing, I think, in 1989.

II. 111

Song Yugui 宋雨桂
(b. 1940, Shandong Province)

Painter. In 1960 he entered the Painting Department of the Lu Xun
Academy in Beijing, later moved to the north, where he became
Director of the Liaoning Museum.

112 *Landscape (no. 6 in series)*

Ink and slight colour on paper, mounted and framed, 67.5 × 87.6 cm.
Signed with one artist's seal.
Gift of the artist to K & MS in 1999.
Publ. *Song Yugui huaji* (Beijing, 1998), pl. 116b.

113 *Landscape (no. 7 in series)*

Ink and slight colour on paper, mounted, 67 × 84.5 cm.
Signed with one artist's seal.
Gift of the artist to K & MS in 1999.
Publ. *Song Yugui huaji* (Beijing, 1998), pl. 117.
(*not illustrated*).

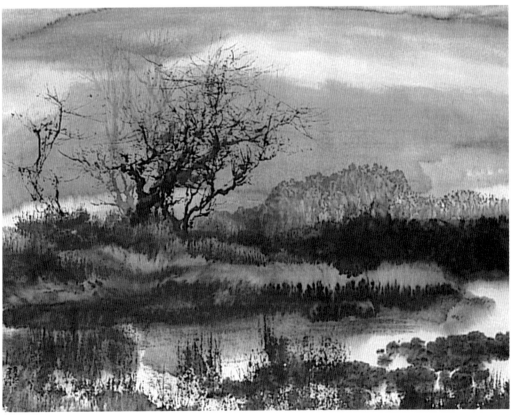

II. 112

128

Tang Yun 唐雲
(1910–93)

114 *Bamboo and Rock*

Hanging scroll, ink on paper.

Inscribed by the artist to Geoffrey Hedley. One artist's seal. Painted about 1948.

Bequeathed to K & MS by Geoffrey Hedley in 1960.

(*not illustrated*).

Wan Qingli 萬青力
(b. 1945, Beijing)

Painter, teacher and art historian. From 1963 to 1968 he studied in the Department of Art History in the Central Academy of Art. In 1967/68 he was detained in the *niupeng* ('cowshed') where he met Li Kuchan, Li Keran (II. 64), Wu Zuoren (II. 124) and Huang Yongyu (II. 55 and 56). Worked as a farm labourer from 1968–1973, later studied painting with Li Keran and Lu Yanshao. After earning a PhD (1989) in the University of Kansas, he joined the art department of Hong Kong University where he was appointed Professor in 1999. In 2005 he was appointed Director of the Academy of Visual Arts in the Baptist University, Hong Kong. Among his writings on Chinese 19th and 20th century art, his study of Li Keran is definitive.

115 *Landscape*

Hanging scroll, ink and colour on paper, 116.8 × 33 cm.

Dated 1996.

Given by the artist to K and MS in 1997.

The inscription says that he had been in Hong Kong for six years and this was the first time he had painted a landscape.

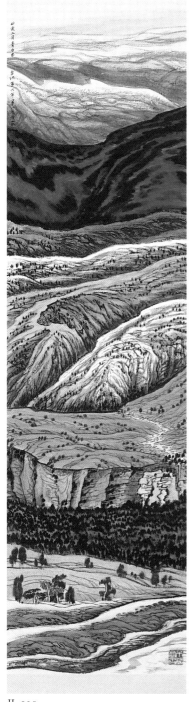

II. 115

Wang Huaiqing 王懷慶
(b. 1944, Beijing)

Oil painter. He first worked as a designer for an army song-and-dance troupe, then in 1980 enrolled as a post-graduate student in the Central Academy of Arts and Crafts. After working in Wu Guanzhong's studio, he joined the staff of the CAFA. In 1991, he won a gold medal at an exhibition of Chinese oil painting in Hong Kong. His semi-abstract works, inspired by 'deconstructed' ancient masterpieces and traditional Chinese furniture, were prominent in the Shanghai 2000 Biennale.

116 *Fan-shaped stool*

Oil on canvas, 100 × 80 cm.

2000.

Given by the artist to K & MS, 2001.

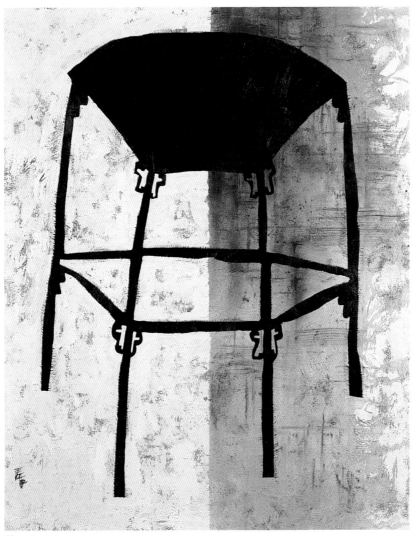

Il. 116

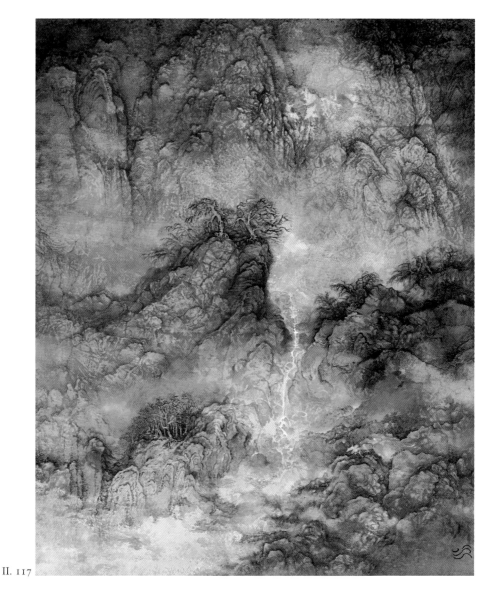

II. 117

Wang Jia'nan 王迦南
(b. 1955, Harbin, Heilongjiang)

Painter. After graduating from the Central Academy of Fine Art in 1982, he taught there, working also on art projects for public buildings and establishing his own independent studio. Since 1987 he has lived in London and Beijing with his wife, the painter Cai Xiaoli (II. 2).

117 *Listening to the sounds of the autumn mountains*

Ink and colour on paper, mounted and framed, 119 × 98 cm.

Inscribed with a form of the archaic graph for *shui* (water) and dated 2000.

Acquired in 2001 from Michael Goedhuis' exhibition at Sotheby's, New York.

This is a fine example of rediscovery and reinterpretationin contemporary terms of Northern Song monumentalism.

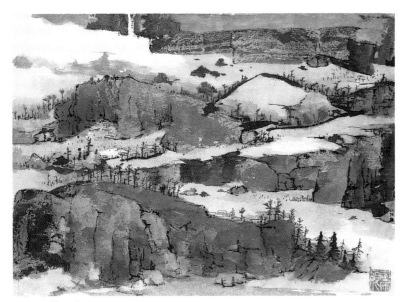

II. 118

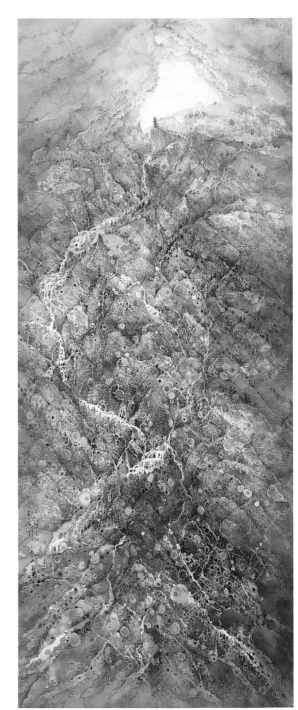

II. 120

II. 119

Wang Jiqian (CC Wang) 王己千
(b. Suzhou, 1907–2003)

Guohua painter, collector and connoisseur trained in Shanghai under Wu Hufan (1894–1970), where he became well-known as a connoisseur, and collaborated in research into Chinese painting with Victoria Contag. In 1954 he settled in New York and in the following decade developed his unique style of landscape painting.

118 *Landscape*

Ink and colour on paper, mounted and framed, 43.5 × 57.4 cm.
Signed, with two artist's seals and dated 1967.
Given by the artist to K & MS in, I think, 1968.

Wang Wuxie (Wucius Wong) 王無邪
(b. 1936, Tongguanxian, Guangdong)

He moved with his family to Hong Kong where he joined the Hong Kong Art Club and in 1956 the Modern Literature and Art Association. He studied painting first under Lü Shoukun (II. 75–81), and from 1961 to 1965 in the USA. He became assistant curator in the Hong Kong City Hall Museum and Art Gallery. From 1984 he lived for some years in the States, but by 1997 Hong Kong had become his permanent home.

119 *Valley of the heart, No. 7* 心壑之七

Hanging scroll, ink, watercolour, gouache, liquefied acrylic etc., on paper, 84.5 × 34.8 cm.
Signed and dated 1997.
Given by the artist to K & MS in January, 1998.

120 *Autumn*

Collage, with autumn leaves and colour on paper.
Mounted and framed, 29 × 29 cm.
Given by the artist to K & MS in the 1970s.

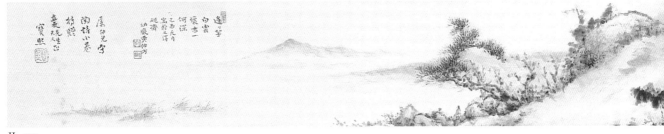

II. 121

Huang Zhongfang (Harold Wong) 黃仲方
(b. 1943, Shanghai)

Guohua painter. In 1948 he moved with his family to Hong Kong, where he studied painting under Gu Qingyao, who had been his mother's teacher in Shanghai. After studying for a while in London, in 1977 he founded the Hanart Gallery in Hong Kong, but later returned to painting full-time. He held his first major exhibition in Hong Kong in 1997, which was followed in 2000 by an equally successful show in Shanghai and Beijing.

121 *Landscape*

Handscroll, ink and light colour on paper, 11 × 128 cm.

Dated first month, 1969.

With inscription added by his father, the collector Huang Baoxi (Huang Pao-hsi). Given by them both to K & MS in Hong Kong in 1969.

Wu Guanzhong 吳冠中
(b. 1919, Yixing, Jiangsu)

Guohua and oil painter. He studied from 1937–42 in the Hangzhou Academy under Pan Tianshou and Lin Fengmian. 1942–46 he taught in Qinghua University in Kunming. 1946–50 in Paris. After he returned to China he taught in the Central Academy, but being too 'modern' was exiled to teach in the Beijing Normal College and College of Arts and Crafts. Now known world-wide, he held a one-artist exhibition at the British Museum in 1992. He lives in Beijing.

122 *Wuxi and Lake Tai*

Oils on panel, framed, 26 × 34 cm.

Signed and dated 1973.

Given by the artist to K & MS in Beijing in 1980.

Publ. in *Art and Artists of Twentieth Century China*, col. pl. 78.

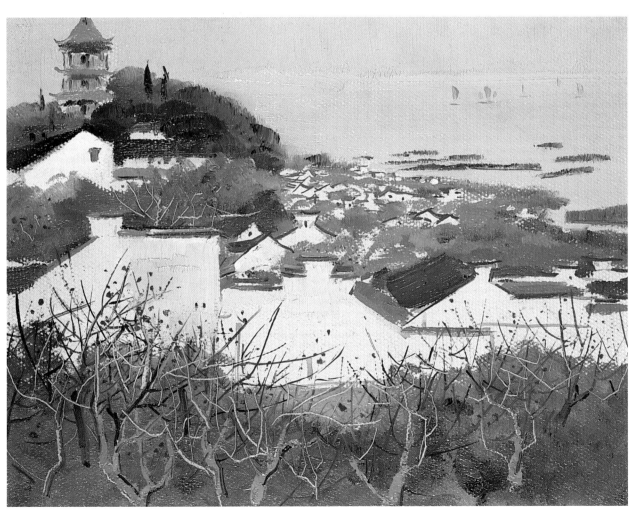

II. 122

Il. 123

123 *A canal in Suzhou*

Ink and colour on paper, mounted and framed, 45 × 69 cm.

Two artist's seals.

Given by the artist to K & MS in Beijing in 1980.

Wu Zuoren 吳作人
(1908–1999)

Guohua and oil painter. Born in Jiangyin, Jiangsu; a native of Anhui. After studying art in Shanghai, he spent the years 1928–35 in France and Brussels, returning to become lecturer in the Department of Fine Arts in National Central University, Nanjing. He travelled widely in west China during World War II. After 'Liberation', he became Provost of the Central Academy of Art in Beijing and held various senior posts in the Chinese Artists Association.

124 *Market in Qinghai*

Oils on plywood board, framed, 29 × 38.4 cm.

On the back the artist wrote 'Marché à Kokonor (Loussal). Esquisse, by Ou, Sogène. 1943'. Sketch made on the spot and given to K & MS late in 1943 or early in 1944. The artist made a large-scale version of this picture on our verandah in Chengdu in 1944.

Publ. *Art and Artists of Twentieth Century China*, col. pl. 24.

Xie Qusheng 謝趣生
(1906-59)

Cartoonist and *guohua* painter. A native of Sichuan, where he was active in the 1930s and 1940s. He stopped doing cartoons in 1951.

125 *The Bodhisattva Guanyin*

Hanging scroll, *gongbi* (ink line) on paper, 60 × 35 cm.

Signed and dated Summer, 1945.

Painted for Mr & Mrs Roxby (he was head of the British Council in Chongqing) in 1945. Presumably the Roxbys were on a visit to Chengdu. They must have given it to Geoffrey Hedley, for it was among the works that Hedley bequeathed to K & MS in 1960.

(NB. Xie is chiefly known as a cartoonist. How often did he paint this sort of picture?)

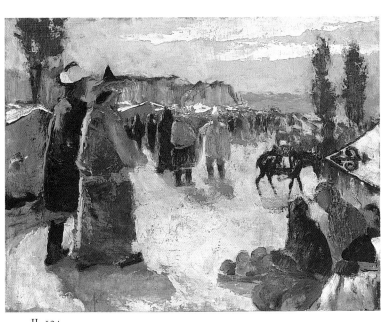

II. 124

II. 125

Xie Yuqian 謝玉謙 (Chia Yu Chian)
(b. 1936, Kota Tinggi, Malaysia)

He studied part-time with Chen Wenxi at the Nanyang Academy in Singapore. In 1959 he went to Paris on a French government scholarship, to study painting at the Ecole des Beaux Arts, then returned to Kuala Lumpur, Malaysia, where he works as a professional artist.

126 *Landscape in Johore*

Oils on board, 51 × 61 cm.

1959.

Gift of the artist to K & MS.

II. 126

Yang Xiyun (Yeung Hai Shuet) 楊希雲

Painter and restaurateur. Graduated in 1955 from Huanan Teachers Training College, Canton. After teaching in Canton and Shenzhen, he moved to Hong Kong and in 1969 to England, where he is active as a painter and restaurateur in Grimsby, Lincolnshire.

127 *Abstraction*

Ink and colour on paper, mounted, 66 × 66 cm.
Given by the artist to K & MS in December 1992.
(*not illustrated*).

128 *Abstraction*

Ink and mixed media on paper. Mounted 67.5 × 67.8 cm.
Given by the artist to K & MS in December, 1992.
(*not illustrated*).

Yang Yanping 揚燕屏
(b. 1934, Beijing)

Painter. She graduated in architecture from Qinghua University, after
which she taught industrial design and created historical paintings for the
Museum of Chinese History. Member of the Beijing Academy of
Painting. In 1976 she settled in Long Island, New York, with her husband,
the painter Zeng Shanqing (II. 137). She has exhibited widely, separately
and with her husband, in the US, Japan, Taiwan, Hong Kong and Europe.

129 *Lotus plants in autumn*

Ink and colour on paper, mounted and framed, 30 × 33.3 cm.
One artist's seal. Painted about 1980.
Given by the artist to K & MS in Beijing in 1980.

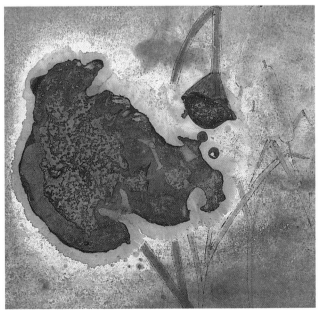

II. 129

II. 130

II. 131

130 *Fishing nets*

Hanging scroll, ink and colour on paper, 67×66.5 cm.

One seal of the artist.

Given by the artist to K & MS in Beijing in 1979.

131 *Landscape*

Ink and colour on paper, mounted and framed, 45.5×66.5 cm.

One seal of the artist.

Exhibited at Michael Goedhuis' Gallery, London, in 1996, and given by the artist to K & MS in 1997.

Ye Qianyu 葉淺予
(1907–95)

Painter and graphic artist, self-taught. In early World War II he was in charge of the All-China Association of Cartoonists for National Salvation. He later studied *guohua* in Sichuan with Zhang Daqian. In 1945 he visited India with the dancer Dai Ailian, who had been trained at Dartington Hall. After 'Liberation', he became head of the Chinese Painting department in the National Academy in Hangzhou.

132 *Indian youth*

Charcoal on paper, unmounted, 29.9×23.6 cm.

Drawn in India in 1945.

Given by the artist to K & MS in Chengdu in 1945 or 1946.

II. 132

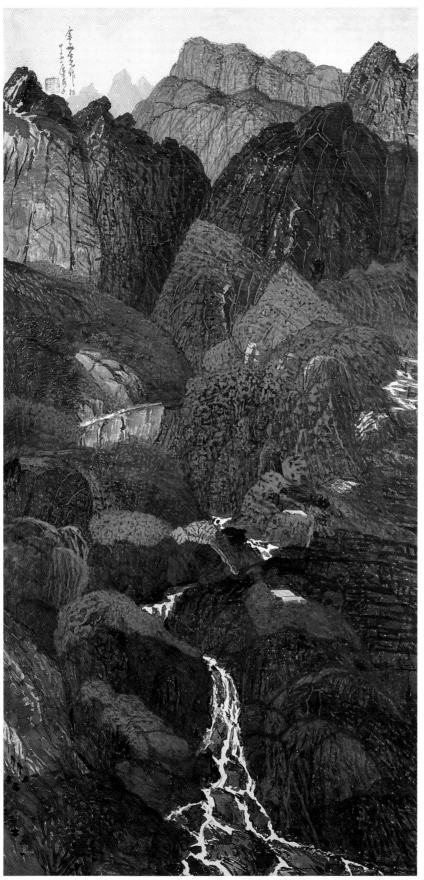

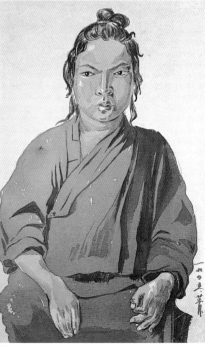

II. 133

II. 134

Yu Chengyao 余承堯
(1898–1993)

Guohua painter and calligrapher. After rising to the rank of General in the Guomindang army, he retired to Taiwan where he took up painting, developing an individualistic style inspired by classical models. Although when this picture is examined closely it is full of technical mistakes, the power of his style and his refreshing use of colour transcend orthodox standards. He was also a student of Chinese classical music.

133 *Rocky mountains and gurgling streams*

Hanging scroll, ink and colour on paper, 119.8 × 60 cm.

Dated summer, 1988.

Given by the artist to MS in 1988.

Publ. *The Art of Yu Chengyao* with an introduction by MS, Hanart Gallery, Hong Kong, 1987, p.137, and *Art and Artists of Twentieth Century China*, col. pl. 46.

Yu Feng 郁風
(b. 1916, Fuyangxian, Zhejiang)

Oil painter and graphic artist. Niece of the writer Yu Dafu, married to the art historian, calligrapher and critic Huang Miaozi. She studied oil painting in Nanjing 1938–41, and was in west China during World War II. In the 1950s and 1960s she worked for the Chinese Artists Association, and after spending some years from 1990 in Brisbane, Australia, returned to Beijing.

134 *Daoist Priest on Jingchengshan, Sichuan*

Ink and watercolour on paper, 38 × 24.4 cm.

Dated 1945.

Given to K & MS in Chengdu in 1945 or 1946.

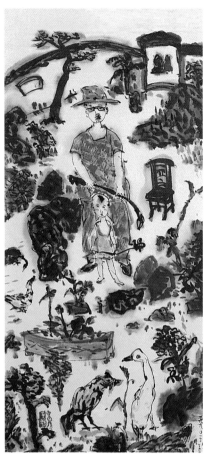

II. 135

Yu Peng 于彭
(b. 1955)

Painter, sculptor and ceramicist, living in Taipei, where he had his first one-artist exhibition in Taipei. In 1981 he visited Europe and is a frequent visitor to Hong Kong.

135 *Father and Son in the Garden*

Hanging scroll, ink and colour on paper, 34×16.8 cm.
Dated 1990 with one seal of the artist.
Gift of the artist to K & MS.

Yuan Songnian 袁松年
(1895–1966)

Painter, native of Fanyuxian, Guangdong province. Graduated from St. John's University, Shanghai. After studying Chinese and Western painting in Shanghai, he gradually abandoned Western techniques and his *guohua* became more purely Chinese.

136 *River scene*

Ink and colour on paper, mounted and framed, 11.8×32.2 cm.
Artist's inscription, No. 121 in series. One seal.
Acquired from Dr. James Soong in San Francisco in April, 1998.

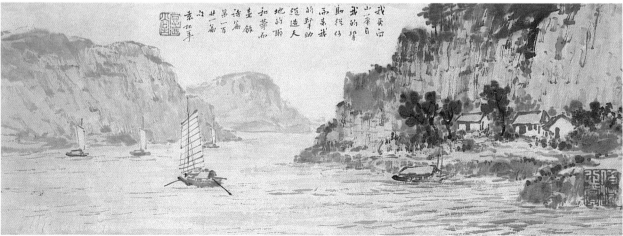

II. 136

II. 137

Zeng Shanqing 曾善慶
(b. 1932, Beijing)

Oil and *guohua* painter. Graduated in 1950 from the Central Academy and became a research student under Xu Beihong. Later he taught at Qinghua University. After much suffering in the Cultural Revolution, he joined the staff of the Central Academy. In 1986 he settled in Long Island, New York, with his wife, the painter Yang Yanping (II. 129–131).

137 *Head of a North China peasant*

Watercolour on paper, unmounted, 63 × 51.3 cm.
Inscribed to K & MS with signature and one seal of the artist.

Zeng Youhe (Betty Ecke) 曾幼荷
(b. 1923, Beijing)

Guohua and abstract painter, during World War II she studied under, and ghosted for, Pu Quan at Furen University, where she met her future husband, Dr Gustave Ecke. In 1948 they left for Hong Kong, then settled in Honolulu where she became Curator of Chinese art at the Honolulu Academy of Art. After rigorous training in traditional techniques, she developed in the West into a modern experimental artist in whose work Chinese and Western elements are combined. In 2006 she returned to settle in Beijing.

II. 138

145

138 *Mountain landscape*

Ink, colour and silver paper collage on stretched canvas, framed, 39.2 × 49.5 cm.

Signed. N.d.

Given by the artist, already framed, to K & MS in the 1970s.

139 *Trees in the Mist*

Ink on Korean paper, mounted and framed, 79.5 × 78.5 cm.

Given by the artist to K & MS when she visited Oxford in April 1993.

II. 139

II. 140

140 *Cloudy forest pale*

Ink and slight colour on paper, unmounted, 61 × 81.3 cm.
Given by the artist to K & MS in the 1980s.

Zeng Yu 曾堉
(b. 1930, Changshu, Jiangsu)

Painter and art scholar. After art training in London, he went to Taipei where he worked as an art researcher in the National Palace Museum. He later took up an appointment in the art department of the Chinese University in Hong Kong. With his wife, Wang Baolian, he has translated several western art books into Chinese, including MS's *The Arts of China* (third edn.).

141 *The City of London from the River*

Ink drawing with added colour wash on canvas mounted on board, 23.7 × 49.7 cm.
Signed and dated 1955.
Given by the artist to Geoffrey Hedley, and bequeathed by him to K & MS in 1960.

II. 141

147

142 *Westminster Hall*

Ink line and wash with slight colour on paper, unmounted, 44 × 55 cm.

Signed London 1953.

Given by the artist to Geoffrey Hedley, and bequeathed by him to K & MS in 1960.

(*not illustrated*).

Zhang Anzhi 張安治
(1911–91, b. Yangzhou, Jiangsu)

Painter, calligrapher and art historian. He studied under Xu Beihong, Lü Fengzi and others from 1928–31 in the Art Department of National Central University. In 1936, he was invited by Xu Beihong to organise the Guilin Art Academy, which he ran until 1944. From 1947 to 1948 he was in London on a British Council Scholarship. In 1953 he became Professor in the Art Department of Beijing Normal College, and later Professor in the Central Academy, Beijing.

143 *Mountain road in Yunnan*

Ink and colour on paper, unmounted, 40.6 × 33.3 cm.

Inscription and one seal of the artist, n.d.

Painted after 1949.

Given to MS by the artist on our visit to his studio in Beijing in 1979 or 1980.

(*not illustrated*).

144 *By the Serpentine, Hyde Park, London*

Ink and colour on paper, mounted, 31.8 × 44.5 cm.

Signed and inscribed by the artist to MS in London in 1948.

145 *Swans on the Serpentine, Hyde Park, London*

Ink and colour on paper, unmounted, 26.7 × 34 cm.

One artist's seal.

Signed and inscribed by the artist to MS in London in 1948.

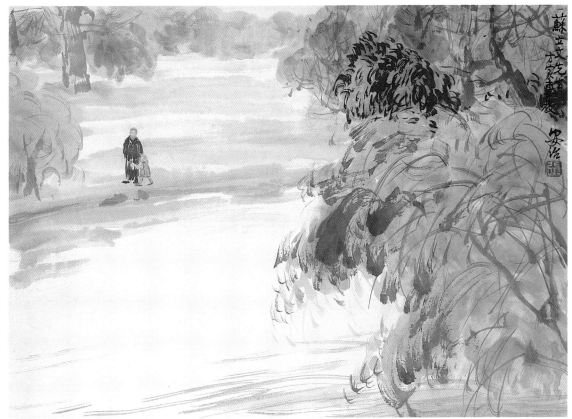

II. 144

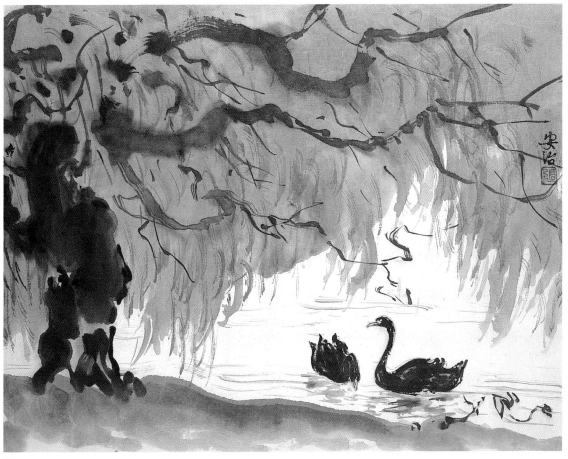

II. 145

II. 146

Zhang Dali 張大力
(b. 1963, Harbin)

146 *Dialogue (China National Art Gallery, Beijing)*

Colour photograph 24 × 35 cm.

Acquired from the CourtYard Gallery, Beijing, in November 1999.

A satirical comment on the destruction of the old Beijing while the Mao-period National Art Gallery in the background survives intact.

Zhang Daqian 張大千
(1899–1983)

Guohua painter, collector, connoisseur and forger, native of Neijiang, Sichuan. In 1917 he studied textiles in Japan. 1919 returned to Shanghai where he studied under Zeng Xi and later learned calligraphy from Li Ruiqing. In 1927 he started to travel widely in China. After a brief spell teaching with Xu Beihong in Nanjing, he spent the years of World War II in west China, visiting Dunhuang 1941/3 to copy the wall paintings, making his base in Chengdu. From 1948 till 1977 he lived in Hong Kong, India, Argentina, Brazil and Carmel, California. In 1977 he settled finally in Taipei. From *guohua* traditionalism, his art developed in the 1960s, partly under Western stimulus, into a free expressionist style, although in his last and finest work, his *Panorama of Mount Lu*, the Western elements are so absorbed as to be invisible.

147 *Woman with censer*

After detail of a Dunhuang fresco.

Hanging scroll, ink on paper, 103.8 × 37.2 cm.

Inscribed and signed by the artist.

Rongbaozhai Studio woodblock reproduction.

Bequeathed by Geoffrey Hedley to K & MS in 1960.

148 *Figure of a lady reading a poem, connected with the poetess Xing Jiaxuan*

Hanging scroll, ink on paper, 170 × 64.3 cm.

Inscribed by the artist and dated tenth month, 1940. Three artist's seals.

The artist saw this painting again in our house at Stanford in 1967, and inscribed it to MS.

Bequeathed by Geoffrey Hedley to K & MS in 1960.

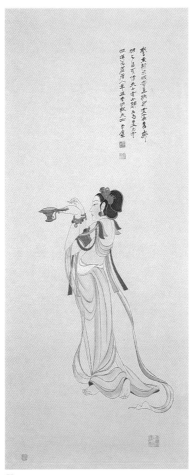

II. 147

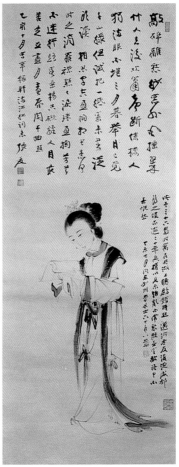

II. 148

II. 149

149 *Lotus*

Handscroll, ink on paper, 12.5 × 116.4 cm.

Inscribed by the artist: My friends Michael Sullivan and Madame Wu Khoan ardently love my expressionist painting on small scrolls. I left America and returned to Taiwan recently and I met them there. I have been ill, but I drop the brush on the page and try to doodle. My work is not even worth a laugh. In my sixty-seventh year, May 21, 1978.

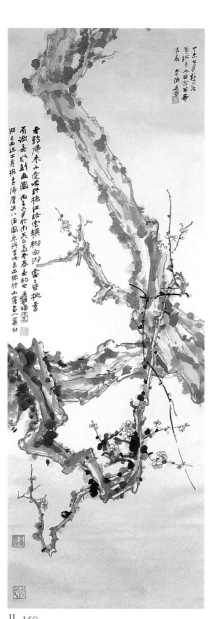

150 *Old plum-branch with young shoots*

Hanging scroll, ink and colour on paper, 183 × 63.4 cm.

Inscription and five seals of the artist. Painted in Brazil in 1965.

K & MS selected this when he brought his paintings to our house in Stanford for an exhibition at the Stanford Museum in 1967. When he saw how much we admired it, he gave it to 'Maike xiong' (elder brother Michael) with a dedicatory inscription.

151 *Landscape*

Handscroll, ink and mineral colour on paper, mounted and framed, 13.5 × 53.6 cm.

KS saw this painting at Zhang's exhibition in the Laky Gallery, Carmel, California. Mr Laky told her it was very expensive, but he thought he might get it from Zhang at a lower price. Khoan urged him not to speak to Zhang about it, for if Zhang knew K had bought one of his pictures, he would be very angry. But evidently Laky did tell him, and on the day Zhang left to return to Taipei this painting arrived, beautifully framed, as a gift to K from the artist.

Exhibited and published San Francisco State University and the National Museum of History, Taipei, *Chang Dai-chien in California* (San Francisco, 1999) Cat. No. 32.

II. 150

152

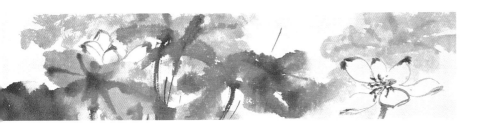

II. 151

Letter accompanying the gift to KS runs:

Madame Wu Khoan,

My small scroll has been admired by your eyes. It has been displayed for two weeks, but no one has asked about it. I really feel like crying for my unappreciated jewel. I send it to you through the mail and hope you will accept it so I can thank you for your esteem. I, Yuan, will shortly depart for Taiwan, but will return in about a month. If we miss the plum season, we can meet in my small garden to admire the crab-apple.

16 January, wishing peace to both of you. Daqian Zhang Yuan

Equally intending (the scroll) for my friend Michael, I painted only one.

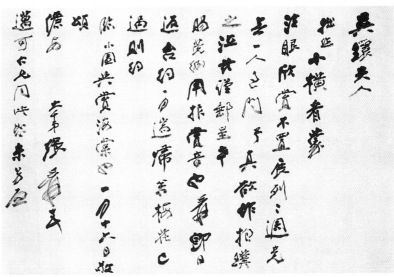

II. 151(a)

153

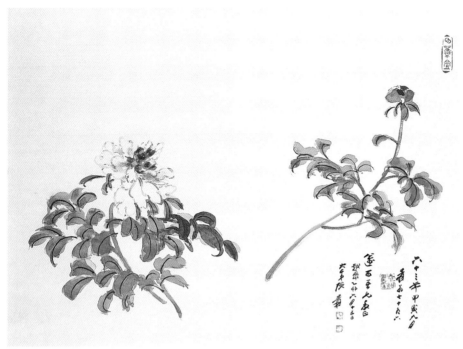

Il. 152

152 *Set of six lithographs:*
Homeward passing through the stone gate at dusk
Cinnabar lotus
Mountain monastery by the waterfall
Peonies (illustrated)
Shrike amidst the autumn leaves
Gibbon hanging over an autumn stream

Made directly on the stone in California in 1974 and 1975, and published in 125 sets in a portfolio by WB Fountain Co-publisher, and Walter F Maibaum, Director, Editions Press, San Francisco, with a colophon by MS. This is the second set Zhang made; an earlier set had a colophon by Yvon d'Argencé.

153 *Four dancing girls*
(Mara's demonesses tempting the Buddha)

Ink and body colour on paper, mounted (badly!), 79.7 × 116.7 cm.

No signature, seals or date.

Copy made by the artist in the Dunhuang Cave 196 during his stay in 1942/3. Given by the artist to K & MS at Stanford in 1967.

Publ. *Art and Artists of Twentieth Century China*, col. pl. 25.

Note: It was from direct copies such as these that Zhang's finished (and often restored or improved) versions were made. I think that the

II. 153

originals made in the caves are nearly all lost or destroyed; but they may be hidden away somewhere. It is worth noting that a comparison of our 'copy' with a colour reproduction of the actual painting shows that for his finished version for exhibition Zhang has taken some liberties, tidied it up, made the features, feet etc., more refined than in the original.

154 *River landscape*

Ink and colour on paper, 11.2 × 45.2 cm.

Painted in the summer of 1975 for Khoan Sullivan, who he knew liked small things.

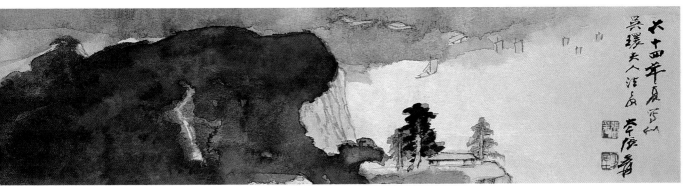

II. 154

Zhao Wuji (Zao Wou-ki) 趙無極
(b. 1921, Beijing)

In 1935 he entered the National Art Academy, Hangzhou, studying under Lin Fengmian and Pan Tianshou. In 1941 he became Professor of Drawing in Chongqing. In 1948 he settled in Paris and from 1950 to 1957 worked with Pierre Loeb, visiting the US in 1957/58. In 1972 he paid his first return visit to China where he was influential in securing the eventual release of Lin Fengmian. In 1984 he was appointed Officer of the Légion d'Honneur. In 1985 he became Visiting Professor at the National Academy, Hangzhou. A quasi-abstract expressionist and distinguished member of the School of Paris, his exhibitions world-wide include a major retrospective 1998/9 in Shanghai, Beijing, Canton and Valencia, Spain.

155 *18.01.95 Triptyque*

Triptych, oils on canvas, 41 × 82 cm.

Signed.

Acquired from Alice King's Alisan Gallery, Hong Kong, in 1998.

Publ. Gérard de Cortanze, *Zao Wou-ki* (Paris, 1998) p. 275; *The Arts of China* (4th edn, 1999), Fig. 12.16.

156 *Abstraction*

Lithograph, colour on paper, mounted and framed, 21.3 × 15.8 cm.

Signed, and dated '89.

Given by the artist to K & MS in about 1990.

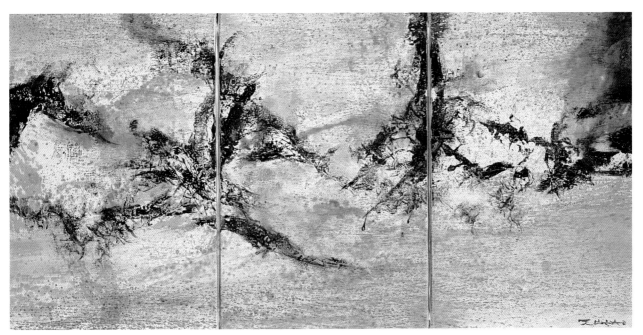

II. 155

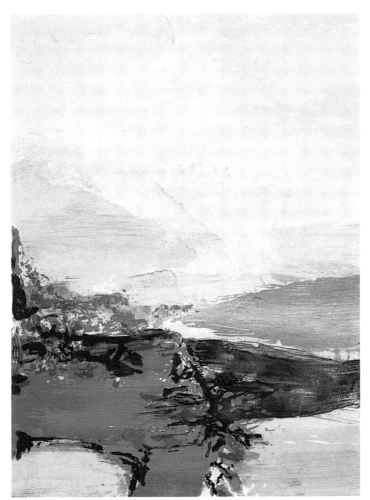

II. 156

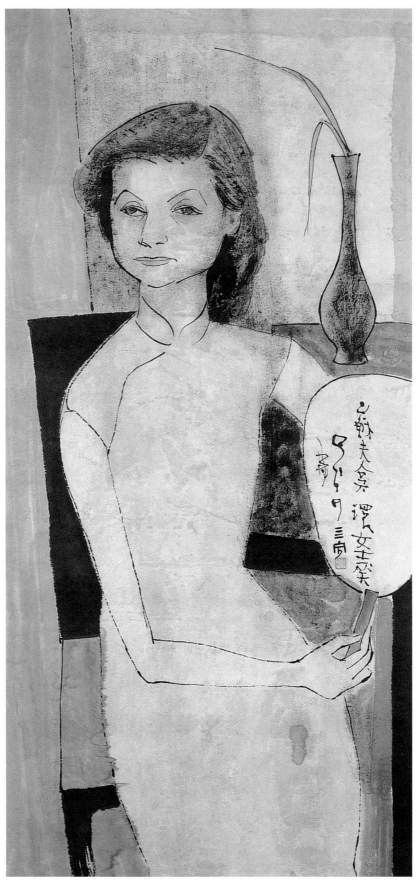

II. 157

Zhong Sibin (Cheong Soo Pieng) 鍾泗濱 (1917–83)

Painter, born in Xiamen and trained in the Xinhua Academy, Shanghai, and the Xiamen Academy. In 1946 settled in Singapore. He travelled widely and taught in the Nanyang Academy of Art in Singapore. Most of his work is landscapes and figure subjects, although in his later years he worked also in batik and metal. He was the most talented of the Singapore artists of his generation.

157 *Portrait of Khoan Sullivan*

Ink and colour on paper, mounted and framed, 93.2 × 44.6 cm.

Signed and inscribed to KS by the author, dated 1959.

Soo Pieng painted this on the day when K & MS visited his studio in Singapore. She was sitting with a fan chatting with him when he told her to keep still, put a piece of paper on his easel/board, and began very rapidly to draw the figure in outline; he added the colour and inscription later.

Publ. *Art and Artists of Twentieth Century China*, col. pl. 55.

158 *Malayan Kampong in the evening*

Ink and colour on paper, mounted and framed, 45 × 63 cm.

Signed, one seal. Painted about 1958(?).

Given to K & MS by the artist in Singapore in about 1958.

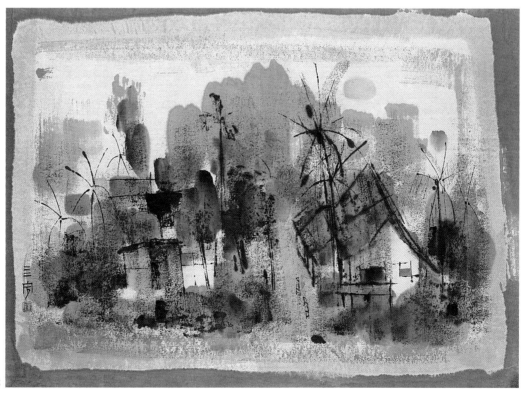

II. 158

159 *Kampong at Sunset*

Ink and colour on paper, 45×63 cm.

Signed, one seal.

Given to K & MS by the artist in Singapore in about 1958/59.

160 *Fisherman's House on stilts over the water*

Ink and colour on paper, mounted.

Signed with one seal.

Given to K & MS by the artist in Singapore in 1958/59.

161 *Waterside Scene in Singapore*

Oil on canvas, framed, 38.3×48 cm.

Signed Soo Pieng, 1957.

Given to K & MS by the artist in Singapore in about 1958.

(*not illustrated*).

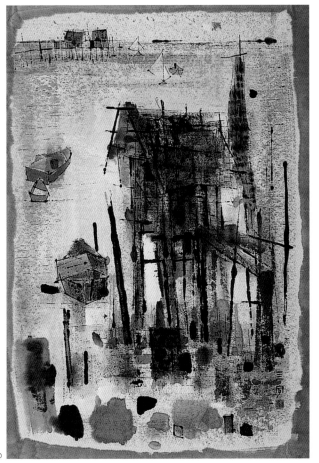

II. 160

II. 159

162 *Malayan Fishing Village*

Ink and colour on paper, mounted, 93 × 44.5 cm.

Signed Sibin, one seal. Painted about 1958/59.

Given to K & MS by the artist in Singapore in about 1959.

163 *Landscape in Bali*

Watercolour on paper, mounted and framed, 34.7 × 55.3 cm.

Signed.

Painted on a tour of Bali in 1953, in company with the Singapore artists Chen Wenxi, Liu Kang and Chen Zhongrui.

Given to K & MS by the artist in Singapore in about 1958/59.

II. 163

Zhu Dequn (Chu Teh-chun) 朱德群
(b. 1921, Xiaoxian, Jiangsu)

Painter. In 1936 he entered the Zhejiang Academy, Hangzhou where he studied under Lin Fengmian. During World War II he was in west China, then Nanjing. From 1950 to 1955 he was Professor in the National Taiwan Normal University, Taipei. In 1955 he settled in Paris where, in 1999, he was installed as a member of the Academie des Beaux Arts.

164 *Abstraction*

Oil on panel, framed, 45×60 cm.

Signed.

Painted in 1988 for KS who wished for something with a predominantly blue colour.

Zhu Qizhan 朱屺瞻
(1892–1996)

Oil and *guohua* painter, born in Taicangxian, Jiangsu. In 1912 he began to study oil painting in the Shanghai Meizhuan. In 1922 and 1930 he studied in Japan, later returning to Chinese painting. On returning to China, he taught in the Shanghai Meizhuan and Xinhua Academy, then for many years in the Hangzhou Academy and in Shanghai.

165 *The Jade Mountain*

Ink and mineral colour on paper, mounted and framed, 68×68 cm.

Signed with two artist's seals. Painted in 1988.

Acquired from L. J. Wender in New York in December 1999.

Publ. L. J. Wender, *At the Height of Inspiration* (1994), pl. 9.

II. 164

II. 165

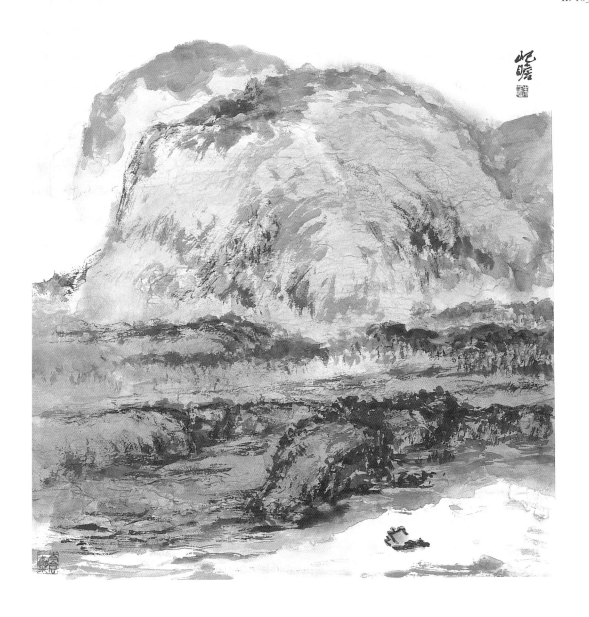

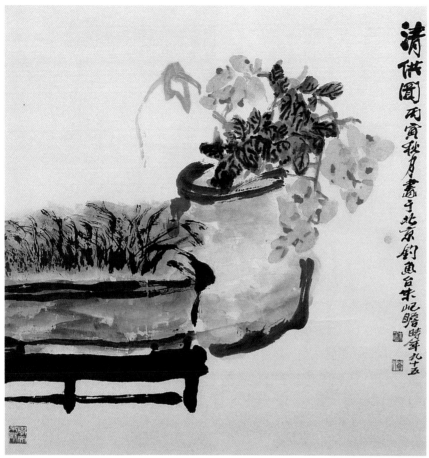

II. 166

166 *Still Life*

Ink and colour on paper, 69 × 69 cm.

Inscribed: 'Painted in the autumn of Dingyin (1986) at Diaoyutai in Beijing, at the age of 95', with two artist's seals.

Acquired from L. J. Wender in December 1999.

Publ. L. J. Wender, *The Painting of Zhu Qizhan* (New York, 1988), pl. 32, and *Unafraid of the Autumn Wind: Retrospective Exhibition of Paintings of Zhu Qizhan (1892–1996)* (New York, 1999), pl. 18.

Zhu Xinghua (Chu Hing-wah) 朱興華
(b. 1935, Guangdong)

Painter. In 1960–65 he trained in psychiatric nursing at the Maudsley Hospital in London, then from 1968 to 1992 worked in the Castle Peak Psychiatric Hospital, Hong Kong. In 1992 he retired to devote himself full-time to painting.

167 *Eiffel Tower Park*

Hanging scroll, ink and body-colour in paper, 176×97 cm.

Signed and dated 2000.

Acquired from the artist's exhibition at the Hanart TZ Gallery, Hong Kong, in November 2000.

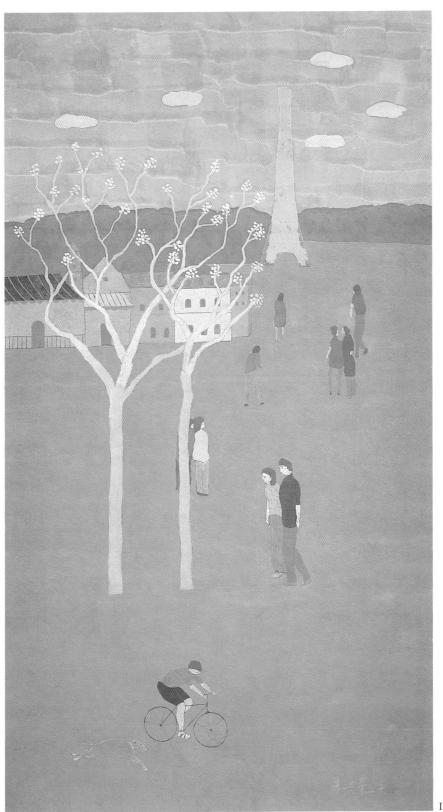

168 *The Eiffel Tower*

Pen drawing on paper, framed, 18.5 × 12.9 cm.
Dated 4.7.99, unsigned.
Given to K & MS by the artist in November 2000.
(*not illustrated*).

Zhuang Zhe 莊喆
(b. 1935, Beijing)

Painter, son of Zhuang Yan, curator of paintings in the National Palace Museum. In 1948 the family moved to Taiwan and in 1958 he graduated from the Art Department of the National Taiwan Normal University. He was a member of the Fifth Moon Group with Liu Guosong and became head of the Department of Art and Architecture at Donghai University. In 1973 he emigrated to Ann Arbor, Michigan, later settling in New York.

169 *The Boulder 壘 (1993)*

Oil painting on canvas, 98 × 126 cm.
With the artist's signature.
Acquired from the artist in 1999.

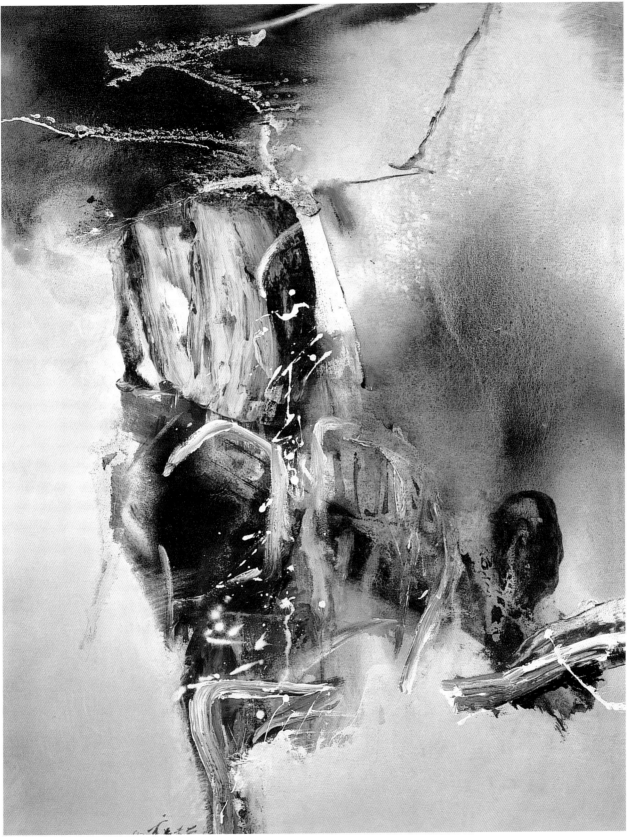

II. 169

170 *Abstraction*

Ink on paper, 59.4 × 112 cm.
Signed with one artist's seal and dated in 1967.
Given to K & MS by the artist at Stanford in 1967.

171 *Abstraction*

Ink on paper, mounted, 59.2 × 113 cm.
Signed and dated in 1967.
Given to K & MS at Stanford in about 1967.

172 *Untitled (abstraction)*

Ink on paper, 59.7 × 46.3 cm.
Signed, n.d.
Given to K & MS by the artist at Stanford in about 1967.
(Not illustrated)

173 *Untitled*

Mixed media, 51 × 61 cm.
2000.

Acquired from his exhibition of 2001 in the Han Art Contemporary Gallery, Montreal, Canada.

Zhuang Zhe wrote to MS that this is one of a group of paintings inspired by his recent visit to Anshun, a remote and backward town in western Guizhou province, where during World War II treasures from the Palace Museum were stored in caves under the care of the museum staff, headed by his father, Zhuang Yan

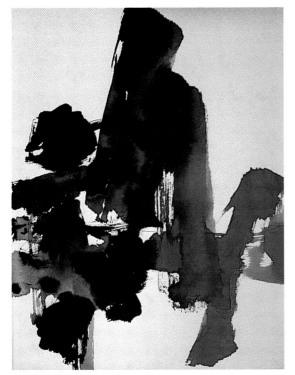

II. 170

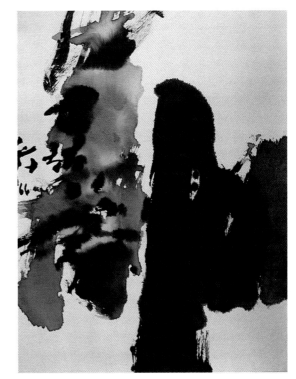

II. 171

II. 173

III. WOODCUTS & SHUIYIN PRINTS

Huang Xuanzhi 黃玄之
(b. 1924, Jiangsu)

Graphic artist. In 1947 he graduated from the Suzhou Academy and in 1954 joined the National Academy at Hangzhou as a teacher of graphics, and especially of the revived technique of *shuiyin* printing with multiple wood blocks, a technique that he demonstrated to K & MS in Hangzhou.

1 *Island in the Lake*

Shuiyin colour woodblock print on paper, framed, 38.3 × 41.1 cm.
Inscribed to K & MS in Hangzhou in October, 1980.

Huang Yongyu 黃永玉
(b. 1924)

2 *Goose Farm* 鵝城

Two colour woodcut on paper, 31.5 × 22.6 cm.
With the artist's signature.
Dated 2 May 1948.
All the Huang Yongyu woodcuts were bequeathed to K & MS by Geoffrey Hedley in 1960.
Publ. *Chinese Art in the Twentieth Century*, fig. 67.

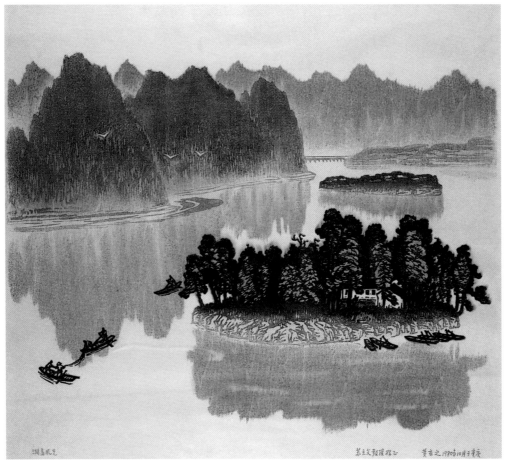

III. 1

III. 2

3 *A Monkey, a Rabbit and a Porcupine (No. 23)*

Woodcut on paper, 19 × 14 cm.
Signed.

4 *Soldier on horse, peasant on ox (No. 17)*

Woodcut on paper, 19.5 × 21 cm.
Signed.

5 *The Borderland* 邊城

Woodcut on paper, 22.7 × 16.7 cm.
Signed.

6 *Puppeteer* 儺誦

Woodcut on paper, 23.5 × 17.5 cm.
Signed.
(*not illustrated*).

7 *Bathing* 浴

Woodcut on paper, 17.5 × 22 cm.
Signed.

8 *A man looking at a woman in a round shaped window (No. 25)*

Woodcut on paper, 16 × 21.3 cm.
No signature.

III. 3

III. 4

III. 7

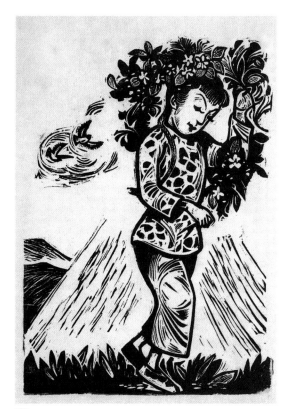

III. 5

III. 8

III. 9

III. 10

9 *An Ox (No. 191)*

Woodcut on paper, 15 × 22 cm.
Signed (in English).

10 *Folk Song* 民歌

Woodcut on paper, 17 × 25 cm.
Signed.
Made in Hong Kong on 24 November 1948.
Gift to Geoffrey Hedley.

11 *A Girl and an Ox (No. 190)*

Woodcut on paper, 16.5 × 22 cm.
Signed (in English).

III. 11

III. 12

III. 13

12 *The Frontier* 邊城 *(No. 2)*

Woodcut on paper, 14 × 17.5 cm.
Signed.

13 *The Frontier* 邊城 *(No. 4)*

Woodcut on paper, 14.4 × 29.5 cm.
Signed.

14 *Comrade, have a cup of hot tea before you go!*
同志!喝碗熱茶再走

Woodcut on paper, 21 × 51 cm.
Signed.
Dated 1948, in Hong Kong.

III. 14

III. 15

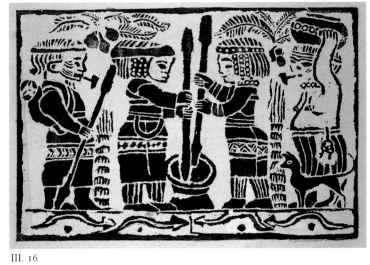

III. 16

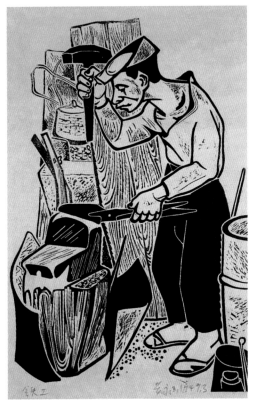

III. 17

III. 18

15 *Dance of a Miao Girl*

Woodcut on paper, 19.3 × 13.8 cm.
Signed, a seal of the artist.

16 *The Song of mortar (or pestle): the life of the indigenous people*

Woodcut on paper, 21 × 51 cm.
Signed.
Dated 1948, in Hong Kong.
Made in Taiwan.

17 *Iron Worker 5 (No. 20)*

Woodcut on paper, 26.5 × 17.7 cm.
Signed, March 1949.

18 *The South (No. 70)*

Woodcut on paper, 28.5 × 28 cm.
Signed, Hong Kong, April 1949.

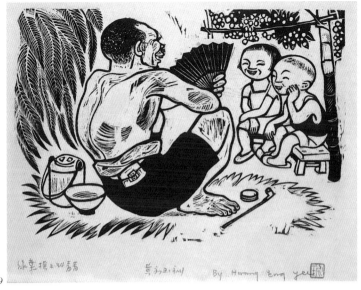

III. 19

19 *The Leaves Rattle and the Grass is Green*
 綠葉搖搖草青青

 Woodcut on paper, 22.5 × 33 cm.
 Signed with an artist's seal.

20 *The Masseuse* 捉龍者

 Woodcut on paper, 33.5 × 22 cm.
 Signed.
 Made in Taiwan in March 1948.

21 *By the Stove* 爐邊

 Woodcut on paper, 22.7 × 34.5 cm.
 Signed.

22 *Picking up the Grains* 拾麥子 *(No. 132)*

 Woodcut on paper, 22 × 16.5 cm.
 Signed, one artist's seal.

III. 21

III. 20

III. 22

III. 23

III. 24

23 *Mouse Getting Married* 老鼠娶親 *(No. 186)*

Woodcut on paper, 14.2 × 22.2 cm.

24 *A Cat (No. 189)*

Woodcut on paper, 14.8 × 22.6 cm.

25 *A Man in a Boat at Night (No. 188)*

Woodcut on paper, 14 × 22.5 cm.

26 *Conducting the Orchestra*

Woodcut on paper, 23 × 33 cm.

27 *The Happiness of the Farmers* 畫農家樂 *(No. 8)*

Woodcut on paper, 14.5 × 47 cm.

III. 25

III. 26

III. 27

28 *Monkey* 猴

Woodcut on paper, 23 × 16.5 cm.
Signed.

29 *Taiwan food stands* 台灣食攤

Woodcut on paper, 40.3 × 38 cm.
Dated 29 November 1948.
Signed, made in Taiwan.

III. 28

III. 29

III. 30

III. 31

30 *The Music Lesson*

Woodcut on paper, mounted and framed, 20 × 29.6 cm.
About 1948.
Publ. *Chinese Art in the Twentieth Century*, fig. XII.

Jiang Feng 江豐
(1910–82)

Born in Shanghai, he was originally a *guohua* artist who became a wood
engraver in Shanghai. In 1932 he joined the Communist Party and went
to the Lu Xun Art Academy in Yan'an. After 'Liberation' became a key
figure in Party cultural affairs and art. Director of the Central Academy
and Chairman of the Artists Association. He died of apoplexy during a
heated debate about modern art.

31 *Food Peddlers* 賣小食者

Colour woodcut on paper, 23 × 16 cm.

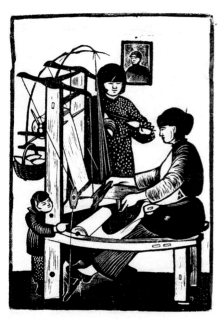

III. 32

32 *Jingyun* 景雲 *Weaving* 織布

Woodcut on paper, 15 × 11 cm.
Signed on a small paper attached at the back of the woodcut.

Lu Fang 陸放
(b. 1932, Jiangsu)

Print-maker. In the 1980s and 1990s Lu Fang, who was teaching print-making in the National Academy of Fine Arts in Hangzhou, was one of a group of artists who developed the *shuiyin* (water-printing) technique into an expressive art form.

33 *Trees in the Snow*

Shuiyin colour woodblock print on paper, unmounted, 39 × 51.2 cm.
Inscribed and signed by the artist and dated August 1986.
This print was made in March 1987.
Given by the artist to K & MS in Hangzhou in 1988.

34 *Autumn Moon over the Calm Lake, Hangzhou*

Shuiyin colour woodblock print, mounted, 39.3 × 52 cm.
Inscribed and signed by the artist and dated.
Given by the artist to K & MS in Hangzhou on 22 May 1984.

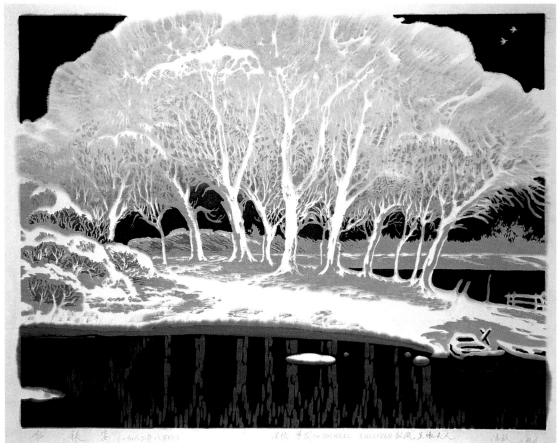

III. 33

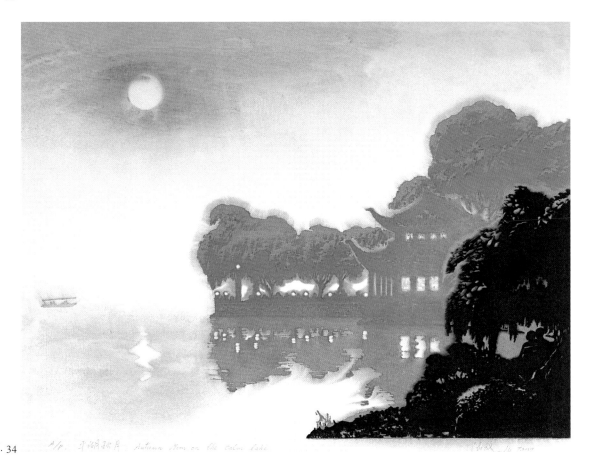

III. 34

187

Mai Kan 麥桿
(1921–2002)

Wood-engraver, a native of Shandong who settled in Shanghai. He began making woodcuts in 1940. After World War II he became a friend of Geoffrey Hedley, and paid a visit to Taiwan.

All our woodcuts by this artist were bequeathed to us by Geoffrey Hedley.

35 *Selling musical instruments*

Woodcut on paper, 32 × 25 cm.
Signed and dated 1948.

36 *Farmers in Taoyuan (Taiwan)*

Colour woodcut on paper, 51.3 × 34 cm.

III. 35

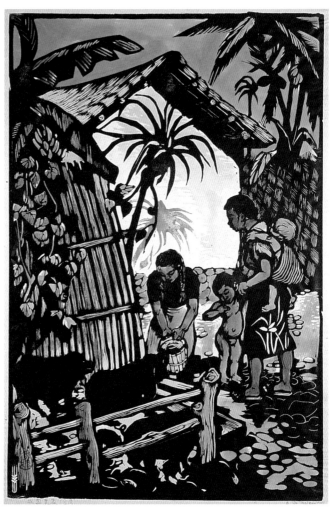

III. 36

III. 37

III. 38

37 *A boy seated*

Colour woodcut on paper, 53.3 × 38 cm.
Signed with one artist's seal.

38 *Everybody goes to school and studies*

Woodcut on paper, 43 × 40 cm.
One artist's seal.

Qiu Xietang 裘燮堂
(dates unknown)

39 *Picking tea leaves (No. 78)*

Woodcut on paper, 25.8 × 18.1 cm.
Signed.

Zeng Yu 曾堉

Painter and art scholar. After art training in London, he went to Taipei where he worked as an art researcher in the National Palace Museum. He later took up an appointment in the art department of the Chinese University in Hong Kong. With his wife, Wang Baolian, he has translated several western art books into Chinese, including MS's *The Arts of China* (third edn.)

40 *The Tower of London (No. 10 of 40)*

Etching on paper, mounted, 30.5 × 37.3 cm.

Signed in pencil and dated London, 1956.

Given by the artist to Geoffrey Hedley, and bequeathed by him to K & MS in 1960.

Zhang Xiyai (Chang Hsi-yai) 章西涯
(1917–96)

41 *The Dream*

Woodcut on paper, 19.8 × 14.4 cm.

42 *In the Autumn*

Woodcut on paper, 17.2 × 8.5 cm.
Signed.

III. 39

III. 41

III. 40

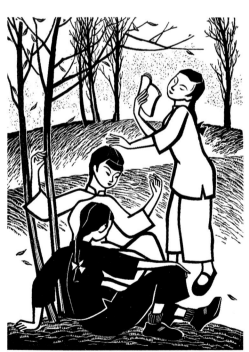

III. 42

III. 43

III. 45

43 *Springtime*

Woodcut on paper, 13 × 18 cm.
Signed.

44 *A suburb in the autumn* 秋郊 *(No. 73)*

Woodcut on paper, 26.7 × 20.3 cm.
Signed.
(*not illustrated*).

45 *Potter* 瓦鉢子工人

Ink on paper, unmounted, 69.2 × 46.2 cm.
Inscribed to MS in Chengdu in 1980.

III. 46

III. 47

46 *Beginning of a day* 一天開始

Woodcut on paper, 21 × 12.5 cm.
Signed: Shih-yeh Chang.

47 *Warming up* 取暖

Woodcut on paper, 23 × 13.5 cm.
Signed: Hsi-ya Chang.

Zhang Yang 張 (?)

48　*Street scene*

Colour woodcut on paper, 20.1 × 14.8 cm.
Unsigned.

Zhao Zongzao 趙宗藻
(b. 1931, Jiangsu)

Print-maker and teacher. Professor of print-making in the 1980s and 1990s in the National Academy of Art, Hangzhou.

49　*Huangshan*

Shuiyin colour woodblock print on paper, 47 × 40 cm.

No. 17 of an edition of 30. Signed in pencil.

Given to K & MS by the artist in Hangzhou in 1982.

We had seen a print of this in the otherwise dreary exhibition of the Hangzhou Academy celebrating the fortieth anniversary of the Yan'an Talks on Art and Literature, and later met the artist in the Academy. He stayed up all night making this print for us.

He had paid a short visit to Japan, and it seems that this work shows the influence of the modern Japanese print.

Publ. *Art and Artists of Twentieth Century China*, fig. 17.3.

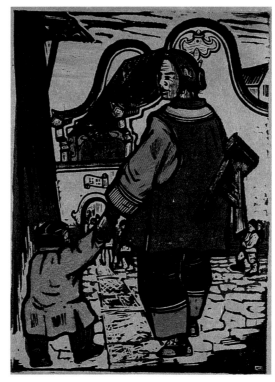

III. 48

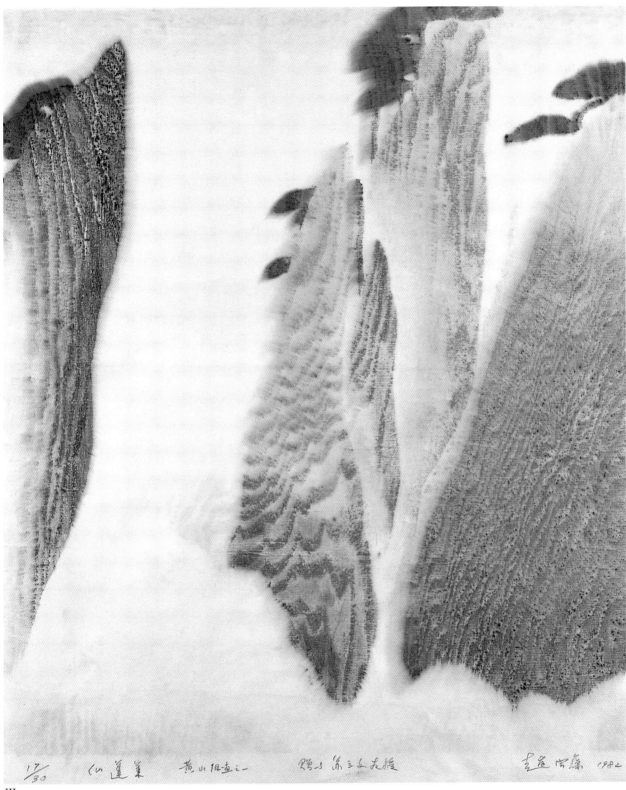

III. 49

IV. Miscellaneous

A. CALLIGRAPHY

Sun Xingge 孫星閣 (Shiwan Shanren 十萬山人)
(1897–1997)

Poet, painter and calligrapher born in Zhaozhou, Southeast Guangdong. At the age of 23 he moved to Shanghai where he taught painting in a university and was active in literati circles. He also organised the Jin Cheng Art Society. He later settled in Hong Kong. The painter, Wang Zhen, said of him, 'with age, his bitter-sharpness had intensified like seasoned ginger' – qualities very evident in this couplet.

I *Duilian*

A pair of hanging scrolls, ink on paper, mounted, 138 × 33.3 cm.

Signed with two artist's seals.

思放水流處
龍吟虎嘯時

Dr Wang Tao at SOAS has suggested a possible translation:

Put down your thoughts at the river bank
When the dragon sings and the tiger roars.

IV. A. 1

Wang Fangyu 王方宇
(1913–97)

Calligrapher and art scholar, born in Beijing. He graduated from Furen University in Beijing and earned his MA at Columbia University, New York. He taught Chinese at Yale University (1945–65) and Seton Hall University (1965–78). Among his numerous textbooks, dictionaries and studies of Chinese art, his work on Bada Shanren is definitive.

2 *Calligraphy: Mowu* 墨舞 *'Dancing ink'*

Ink on paper.
Three artist's seals.
Given by the calligrapher to K & MS.
(*not illustrated*).

3 *Calligraphy: Sanjue* 三絕
(The Three Perfect Things, i.e. poetry, painting and calligraphy)

Ink on paper, mounted, 33.2 × 47.8 cm.
One artist's seal.
Given by the calligrapher to K & MS.

Wang Jiqian (CC Wang) 王己千
(1907–2003)

Guohua painter, collector and connoisseur trained in Shanghai under Wu Hufan (1894–1970), where he became well-known as a connoisseur, and collaborated in research into Chinese painting with Victoria Contag. In 1954 he settled in New York and in the following decade developed his unique style of landscape painting. (fig. II. 118)

4 *Calligraphy: the character shou* 壽 *(long life)*

Hanging scroll, ink on paper, 66 × 34 cm.

Given to MS at Stanford in September 1999 by his former students Shirley Sun, Kumja Kim, Mayching Kao, Jim Soong and Pat Maveety at the showing of Shirley Sun's films on modern Chinese calligraphers.

(*not illustrated*).

Xu Xuebi (Pat Hui Suet Bik) 許雪碧
(b. 1943, Hong Kong)

Poet, designer and calligrapher. She studied philosophy at Hong Kong University and later art history. From 1975–80 she worked in silk-screen printing and fashion design. In 1980 she settled in Minneapolis, established Hui Arts to print and exhibit contemporary Chinese art, especially work of Wucius Wong with whom she collaborated in painting and calligraphy.

5 *Poem*

Calligraphy on paper with colour, mounted, 21.6 × 41.5 cm.
Given by the artist to K & MS in the 1970s.

IV. A. 5

6 *A eulogy on wine by Su Dongpo*

Handscroll, on painted paper, 137 × 38 cm.
Given by the artist to MS in the 1970s.
(*not illustrated*).

IV. A. 7

Yang Caoxian 楊草仙
(1837-1944)

Calligrapher.

7 *Calligraphy, lines from the poet Qu Yuan* 屈原

Hanging scroll, ink on paper, 137.5 × 46 cm.
Signed and dated 1955, with four seals of the calligrapher.
Written for K & MS in Mr Yang's home in Singapore. He was 118 years old at the time. He died aged 123. If he exaggerated his age, he did so before the year of the Tokyo earthquake (1923), when a newspaper reported (re his current exhibition) that he was 86.

Yang Yanping 揚燕屏
(b. 1934, Beijing)

Painter. She graduated in architecture from Qinghua University, after which she taught industrial design and created historical paintings for the Museum of Chinese History. Member of the Beijing Academy of Painting. In 1976 she settled in Long Island, New York, with her husband, the painter Zeng Shanqing. She has exhibited widely, separately and with her husband, in the US, Japan, Taiwan, Hong Kong and Europe.

8 *Calligraphy. Characters in 'big seal' script*

Hanging scroll, ink on paper, 67 × 16 cm.
One seal of the artist.
Written for KS, to hang beside her desk.
(*not illustrated*).

Yu Chengyao 余承堯
(1898–1993)

Guohua painter (see fig. II. 133) and calligrapher. After rising to the rank of General in the Guomindang army, he retired to Taiwan where he took up painting, developing an individualistic style inspired by classical models. Although when this picture is examined closely it is full of technical mistakes, the power of his style and his refreshing use of colour transcend orthodox standards. He was also a student of Chinese classical music.

9 *Calligraphy*

Hanging scroll, ink on paper, 52.2 × 45 cm.

Signature and one seal of the artist.

Written for MS by the artist at the time of his exhibition at the Hanart TZ Gallery, Hong Kong, 1987.

10 *Calligraphy*

Hanging scroll, ink on paper, 52.5 × 45 cm.

Signature and one seal of the artist.

Written in 1987 for MS in appreciation of the essay he wrote for the artist's Hong Kong exhibition.

IV. A. 9 IV. A. 10

200

B. SCULPTURE

Ju Ming (Zhu Ming) 朱銘
(b. 1938, Miaolixian, Taiwan)

Sculptor. After apprenticeship to a wood-carver he became an independent carver of religious images. In 1960 he began to study modern sculpture and from 1968 to 1976 was assistant to Yang Yingfeng, who worked chiefly in metal. Meanwhile he took up *taiji*. He became an independent sculptor working in a wide range of materials, including wood, bronze, styrofoam, ceramics and glass. He has had many public commissions, and his work has been exhibited round the Place Vendôme in Paris and on the terrace of the Festival Hall, London.

I *Two* taiji *figures*

Bronze, Ht. 22.2 cm. and 22.4 cm.
Sent to K & MS by the artist from Taipei in about 1990.

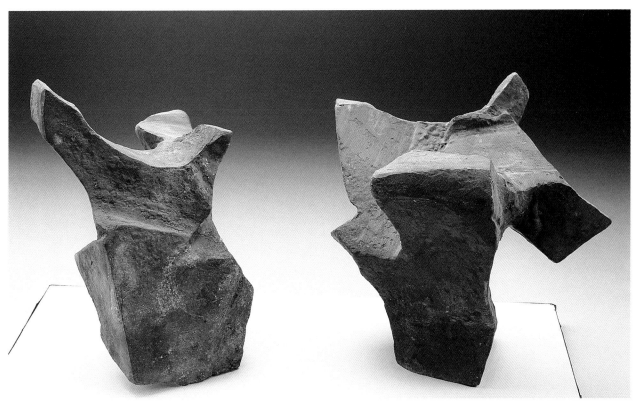

IV. B. I

IV. B. 2

2 *Fish*

Ceramic, L. 53 cm.
Given to K & MS by the artist in about 1991.

Wang Keping 王克平

Self-taught sculptor born in 1949 in Beijing. After being active in the Red Guard during the Cultural Revolution, he was a founding member of the dissident Stars group (Xingxing pai) in 1979. In 1984 he settled in Paris with his French wife Catherine.

3 *Crouching woman*

Carved wood, L. 34.5 cm.
Gift of the artist to K & MS in Beijing in 1980.

4 *Couple*

Carved bamboo, Ht. 25.6 cm.
Gift of the artist to K & MS in Beijing in 1980.

IV. B. 3

IV. B. 4

C. *NIAN HUA* 年畫 , (NEW YEAR PRINTS)

1 *The deity Guangong* 關公

Colour print on paper, 51.7 × 27 cm.

All our *nian hua* were bequeathed to us by Geoffrey Hedley in 1960.

2 *Guangong with sword* 關公帶刀

Colour print on paper, 51.7 × 27 cm.

Shuang Xi Tongzi 雙喜童子

3 and 4 (a pair) Children for Conjugal Blessing

Colour prints on paper, 45.5 × 26.6 cm.

IV. C. 1

IV. C. 2

IV. C. 3 & 4

Qin Jian Tongzii 琴劍童子

5 *Children of the Zither and the Sword*

Colour print on paper, 47 × 27.3 cm.

Inscription:

Washing the sword and watching the dragon jump;
Playing the zither while seeing the crane return.

洗劍看龍躍，彈琴見鶴還

Qin Jiu Tongzi 琴酒童子

6 *Children of the Zither and the Wine*

Colour print on paper, 48.8 × 27 cm.

Inscription:

Playing the zither in order to while away the daytime;
Holding the wineglass and overlooking the green mountains.

彈琴消白晝，把酒看青山。

Fu Lu Shou 福祿壽

7 and 8 (a pair)
 Fu Lu Shou (Prosperity, Emolument and Long life)
 with Children 福祿壽童子

Colour print on paper, each 48.4 × 34.5 cm.

IV. c. 6

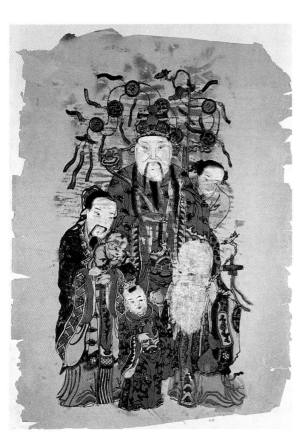

IV. c. 7 & 8

9 *Fu Lu Shou on an altar* 福祿壽

Colour print on paper. 36.1 × 26 cm.

Inscription:

The real lord of the Heaven and the Earth, the three Boundaries, and the ten Directions.

天地三界十方萬靈真宰

Qilin Tongzi 麒麟童子

10 *Children of the Chinese Unicorn*

Colour print on paper, 47 × 27 cm.

Men Shen 門神

11 *The Door Gods*

Colour print on paper, 42.3 × 22.9 cm.

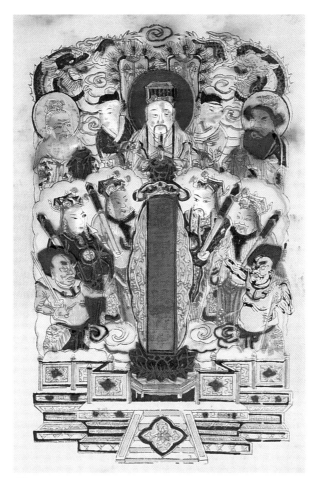

IV. C. 9

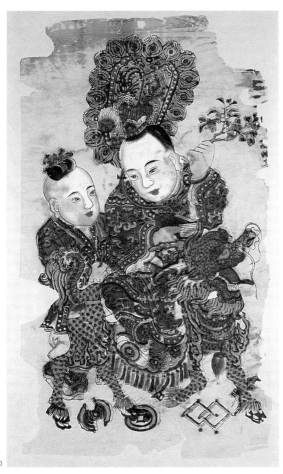

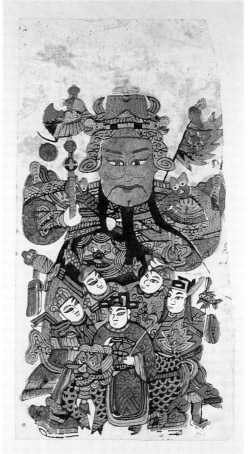

IV. C. 11

D. BATIK PAINTING

Huang Yongyu 黃永玉
(b. 1924, Fenghuan, Hunan)

I *Owl* 益鳥也

Batik on cotton, 67 × 82 cm.

Dated 1979 with artist's signature.

Given by the artist to K & MS in Beijing in 1979 or 1980.

After the death of Mao Zedong in 1976, Huang Yongyu loved to make pictures, in any form, of the owl with one eye shut that had earned him the wrath of Mao's wife Jiang Qing.

E. GLASS PAINTING

Anon

I *Lady with a fan*

Painting on glass, 58 × 41.7 cm

Canton, about 1800.

Acquired in Singapore about 1956.

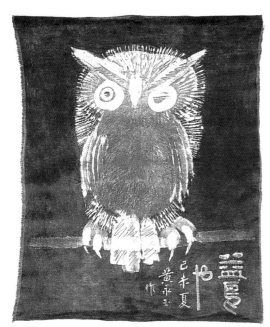

IV. D. 1

210 IV. E. 1

F. OTHER

Xu Bing 徐冰
(b. 1955, Chongqing, Sichuan)

Wood-engraver, print-maker and installation artist. In 1977 he entered the Central Academy, Beijing; 1987 MA, 1988 Instructor. In 1985 he became active in the New Wave modern art movement. Since completing the *Ghosts Pounding the Wall* (1990) he has embarked upon other controversial projects, including the now widely-known 'square words'. He lives in New York.

1 *Work known as the* Tianshu *(A Book from the Sky)*

Installation, printed and bound as a book in four volumes in walnut-wood box.

Created between 1987 and 1991. 46 × 30 cm.

First exhibited (unfinished) in October 1988 in China National Art Gallery, Beijing. First exhibited in the West in Elvehjen Museum of Art, University of Wisconsin, Madison, November 1991 to January 1992.

The so-called *Tianshu* is an imaginary text printed in the traditional Chinese way from small individual blocks of wood on which the characters were carved, in reverse and by hand. As all these characters were invented by Xu Bing himself, the text is not only illegible but

unintelligible. Although this remarkable work drew a good deal of attention, when exhibited in the West, as an expression of post-Modernist ambiguity, it was in fact created, as Xu Bing wrote to MS, in response to his circumstances in Beijing in the turbulent 1980s. So it can be seen as a form of protest against the meaninglessness of the printed word and the futility of human endeavour under that erratically authoritarian regime.

Acquired from Hanshantang Books, London.

Publ. *Art and Artists of Twentieth Century China*, figs. 24.16 and 17.

2 *Handscroll*

380 × 9.4 cm.

This scroll was brought in the blank to England by the writer Xu Zhimo (1895–1931), at the request of Ling Shuhua when he made his return visit in 1925. He had spent two blissfully happy years (1920–21) at Cambridge where he had made a wide circle of friends. He brought with him an album of his own, which is now somewhere in China. Ling Shuhua (then in Beijing) asked him to see if he could get any of his English friends, particularly those in the Bloomsbury Group, to contribute something to it. In the event, it was summer, and most of them were away. He only saw Bertrand and Dora Russell,

IV. F. 2

and Roger Fry. Ling Shuhua kept her scroll for many years as her friends added their contributions to it. When MS published it (See 'A Small Token of Friendship', *Oriental Art*, New Series Vol. 32.2, Summer, 1989, 76-85) she was so pleased that she gave the scroll to K & MS, inscribing it to them on the back. It is worth noting that the various items are not in strict chronological order. Several were squeezed into available spaces at a much later date than their neighbours.

1 Title; *Chun shu mu yun* 春樹木雲 (Spring Trees and Autumn Clouds) written by Zhang Daqian, probably in 1958 in Tokyo.

2 Roger Fry (1866–1934). Classical landscape. Monochrome ink wash. Signed, n.d. Painted presumably in London during Xu Zhimo's stay in England, 7 April to August 1925. It is interesting to see that here Roger Fry reverts to his original pseudo-classical style; perhaps he thought it more appropriate to a Chinese scroll than his later Post-Impressionist manner.

3 Dora Russell (1894–1986). Inscription: 'The dualism of mind and matter is essentially a masculine philosophy. Hypatia'. Signed Dora Russell, Carn Voel, Porthcurno, July, 1925. *Hypatia* was the title of her own feminist tract, published in that same year.

4 Zhang Daqian 張大千 (1899–1983). Gentleman under a pine tree. Signed, n.d.

5 Xu Beihong 徐悲鴻 (1895–1953). Two horses galloping through long grass. Signed and dated 1925, when Xu Beihong was in Paris.

6 Xiong Shiyi 熊式一 (Hsiung Shih-I, 1902–91). Poem, dated in the Spring of 1947, when Ling Shuhua visited the author of *Lady Precious Stream* in Oxford.

7 Lin Fengmian 林風眠 (1900–1991). Impression of two Westerners. Dated Beijing, 1926. He had just returned from Paris to head the Beijing Academy of Art.

8 Chen Xiaonan 陳曉南 (b. 1909). Gentleman in a boat. Signed 'Xiaonan, London'. Presumably painted during the artist's stay in 1948.

9 Wen Yiduo 聞一多 (1899–1946). Writer, poet and artist. Rabindranath Tagore. Signed 'Yiduo', n.d. Tagore, who made a memorable tour of China in 1924, contributed to Xu Zhimo's own album a poem in Sanskrit and a psudo-Chinese brush painting of a mountain.

10 Xie Bingxin 謝冰心 (1900–). Inscription to Ling Shuhua, probably written when this noted woman novelist visited London in 1958 with a cultural delegation from the PRC.

11 Wang Daizhi (dates uncertain). Child with a ball. Signed, n.d. Possibly painted when he visited London in 1958.

12 Wu Mi 吳密. A poem by Li Shizhen, written out for Ling Shuhua in Beijing in 1926, when he was Professor of English Literature in Qinghua University. He had studied Western literature in the States, and briefly at Oxford.

13 Oshu Sanjin 櫻州山人. Horse. Signed, n.d. Unidentified artist, not a close friend of Ling Shuhua.

14 Jiang Xiaojian 江小鶼 (1893–before 1937). Still life. Signed, n.d. This well-known sculptor and painter, who had spent two years in France, was a friend of Wen Yiduo (No. 9 on this scroll), and Wang Jiyuan (No. 16).

15 Gu Jiegang (1893–1980). Dedicatory inscription, dated 23 June, 1926; presumably written when he was a research scholar at Beijing University, which he left in 1926, at the persuasion of Lin Yutang, to take a teaching position in Xiamen (Amoy) University.

16 Wang Jiyuan 王濟遠 (1895–1975). Inscription in seal characters, evidently incorrectly copied from an ancient bronze inscription. Dr. Wang Tao of SOAS suggests as a possible reading 'zhen shang' 真賞 'sincerely bestowed', 'true praise', or something of the sort. Dated 1958. Written when he met Ling Shuhua during her visit to Japan.

17 Liu Kaiqu 劉開渠 (1904–1993). Brush, lute and scroll. Painted in the winter of 1926 when he was still a student in the Beijing Art Academy under Lin Fengmian, who had just returned from Paris. To be invited, so young, to contribute to this scroll suggests that Liu Kaiqu was already making his mark.

18 Deng Yizhi (?) Poem: thinking of his parents.

19 Tanizaki Jun'ichiro 以藝并志 (1886–1965). A poem which, in translation by Dr James McMullen, reads:

> When I pass over the Hakone road at dusk
> I see the steam from the hot water
> Where my girl washes her black hair.

Signed 'Recording an old composition. Jun'ichiro' Tanizaki, Japan's greatest modern novelist, lived in the Kyoto area, where he and Ling Shuhua met in 1927.

20 Wang Jiyuan 王濟遠 (1895–1975). Landscape sketch for Tongbo (Chen Yuan) and Shuhua, dated 1985. Done when he was travelling with Zhang Daqian in Japan.

21 Oshu Sanjin 櫻州山人. Flowers and a poem by the same unidentified artist who contributed the horse (No. 13). Ling Shuhua told MS that this painting was even more unwelcome than the horse.

22 Feng Zikai 豐子愷 (1898–1975). Two children walking away. Painted in Loshan, Sichuan, in 1943. At that time, Feng Zikai was teaching in Lin Fengmian's Hangzhou Academy, which had found a temporary home at Bishan near Chongqing. Feng Zikai was on a visit to his friend the aesthetician Zhu Guangqian, a colleague of Chen Yuan in Wuhan University, which had been evacuated to Loshan, south of Chengdu.

V. RECENT ACQUISITIONS

*Including works omitted from the
First Edition*

Cai Guoqiang 蔡國強
(b. 1957, Quanzhou, Fujian)

A painter, performance and installation artist who, after studying in the Shanghai Drama Institute, spent ten years in Tokyo before moving to New York. He is noted for his spectacular, large-scale works chiefly using gunpowder as the medium. As these cannot be accommodated in a modest private collection, he chose this one for Khoan and Michael Sullivan. The arrow is a reference to the legendary folk hero Yi, who with his bow and arrow shot out of the sky nine of the ten suns that were scorching the earth.

1 *The Archer Yi*

Arrow and fired gunpowder on Japanese paper, 78 × 55 cm. 1994. Gift of the artist, 2002.

Cai Lunyi 蔡論意
(b. 1970, Cambridge, MA)

Cai Lunyi is a mathematician, amateur artist and graphic designer, who held an exhibition in New York in 2002. He spent some years in Seattle, where he painted this portrait, before moving to Florida.

2 *Portrait of Michael Sullivan*

Oil on canvas, 44.8 × 44.8 cm. 2005.
Gift of the artist, 2005.
(*Not illustrated*)

Cai Xiaoli 蔡小麗

3 *Still life*

Watercolour on paper, 23.2 × 16 cm. 1993/4
Gift of Barbara and David Laine, 2008.

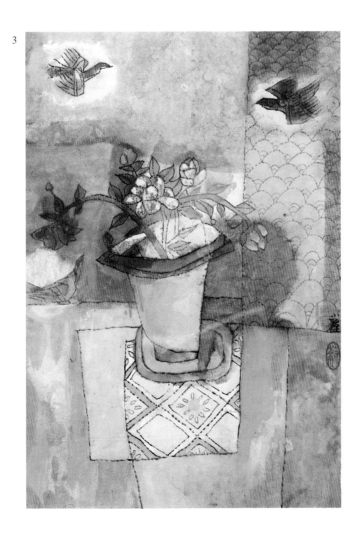

Cai Yiqi 蔡逸溪
(Chua Ek Kai, 1947–2008)

Born in Shantou, Guangdong Province, he came as a child with his family to Singapore. He studied watercolour under Chen Chong Swee and at Lasalle College. After spending some time in Tasmania he returned to teach and practise art in Singapore.

4 *Huangshan*

Ink and colour on paper, 91.5 × 69 cm.
Gift of the artist, 2008.

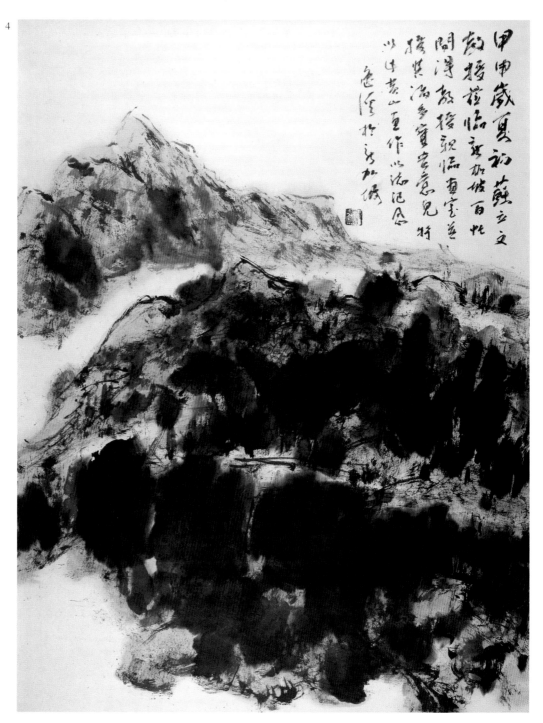

Chen Beixin 諶北新
(b. 1932)

Oil painter. After studying briefly under Xu Beihong, he trained from 1955 until 1957 in the Central Academy of Art under the Russian artist K. M. Maksimov (1913–93), Stalin Prize winner and Professor in the Surikov Art Institute in Moscow, whose influence is reflected in this lively work. He later moved to Xi'an where, apart from a few years with relatives in California, he has spent the rest of his career.

5 *Northern Landscape*

Oil on canvas, 75 × 100.5 cm. 2005.
Gift of the artist and Johnson Zhang, 2006.

5

6

Chen Cheng-hsiung 陳正雄
(Chen Zhengxiong, Robert Chen-hsiung Chen, b. 1935, Taipei)

An oil painter educated in Taipei and at the University of Maryland, 1981–84 President of the Taipei Art Club. His very large abstractions were a feature of the 1998 Shanghai Biennale.

6 *Abstraction*

Ink and colour on paper, 71.5 × 95.5 cm.
Acquired from the artist in Taipei, 2005.

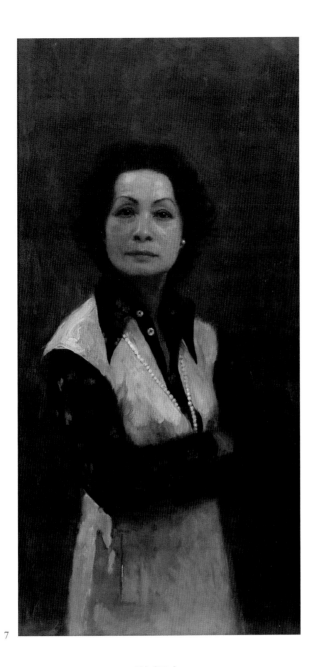

7

Chen Yanning 陳衍寧
(b. 1945, Guangzhou)

A portrait painter who graduated from the Guangzhou Academy in 1985. After visiting Australia he emigrated to the USA, where he lives in New York as a professional artist. In 2000 he was commissioned to paint the Millennium portraits of the Queen, the Duke of Edinburgh, and Princess Anne. In the following year, he had arranged to paint the Queen Mother, but she was ill, and the commission was not carried out.

7 *Portrait of Khoan Sullivan*

Oil in canvas, 121.4 × 61 cm. 2001

Acquired from the artist in 2001

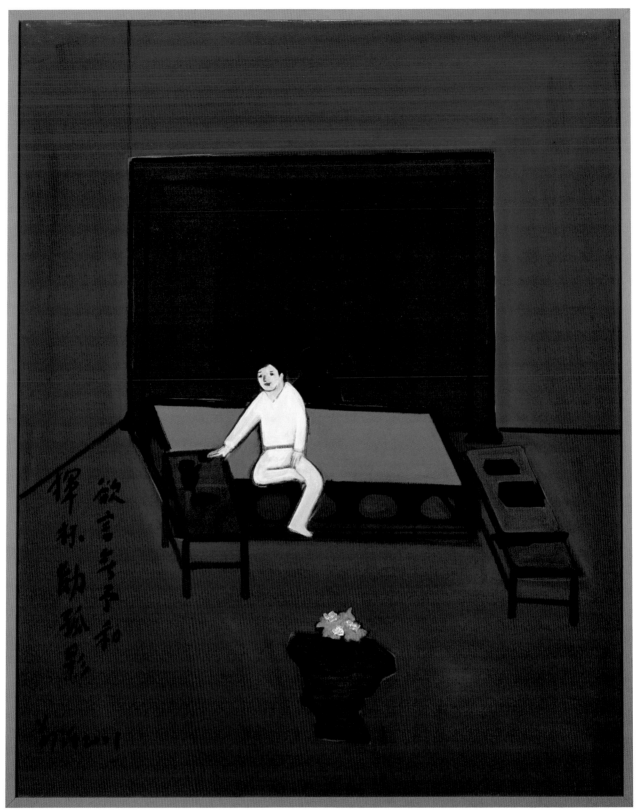

8

Cheng Tsai-tung 鄭在東
(Zheng Zaidong, b. 1953, Taipei)

Self-taught sculptor and painter, especially of figure subjects influenced by Surrealism and the German Expressionists.

8 *A Solitary Voice Finds no Echo*

Acrylic on canvas, 100 × 81cm. 2001.

Acquired from his exhibition at the Hanart TZ Gallery, Hong Kong, November, 2001.

To those who know the great tradition of Chinese scholars' painting, this work clearly has an ironic reference to a well-known anonymous portrait of the reclusive Yuan Dynasty master Ni Zan (1306?–74) seated on a couch before a screen, with his treasures around him. For Cheng Tsai-tung, the message is of the artist's loneliness and isolation.

9 *Wandering in the Woods*

Hanging scroll, ink on paper, 44 × 49 cm. n.d.

Acquired from his exhibition at the Hanart TZ Gallery, Hong Kong, 2000.

Here Cheng Tsai-tung reinterprets the austere style of Ni Zan with his own whimsical charm.

9

10

Cheung Yee 張義
(Zhang Yi, b. 1936, Guangzhou)

He graduated from National Taiwan Normal University before moving to Hong Kong, where in 1964 he became a professional sculptor. After a long and successful career in Hong Kong, he settled in California.

10　*Panel, with archaic zhuanshu (seal characters) in relief.*

Papier maché with printed text on board, 92 × 72 cm. 2004.
Gift of the artist, 2005.

Chiu Teng Hiok, *see* Zhou Jianxu

Chua Ek Kai, *see* Cai Yiqi

Dai Shihe 戴士和
(b. 1948, Beijing, native of Liaoning province)

Oil painter. He studied at the Central Academy, where he became Director of the School of Oil Painting. He also studied in Moscow, and taught painting in Glasgow and Sydney.

11 *The Factory*

Oil on canvas, 30 × 30 cm.

Gift of the artist, 2005.

A painting of the miserable little factory in which Dai Shihe was forced to work from 1968 to 1973, during the Cultural Revolution. His bicycle stands outside. He wrote an account of the factory and his work there on the side of the stretcher.

11

227

Ding Xiongquan 丁雄泉
(Walasse Ding, b. 1929, Shanghai)

A self-taught painter, he went in 1953 to Paris, where he joined the COBRA Group. From 1963 he lived for some time in America, then in Amsterdam.

12 *Still-Life*

Ink and colour on paper, 58.2 × 77 cm. n.d, about 1950.
Bequeathed by Geoffrey Hedley to K & MS in 1960.

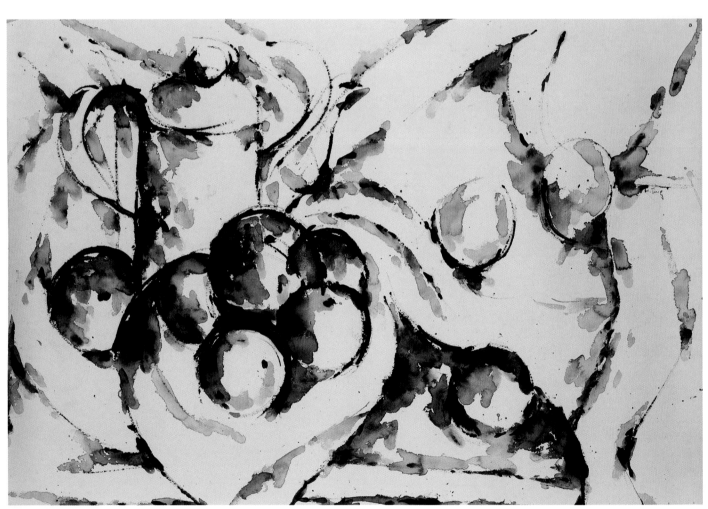

12

Dong Kejun 董克俊
(b. 1939, Chongqing)

He is a self-taught wood-engraver and painter, who spent many years in Guizhou, where he became Chairman of the Chinese Art Association in the province. His early work of the sixties and seventies is typical of the Socialist romantic realism of that period. He later settled in Chongqing, where he developed a powerful style entirely his own.

13 *Little Boy on a Buffalo*

Ink and colour on paper, 70.3 × 70.6 cm.
Gift of the artist, 2008.

14 *Mare and Foal*

Acrylic and ink on paper, 70.3 × 70.6 cm. n.d.
Gift of the artist, 2008.

13

14

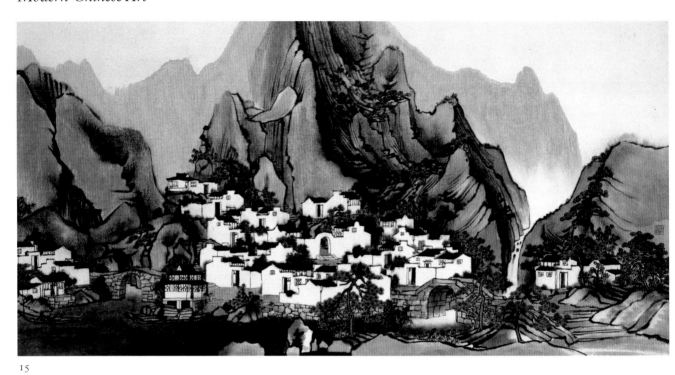

15

Fang Jun 方駿
(b. 1943, Guanyunxian, Jiangsu province)

A professional painter and professor in Nanjing Academy of Art.

15 *Cottages and Verdant Mountains*

Ink and colour on paper, 56 × 90 cm. 2001.
Acquired in 2004.

Feng Zhongrui 馮鍾睿
(b. 1934, Nanyang, Henan province)

In 1934 he moved to Taiwan where, after serving in the Navy, he became
a professional painter, and a member of the Fifth Moon Group, with Liu
Guosong.

16A AND B *Two small compositions*

Collage with ink and acrylic on Japanese paper
A. 24 × 27.2 cm. 2008.
B. 27.1 × 24.3 cm. 2008.
Gift of the artist, 2008.

16A

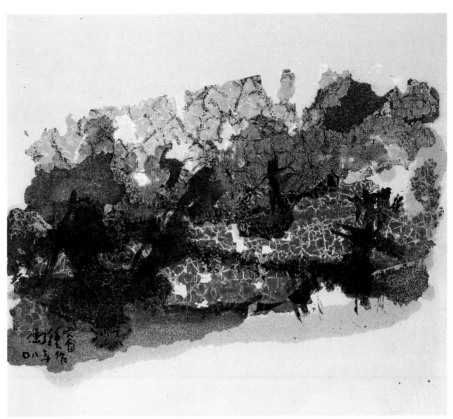

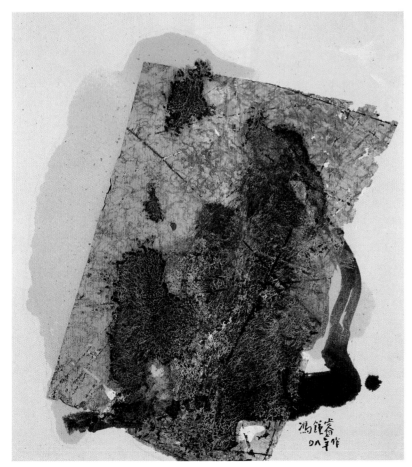

16B

Hong Xian 洪嫻
(Margaret Chang, b. 1933, Yangzhou)

After studying under Pu Ru and Huang Junbi in Taiwan, where she became a member of the Fifth Moon Group, she settled in 1958 in the USA.

17 *Clear Stream*

Ink and colour on card, 45.5 × 53 cm. 1999.
Gift of the artist, 2005.

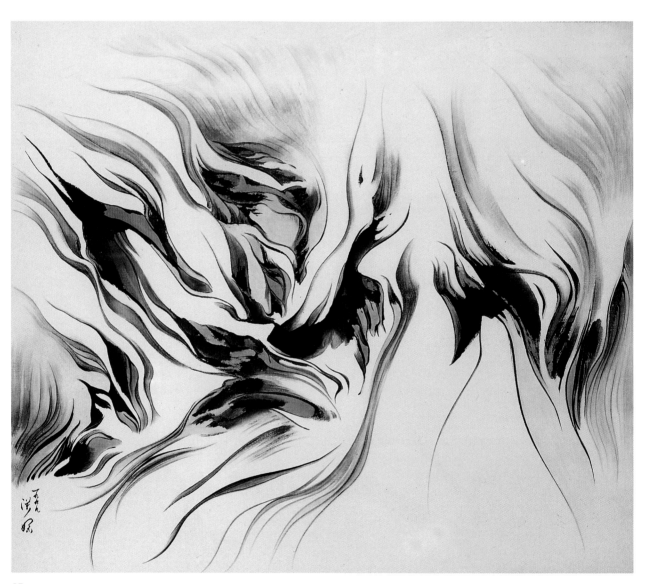

17

Hong Zu'an 洪祝安
(b. 1955, Shanghai)

Painter and calligrapher, trained in the Shanghai Arts and Crafts Institute under Wang Zidou. After teaching in Sydney, he settled in Singapore where he both teaches and works as an independent artist.

18 *Composition*

Ink and colour on paper, 52 × 52.2 cm

Gift of the artist, 2006.

18

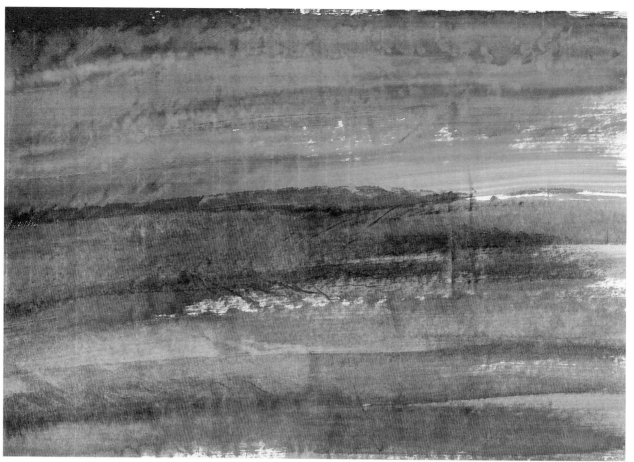

19

20

Pat Hui 許雪碧
(Xu Xuebi, b. 1943, Hong Kong)

Painter and calligrapher who, after studying Philosophy and Art History in Hong Kong and at the University of Minnesota, settled in Minneapolis, where she has over a long period collaborated with Kayin Kwok and Wucius Wong (Wang Wuxie) in poetry, painting, and calligraphy.

19 *Landscape*

Ink and colour on paper, 61 × 83.8 cm.
Gift of the artist, 1991.

20 *Landscape*

Ink and colour on paper, 39 × 83.8 cm. 1994.
Gift of the artist, 1994.

21 *Calligraphy by Pat Hui, painting and poetry by Kayin Kwok*

Ink and colour on paper, 37.8 × 65 cm. 1994.
Gift of the artists, 1999.

21

22

22 *Painting by Pat Hui, and calligraphy by Kayin Kwok*

Ink and colour on paper, 37 × 63 cm.

Gift of the artists, 1999.

23 *Calligraphy by Pat Hui, painting and poetry by Kayin Kwok*

Ink and colour on paper, 28.7 × 41.6 cm.

Gift of the artists.

23

24

Brenda Li Huiling 李惠玲
(b. 1943, Hong Kong)

The artist, in addition to being a painter, and a student of Tibetan culture, is an accomplished performer on several Chinese and ethnic instruments, and on the zither. She lives in Oxford.

24 *The Hulusi Player*
 (a self-portrait)

Watercolour, 61 × 37 cm. 2005.
Gift of the artist, 2007.

Lin Gang 林崗
(b. 1925 on the Shandong-Hebei border)

In 1954 he studied painting in Leningrad and later became Professor in CAFA, and husband of Pang Tao (q.v.). Although best known for his large modern historical paintings, such as his *Funeral of Zhou Enlai* (1977), Lin Gang liked to get away from Beijing, to follow the route of the Long March of 1934–35, sketching along the way. These oil sketches have a spontaneity and freedom that is lacking in his more monumental work.

25 *Sichuan Plateau – Long March Road*

Oil on board, 34.4 × 36.8 cm. 1978.
Acquired in New York, 1993.

25

Liu Guosong 劉國松

26 *The Sun*

Hanging scroll, ink and acrylic on paper, 101 x 58 cm. 1992.
Gift of the artist, 2005.

26

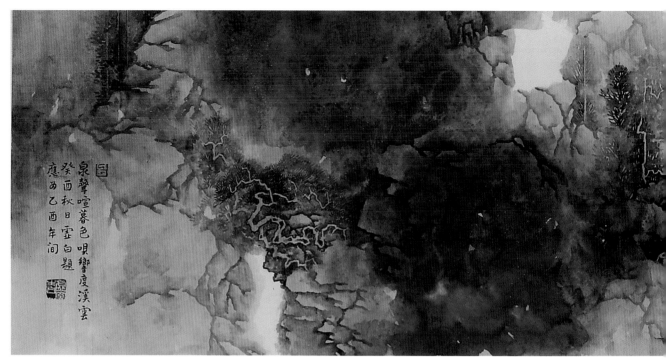

27

Li Shubai 李虛白

27 *Landscape*

Handscroll (framed), ink and colour on paper, 32.3 × 113.5 cm. 1969.
Gift of the artist, 2005.

Lü Sibai 呂斯百
(1905–74, b. Jiangyinxian, Jiangsu province)

In 1929 he was recommended by Xu Beihong to study in Lyon, then transferred to Paris, returning to China in 1931. When he made this drawing and gave it to Khoan in Chongqing, he was teaching on Xu Beihong's staff in the National Central University. Khoan, therefore, acquired it before she met Michael in Chongqing in 1941, so it is the first work in the collection. During the Cultural Revolution, he committed suicide.

28 *Street in Chongqing after Japanese Bombing, 1940*

Pen drawing on paper, 13.2 × 19.3 cm.
Gift of the artist to Khoan in 1940.

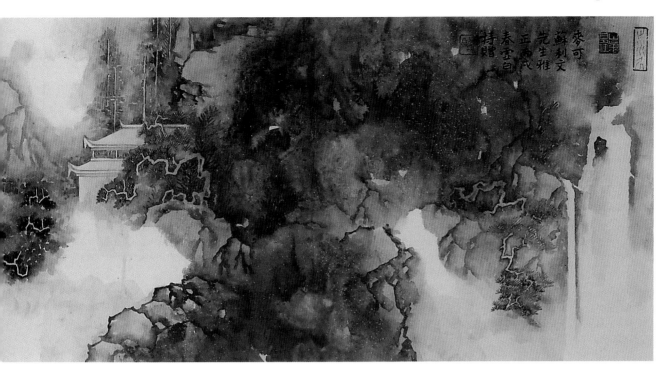

28

29

Luo Erchun 羅爾純
(b. 1929, Xiangxiangxian, Hunan province)

He graduated from the Suzhou Academy, one of Yan Wenliang's last pupils. After working in the People's Fine Art Publishing House, he became a professor in the Central Academy of Fine Art. Noted for his vibrant use of colour.

29　*Portrait of Michael Sullivan*

Oil on canvas, 80 × 60 cm.
Painted in Beijing in 2007.
Gift of the artist to MS in 2007.

30　*Roses in a Glass Vase*

Oil on canvas, 70 × 50 cm. 2006.
Gift of the artist and Mr Li Zuyuan, 2009.

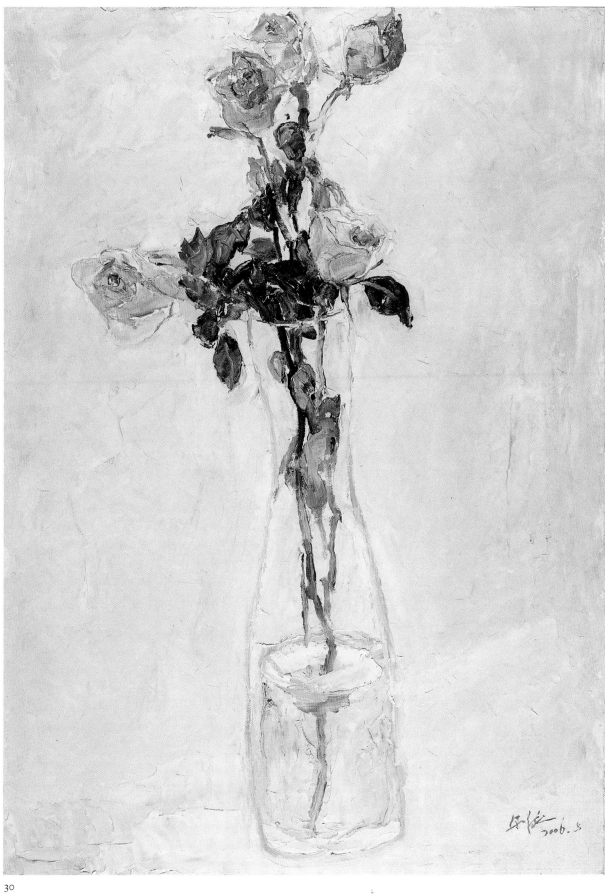

30

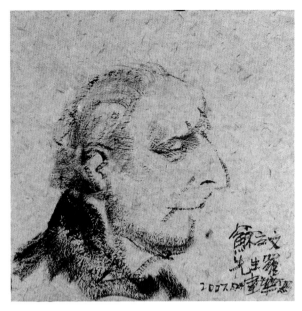

31

Luo Jianhua 羅建華

Artist and musician, a prominent member of the small circle of Kunming artists.

31 *Portrait sketch of MS*

Ink on coarse paper, 73 × 74.2 cm. 2007.
Gift of the artist, 2007.

32 *Mountain Landscape*

Ink and colour on paper, 71 × 89.7 cm. 2007.
Gift of the artist, 2007.

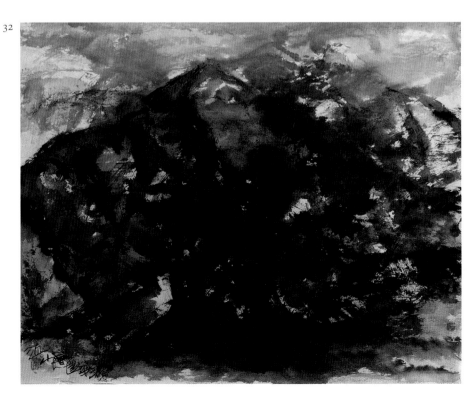

32

Luo Qi 洛齊
(b. 1960, Hangzhou)

Painter and critic. After studying at the National Academy of Art, Hangzhou, he joined the staff as Associate Professor and editor of art journals. He has paid a number of visits to Europe and America.

33 *Love Writing*

Oil on canvas, 100 × 81 cm. 1996.
Gift of the artist and Alice King, 2006.

33

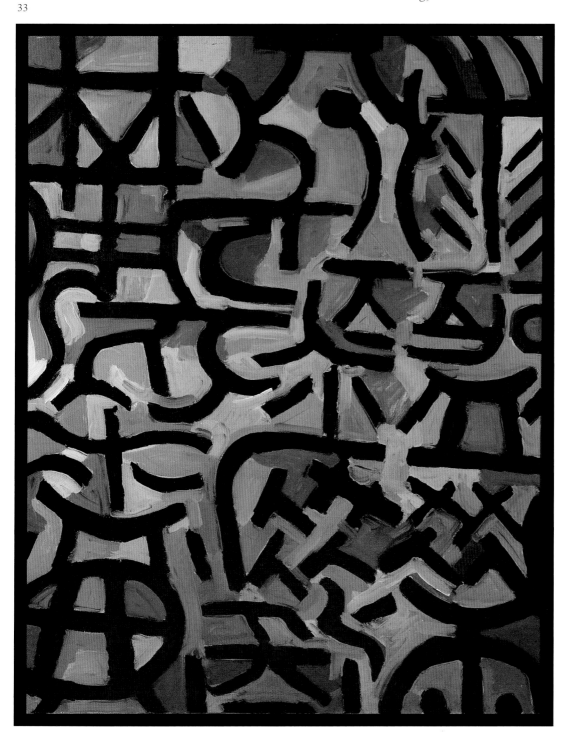

Qi Baishi 曲磊磊

34 *Frogs*

Hanging scroll, ink on paper, 103.5 × 34.7 cm. 1948.
Inscribed by the artist at the age of 88, with three seals.
Bequeathed to K & MS by Geoffrey Hedley in 1960.

34

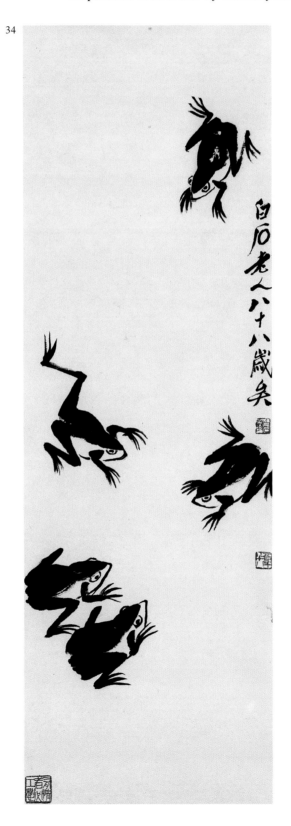

35

Qiu Anxiong 邱黯雄
(b. 1972, Chengdu, Sichuan province)

Painter. In 1994 he graduated from the Sichuan Art Academy. In 1998 he studied for a time in the Art Department of Kassel University, Germany.

35 *Landscape*

Ink on paper, 44 × 65 cm. 2001.
Acquired from his exhibition in Hong Kong, 2002.

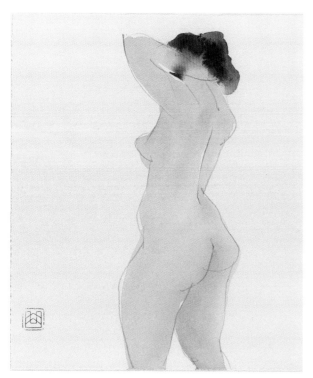

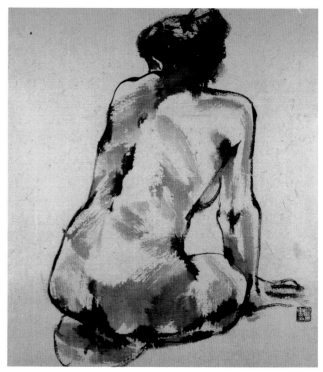

36

37

Qu Leilei 曲磊磊

36 *Figure No. 2*

Pencil and colour wash on paper, 38 × 28 cm. 2001.
Gift of the artist, 2001.

37 *Kneeling Girl*

Ink on paper, 45.5 × 43 cm. 2001.
Gift of the artist, 2001.

38 *Portrait of Khoan*

The artist has, as a tribute to Khoan, carefully written out the *Three Character Classic, Sanzijing*, in the background of this portrait.
Hanging scroll, ink on paper, 111.5 × 107.5 cm. 2002.
Gift of the artist, 2002.

39 *Wo you banfa!*
(I have a way!)
One of Khoan's typical sayings, which Qu Leilei has written at the lower left corner of his portrait.

Hanging scroll, ink and slight colour on paper, 111.5 × 107.5 cm. 2002.
Gift of the artist, 2002.

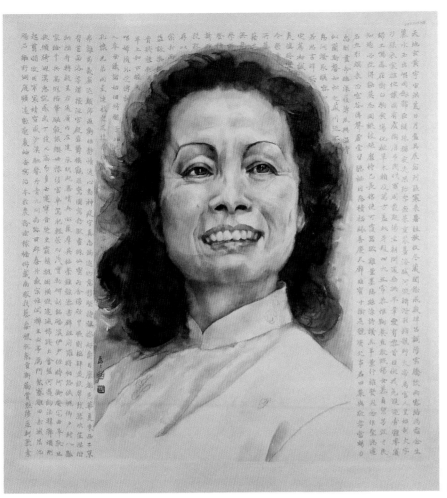

38

39

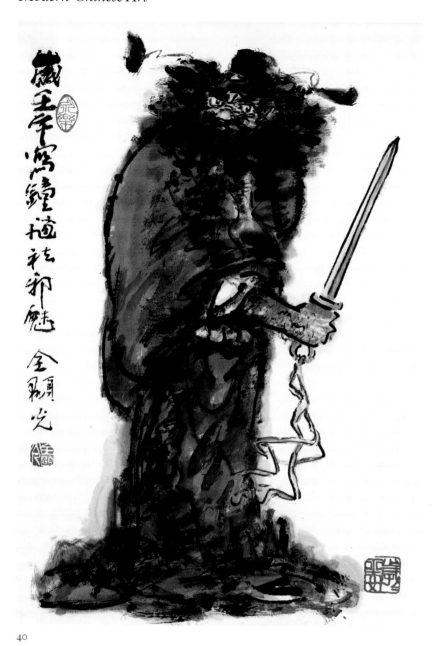

40

Quan Xianguang 全顯光
(b. 1932, Kunming)

An ink painter and print-maker, who graduated from the Lu Xun Academy of Fine Arts in 1955. After studying in Leipzig, he became in 1961 a professor in the Lu Xun Academy, before opening his own studio in Shenyang.

40 *The Demon-queller Zhong Kui*

Ink and colour on paper, 49.2 × 34.2 cm.
Gift of He Weimin, 2007.

Shao Fei 邵飛
(b. 1954, Kunming)

41 *Creatures from the Shanhai jing*
 (Classic of Hills and Seas)

Ink and colour on paper, 90 × 117 cm. 2004.
Gift of the artist, 2004.

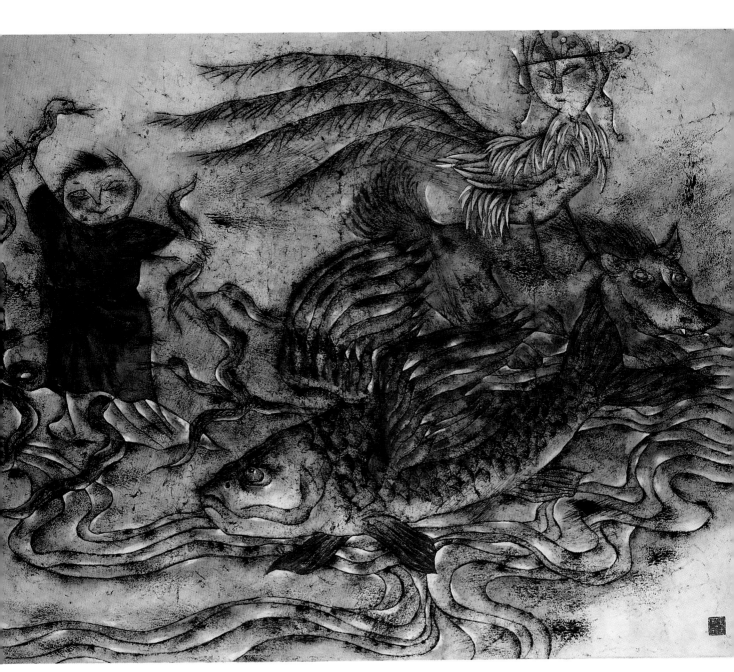

41

42

42 *Going out Riding*

Ink and colour on cotton paper, 48 × 63 cm.
Gift of the artist, 2008.

Vannessa Tran
(b. 1976, Tacoma, Washington State)

Having studied Business and Psychology at the University of Washington, she enrolled for an MFA at the American University in Washington D.C., before becoming an independent artist. She lives in Seattle.

43A & B *Two Drawings of Trees*

Pencil on paper, 38.1 × 28.1 cm.
Gifts of the artist, 2007.
(*not illustrated*)

44 *Untitled*

Oil on canvas, 19.5 × 16.8 cm. 2009.
Gift of the artist, 2009.

45 *A Rose*

Oil on canvas, 17 × 19.5 cm. 2009.
Gift of the artist, 2009.

44

45

Tsai Lun-I, *see* Cai Lunyi

Wan Qingli 萬青力

46 *Sound of Stream*

Hanging scroll, ink and light colour on paper, 68 × 57 cm. 2001.
Acquired from his New York exhibition, 2002.

46

47 *Landscape with Stag*

Ink and colour on card, diam. 21.3 cm.
Gift of the artist, 2001.

48 *Tomatoes*

Ink and colour on card, 24.2 × 27.2 cm.
Gift of the artist, 2002.

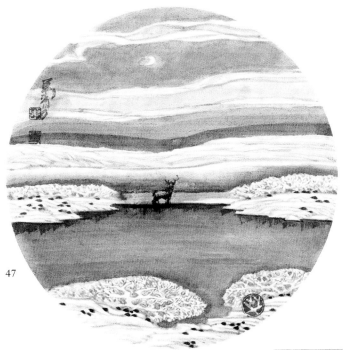

47

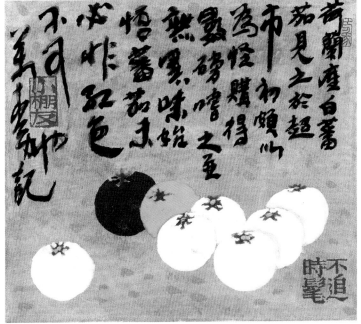

48

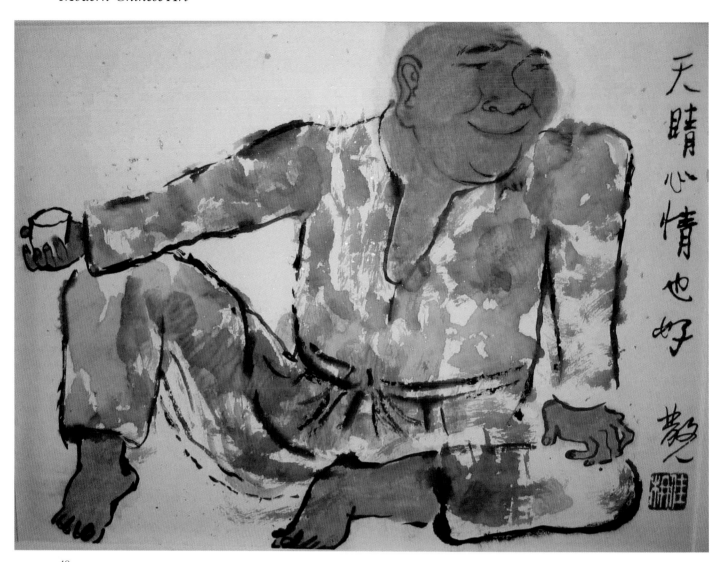

49

Wang Jia'nan 王迦南

49 *The Sky is Clear and my Heart's at Ease too!*

Ink and colour on paper, 32.8 × 44.5 cm.
Gift of the artist, 2002.

Wang Lifeng 王利豐
(b. 1969)

Oil painter and sculptor. After graduating in Stage Design from the Central Academy of Fine Arts, he became a designer for the Beijing People's Theatre of the Arts.

50 *Landscape*

Mixed media on canvas, 114 × 162.3 cm. 2002.
Acquired in 2004 from his exhibition at the Red Gate Gallery, Beijing.

50

51

Wang Tong 王彤

51 *Forest with Small Bird*

Oil on canvas, 87.7 × 112.2 cm. 2006.
Acquired from the artist's Beijing exhibition in 2006.

Nancy Chu Woo 朱楚珠
(Zhu Chuzhu, b. 1941, Guangdong province)

She moved as a child with her parents to Hong Kong. In 1963 she graduated with a degree in Fine Arts from Cornell University, 1964 M.A., Columbia University. She lives in Hong Kong where she has taught, and practises as an independent artist.

52 *Glorious Sunset*

Ink and gouache on paper, 60 × 62 cm. 2007.
Gift of the artist, 2007.

52

53

54

Xia Xiaowan 夏小萬
(b. 1959, Beijing)

In 1982 he graduated from the Oil Painting Department of the Central Academy in Beijing, and later taught in the Central Academy of Drama. A member of the post-1989 Avant-Garde movement.

53 *Figure Study*

Charcoal on paper, 52.7 × 38 cm.
Gift of the artist, 2006.

Xu Bing 徐冰

54 *Landscript*

Ink on paper, 50 × 173 cm. 2002.

The inscription reads: 'Here there are all sorts of trees, some from the north, some from the south. There are also rocks, and calligraphy'. Signed 'Xu Bing' in the artist's 'square words' calligraphy.

Gift of the artist, 2002.

The idea of making a landscape out of the characters for rock, mountain, tree, forest, water and so on, which Xu Bing had been toying with for several years, was first realised in pictures he made in 1999 on a visit to Nepal. That one can both literally and figuratively 'read' a landscape is uniquely Chinese, having its roots in the ancient pictographs from which, according to tradition, both painting and the written language evolved. Seeing Xu Bing's 'landscripts', as he calls them, one is tempted to ask, 'Why did no one ever think of this before?' Once done, it seems so inevitable.

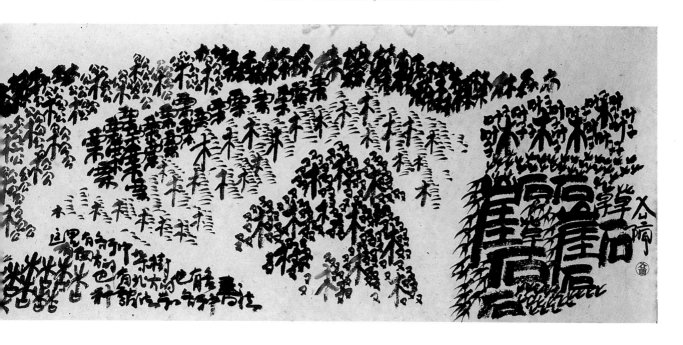

Yang Yanping 揚燕屏

55 *Spring on Snow Rock*

Ink and colour on paper, 59.6 × 85.3 cm.
Gift of the artist, 2001.

56 *Abstract Landscape*

Ink and a little colour on paper, 61 × 81 cm.
Gift of the artist.

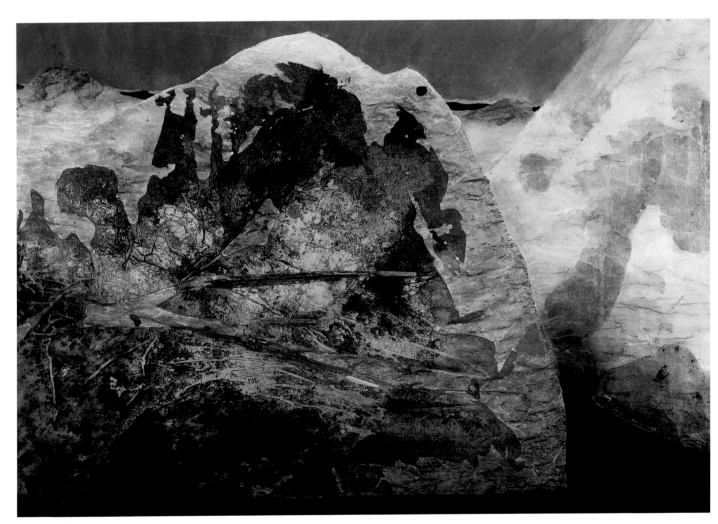

55

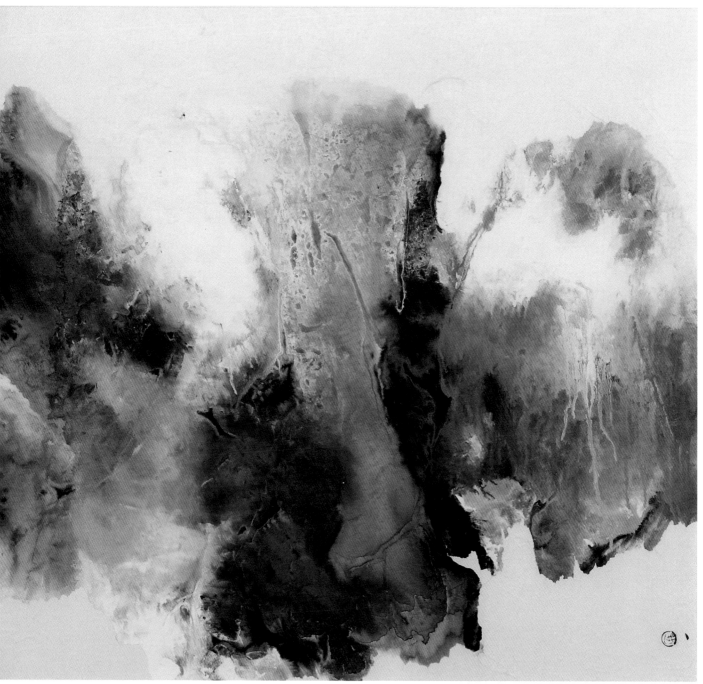

56

Wendy Yao 楊紫霞
(Yang Zixia, b. Hong Kong)

She studied at the Slade School in London, was awarded a travelling scholarship to Italy and France, and attended Atelier 17 in Paris. Since 1959 she has been exhibiting in Hong Kong and around the world.

57 *Old Pine Tree*

Ink and body colour on paper, 96.2 × 63 cm. 1997.
Gift of the artist, 2006.

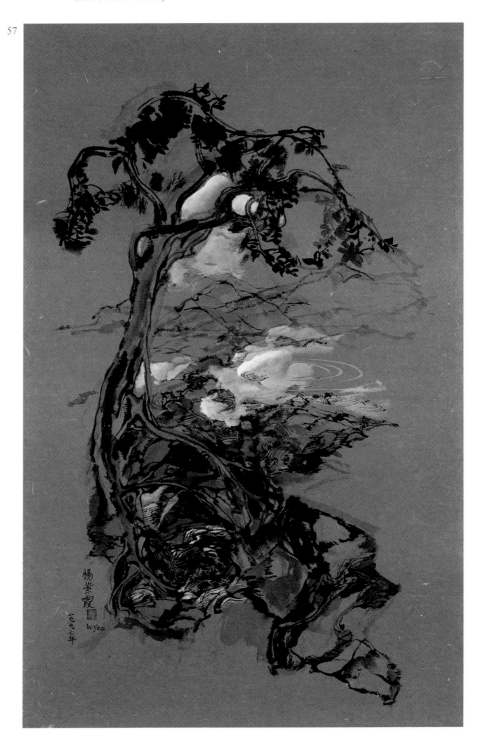

57

58

Yue Minjun 岳敏君
(b. 1962, Daqing, Heilongjiang)

After working in Tianjin as an electrician, Yue Minjun graduated from the Hebei Normal University in 1992, living in the artists' colony at Yuanmingyuan. He later built his own studio in the northern suburbs of Beijing. Noted for his paintings and figures of a laughing man (himself), ambiguously expressive of happiness, mockery, and despair.

58 *Freedom Leading the People*

Ink and wash on paper, 32.5 × 44 cm.

Gift of the artist, 2005.

This is a sketch for, or derived from, his large oil painting of this subject first exhibited in 1997. It is an ironic parody of Eugene Delacroix's *Freedom Leading the People* of 1830. There is another work inspired by the Delacroix, entitled *Les Misérables*, by the Shanghai artist Chen Danqing (b. 1953) in the collection of Guy and Myriam Ullens.

59

Zeng Yu 曾埆
(b. 1933, Shanghai)

59 *Self-portrait*

Oil on canvas, 99.1 × 55.8 cm.
Painted in Hong Kong in 1951.
Gift of Mary Mather, 2008.

60 *Fishing*

Oil on canvas, 102 × 72.2 cm. *c.*1951.
Gift of Mary Mather, 2008.

60

61 *Man and Woman Walking a Dog*

Ink and slight colour on paper, 23.8 × 18 cm.
Painted in Hong Kong in 1951.
Gift of Mary Mather, 2008.

62 *Trafalgar Square*

Ink and colour on paper, 52.4 × 47 cm.
Painted while Zeng Yu was a student at the Slade School in London.
Gift of Mary Mather, 2008.

63 *Seated Young Man*

Ink and a little colour on paper, 36.4 × 14.8 cm.
Painted while Zeng Yu was a student at the Slade School in London.
Gift of Mary Mather, 2008.

61

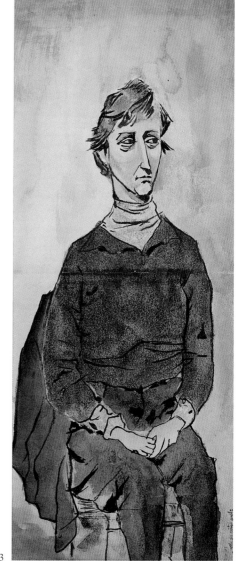

63

62

64

65

Zhang Anzhi 張安治

64　*Two Minority Girls Dancing*

Brush painting in red ink on paper, 43.2 × 35 cm.
Gift of the artist, 1980.

Zeng Shanqing 曾善慶

65　*Portrait Drawing of MS*

Pencil on paper, 27.8 × 23.8 cm. 1995.
Gift of the artist, 1995.

Zhi Lin 林志

(Lin Zhi, b. 1959, Nanjing)

He graduated from the National Academy of Fine Arts, Beijing, the Slade School in London, and the University of Delaware. He has been the recepient of many awards, including Creative Capital Foundation Grant, Lila Wallace-Readers' Digest Artists Award and National Endowment for the Arts Visual Artist Fellowship. He is currently Professor at the University of Washington School of Art in Seattle.

66 *Three Heads, Study for Starvation*

Graphite on paper, 20 × 28 cm. 1996.

This is one of the careful studies the artist made of men condemned to death by starvation (while a banquet goes on nearby), one of a series of four very large paintings he executed between 1993 and 1999 on the theme of human indifference to suffering and cruelty.

Acquired from the artist in 2009.

Zhou Jianxu 周建旭
(Chiu Teng Hiok, 1903–72)

Born in Xiamen, Fujian province, and a cousin of Khoan Sullivan, Chiu Teng Hiok studied in the USA and Paris before becoming Sir George Clausen's student at the Royal Academy School of Art in London (1926–30). He won the Landseer Scholarship and the Creswick and Armitage Prizes, and in 1929 was awarded the Gold Medal for the best landscape composition in oils. He also showed several times in the Royal Academy summer exhibitions. He spent the years 1930 to 1932 in Beijing, travelled to France, Spain and Morocco and Texas, where he was a long-time friend of Georgia O'Keefe, eventually settling in Connecticut, where he painted a number of landscapes of New England scenery.

67 *Barn in Scotland*

Oil on canvas, 50.8 × 61 cm, n.d. About 1930.

Acquired through Professor Kazimierz Poznanski in 2008.

67

68

68 Ju Ming 朱銘

Eggplants

Ink and colour on paper, 33 × 32.5 cm.
Gift of the artist, 2002.

CALLIGRAPHY

69

Wang Jiqian 王己千

69 *Shou*
(Long Life)

Ink on paper, 66 × 34 cm.
Written for Khoan and Michael Sullivan in 2001, and given to them by MS's former students at Stanford University.

Liu Zhengcheng 劉正成
(b. Chengdu, 1946)

Born into a poor family, Liu Zhengcheng never attended university, and was apprenticed into a textile works in Shanghai. Returning to work in textiles in Chengdu, he taught himself to be a calligrapher, became assistant editor of a Sichuan cultural journal, then member, later secretary, of the Chinese Calligraphers Association. In 1994 he was appointed Professor in the College of Calligraphy at Peking University. He has since founded the International Calligraphers Association, and has published sixty of a projected series of 108 volumes of historic examples of Chinese calligraphy.

70 *Eulogy, for Michael Sullivan, written in Kaishu (regular script)*

Ink on paper, 33 × 52 cm. 2006.
Gift of the calligrapher in 2006.
(Not illustrated)

71 *Mu Yun Chun Shu*
 (Evening Clouds and Spring Trees)

Title to essay, written in *kaishu* (regular script) about the life and
work of MS and his relationship with KS.

Signed Liu Zhengcheng and dated 2006.

Handscroll, written in *caoshu* (cursive script).

Ink on paper, 33 × 680 cm. 2006.

Gift of the calligrapher in 2006.

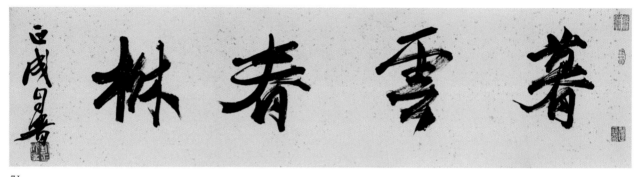

71

PRINTS AND GRAPHICS

An Ling 安琳

72 *Chicks*

Shuiyin print, 26 × 31 cm.

Gift of the artist in Hangzhou in 1980.

72

Cai Tianding 蔡天定

73 *Village Scene*

Woodcut, 14.5 × 16.8 cm.

74 *Fishermen Mending their Nets*

Woodcut, 17 × 12 cm.

75 *Singapore River*

Woodcut, 11.8 × 17 cm.

76 *The Durian Stall*

Woodcut, 9.3 × 11.2 cm.

All gifts of the artist in Singapore, about 1958.

73

74

75

76

He Weimin 何為民
(b. 1964, Mudanjiang, Heilongjiang province)

Printmaker and painter who earned a D. Phil. at Belfast University, then from 2005 to 2008 was a post-doctoral Fellow at the Ashmolean Museum, Oxford.

77 *A. P. under a Tree in Blossom*

Woodcut, 34.6 × 40.6 cm. 2004.
Gift of the artist, 2006.

78 *In the Street*

Woodcut printed with oil-based ink on *xuan* paper, 60 × 50 cm. 1994.
Sponsor's Prize, Third Sapporo International Print Biennial Exhibition, 1994.
Gift of the artist, 2007.

79 *City Diary – Tourists*

Two-block woodcut printed with oil-based ink on *xuan* paper, 60 × 50 cm. 1994.
Award at the 12th China National Print Biennial Exhibition, Shenzhen, Guangdong province, 1994.
Gift of the artist, 2007.

77

78

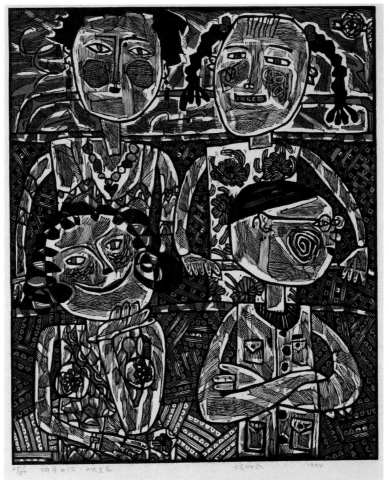

79

80

Wu Guanzhong 吳冠中

80 *Huanghe*
 (Yellow River)

Collotype print on paper, 47 × 58 cm. 2006.
Gift of the artist, 2007.

Wang Huaiqing 王懷慶

81 *Walking*

Etching on *xuan* paper, 74 × 96.8 cm. 2006.

This picture was inspired by the poles the artist saw in Venice, to which the gondolas are tied. He added little feet to some of the poles, hence the title.

Gift of the artist, 2007.

81

Zeng Yu 曾堉

82 *London*

Etching, 42.2 × 42.2 cm. 1952.
Gift of Mary Mather, 2008.

83 *Tower Bridge*

Etching, 33 × 21.2 cm. *c.*1952.
Gift of Mary Mather, 2008.

84 *The Houses of Parliament, Westminster*

Etching, 16.5 × 20cm. *c.*1952.
Gift of Mary Mather, 2008.

82

THE FOLLOWING NEW YEAR PRINTS WERE SENT IN 1963–65
AS A GIFT TO THE SULLIVANS BY YANG XIANYI AND GLADYS
YANG IN BEIJING

85 *Shanhe huanrong mao* 山河換容貌
 (Changing the appearance of mountains and rivers)

 Published by the Taohuawu Workshop in Suzhou.
 47 × 30 cm. n.d.

86 *Reading the Works of Mao and sewing a red flower*

 Painted by Zhu Ming 褚銘 , cut by Yeh Jinsheng 葉金生 and
 Xu Guoliang 徐國良 .
 Published by the Taohuawu Workshop in Suzhou.
 46 × 31.5 cm. May, 1964.

87 *Luli Xuexi Qinjian Chijia* 努力學習　勤儉持家
 (Study hard and manage the home)

 They are reading about the heroes Li Shuangshuang 李雙雙
 and Lei Feng 雷峰 .
 46 × 31.5 cm. n.d.

88 *Tiger Fada* 法大
 (Enormous power!)

 Hand painted; combination of oil-based and watercolour.
 26.5 × 20 cm. n.d.

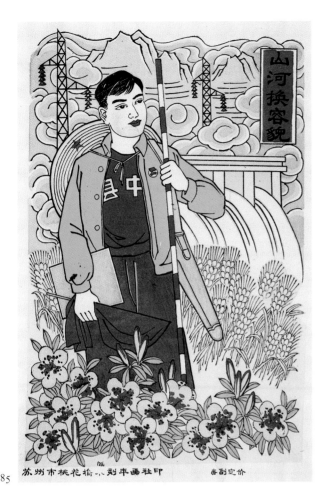

苏州市桃花坞...刻車画社印　　　每副定价

85

裙　铭画　叶金生　涂国良刻　苏州市桃花坞木刻車画社印　1964年5月初版

86

努力学习　勤俭持家

87

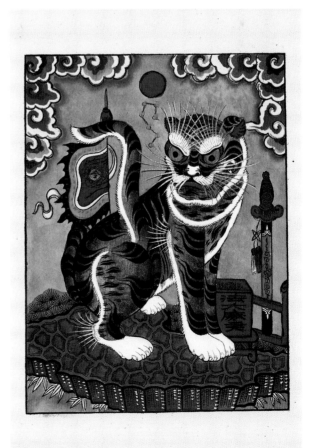

88

89

90

91

92

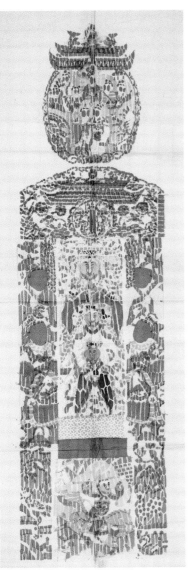

93

89 *Lianlian fengshou: Renmin gongshe hao!*
年年豐收：人民公社好
(Bumper Harvest every Year. People's Communes are Good!)

Drawn by Zhang Lei 張雷 and Yang Zhen 楊震, cut by
Yeh Jinsheng 葉金生 .
Presumably made in the Taohuawu Workshop in Suzhou.

49 × 35 cm. n.d.

90 *On the peach*: *Wan shou wu jiang!* 萬壽無疆
(Long Life – never die!)
BELOW
Zhongguo Gongchandang wan sui! 中國共產黨萬歲
(Long Live the Communist Party!)

48 × 35 cm. n.d.

91 *Nongcun lian xinren* 農村煉新人
(A woman transformed into a new person by being in the countryside)

Artist Zhu Ming 褚銘, cut by Shen Weichen 沈偉臣 and
Shen Yanli 沈偉臣 (?)
46 × 31 cm. August, 1964.

92 *Qilin sunzi* 麒麟孫子
(Qilin with sons and grandsons; for couples getting married)

Entirely hand-coloured, 52 × 35 cm. n.d.

93 *Deities*
(It is not certain who the deities in this very rare print are)

134 × 39 cm. n.d.
The sheet bears the stamp of a government Tax Bureau.

SCULPTURE

Ju Ming 朱銘

94 *Mother-in-law and Daughter-in-law*

Two figures from his Living World Series.
Carved and painted wood, Ht. 51.5 and 45 cm.
Gift of the artist, 2004.

95 *Seated Figure*

Terracotta, Ht. 14 cm.
Gift of the artist, 2005.

94

95

Wang Keping 王克平

96 *Untitled*

Wood, Ht. 55 cm. 2005.
Gift of the artist, 2009.

96

SATIRE

Ding Cong 丁聰

97　*Painted Skin*

Ink and colour on paper, 29.8 × 20.3 cm. Undated.

This sinister figure is a pretty teenage girl who a scholar takes home with him in one chapter of *Strange Tales of a Scholar's Studio* (*Liaozhai Zhiyi*) 聊齋志異 by Pu Songling 蒲松齡 (1640–1715). In the story the girl turns into a demoness and paints his flayed skin in bright colours. She is, very likely, Jiang Qing 江青 (Madame Mao Zedong) who had caused so much suffering to the artist, and this is Ding Cong's revenge. There is another version of this picture, posted on a blog, in which the girl's expression is far more demure.

Gift of the artist to his friends 'Lao Mike' and Khoan in Beijing in October, 1979.

97

288

Michael Sullivan's Writings on Modern Chinese Art

Books

Chinese Art in the Twentieth Century (Faber & Faber, London and University of California Press, Berkeley and Los Angeles, 1959).

Art and Artists of Twentieth-Century China (University of California Press, Berkeley and Los Angeles, 1996; second impression 1999).

A Biographical Dictionary of Chinese Artists (University of California Press, Berkeley, Los Angeles, and London, 2006)

Articles

Condition of the Arts in China. Report commissioned by the Fine Arts Section of the Cultural Division of UNESCO (Paris, 1946; circulated but not published).

'Learning to Paint in China' (*The Studio*, London, July 1947), 46–49.

'The Revolution in Chinese Art' (Contact Books, London, March 1948).

'The Traditional Trend in Contemporary Chinese Art'. *Oriental Art* II, 3 (Winter, 1949), 3–8.

'Recent Trends in Chinese Art' (*Chambers Encyclopedia World Survey*, London, 1956).

'China, Art and Architecture: Modern Developments'. *Encyclopaedia Americana* VI (1972), 572.

'Ethics as Aesthetics: Art in China Today'. *Art News* (September 1974).

'The Masterworks of Chang Dai-Chien'. Foreword to Portfolio of Six Lithographs published by Editions Press, San Francisco (1974).

'Orthodoxy and Individualism in Twentieth-Century Chinese Art'. In Christian F. Murck, ed., *Artists and Traditions* (Princeton, 1976), 201–205.

'Values through Art'. In Ross Terrill, ed., *The China Difference* (New York, 1979).

'Painting with a New Brush' in Robert B. Oxnam & Richard C. Fish, eds., *China Briefing* (New York, 1980), 53–63; reprinted as 'A Review of Art in China since 1949 and a Look at the Future'. *The Asian Wall St. Journal* (12 September, 1980).

'The Chinese Response to Western Art'. *Art International* XXIV/3–4, (November, December, 1980), 8–31.

'New Directions in Chinese Art'. *Art International* XXV/1–2 (January 1982), 40–58.

'Art and the Social Framework'. *Times Literary Supplement*, China Issue (24 June, 1983).

'Chinese Painting Today: Traditional in Style, Modern in Feeling'. In Lucy Lim, ed., *Contemporary Chinese Painting: An Exhibition from the People's Republic of China* (San Francisco, 1983), adapted version reprinted in *Orientations* (October, 1983), 10–33.

'A Fresh Look at Twentieth-Century Chinese Painting'. *Journal of the Royal Asiatic Society*, London (June, 1985).

'Art and Reality in XXth-Century Chinese Painting'. Introduction to Mayching Kao, ed., *Twentieth-Century Chinese Painting* (Hong Kong, 1988), 2–20.

'Wu Guanzhong: Reflections on His Life, Thought and Art'. Introduction to Lucy Lim, ed., *Wu Guanzhong: A Contemporary Chinese Artist* (Chinese Culture Foundation, San Francisco, 1989), 1–8.

'Bliss was it in that dawn to be alive!'. Introduction to *The Stars: 10 Years* (Hanart 2 Gallery, Taipei, 1989).

'A Small Token of Friendship'. *Oriental Art NS.* 35.2 (Summer, 1989), 76–85.

'Chinese Art and Its Impact on the West'. In Paul S. Ropp, ed., *Heritage of China: Contemporary Perspectives on Chinese Civilisation* (University of California Press, Berkeley and Los Angeles, 1990), 263–93.

'Individualism, Protest and the Avant-Garde in Modern Chinese Painting'. Proceedings of International Conference *China: Modernity and Art* (Taipei Fine Arts Museum, 1990), 99–128.

'Realism and the Art of the Revolution', *Britain-China* No. 47 (Autumn, 1991), 3–6.

'Chinese Art in the Twentieth Century'. In Anne Farrer, ed., *Wu Guanzhong: A Twentieth-Century Painter* (British Museum, London, 1992), 11–23.

'Brush Strokes and the Party Line: Tensions between Artists and Officialdom in China'. In Tsong-zung Zhang, *China's New Art, Post-1989* (Hong Kong, 1993), xxiii–xxvi.

'The Sustaining Tyranny of Style: Approaches to Modern Chinese Painting'. In Drew Gerstle & Anthony Milner, eds., *Europe and the Orient* (Humanities Research Centre, ANU Canberra, 1994), 247–61.

'Remembering Pang Xunqin'. In Pang Tao & Pang Jun, *The Storm Society and Post-Storm Art Phenomenon* (Tapei, 1997).

'Some Reflections on *Guohua*'. In *Chinese Painting and the Twentieth Century: Creativity in the Aftermath of Tradition*. Conference Proceedings, Pan Tianshou Foundation, Hangzhou (1997).

'Art in China Since 1945'. In Richard Edmonds, ed., *The People's Republic of China after Fifty Years*. Originally published in *The China Quarterly*. Studies of Contemporary China (Oxford 1999), 150–60.

'A Modest Tribute to Lin Fengmian'. In *The Century of Lin Fengmian*. National Academy of Art, Hangzhou (1999), Vol II, 716–20.

'Some Thoughts about Wang Huaiqing'. Critical essay for volume on his work (Beijing, 2001).

CATALOGUES AND CATALOGUE FOREWORDS

'Cheong Soo Pieng'. Foreword to exhibition catalogue (Singapore, 1961).

Paintings: Chang Ta-ch'ien (Stanford University Museum, Summer 1967).

Trends in Twentieth-Century Chinese Painting (Stanford University Museum, 1969).

Foreword to Li Hua's exhibition catalogue, San Francisco and Pasadena, California (1983).

Introduction to *Chu Teh-Chun* exhibition catalogue, Museum of History, Taipei (1987).

Introduction to *The Art of Yü Cheng-yao*, City Hall and Hanart TZ Gallery, Hong Kong and Taipei (1990).

'The Art of Ju Ming', introduction to exhibition catalogue, *Ju Ming: Taiji Sculpture*. (South Bank Centre, London and Hanart TZ, 1991).

Preface to *Shao Fei: A World of Fantasy* (L'Atelier Products, Singapore, 1992).

Foreword to Wan Qingli, *Li Keran Pingzhuan* (Taipei, 1995).

Introduction to Michael Goedhuis, *Contemporary Chinese Paintings and Sculpture* (London, 1996).

Introduction to *Paintings by Yang Yanping*. Michael Goedhuis's exhibition catalogue (London, 1997).

'Tradition Brought to Life: The Art of Harold Wong'. Introduction to *Harold Wong: The Unending Path: Paintings from 1957–1997*. Hong Kong University Museum and Art Gallery (1997).

Foreword to *The Living Brush: Four Masters* (CC Wang, Wang Fang-yu, Tseng Yu-ho, and Grace Tong). American-Asian Cultural Exchange, San Francisco (1997).

Foreword to catalogue of Chu Ko exhibition, National History Museum, Taipei (1998).

Introduction to *Fusion and Diffusion*, Nancy Chu Woo (Hong Kong 1998).

Introduction to *Ring of Fire: The Art of Wucius Wong*. Kaikodo Gallery, New York (1998).

'Some Thoughts on the Art of Song Yugui'. Foreword to exhibition catalogue (Beijing, 2000).

Foreword to catalogue of Wang Keping exhibition. De Tilly-Blaru Gallery, Hong Kong (2001).

'Some Thoughts on Gao Xingjian'. Foreword to catalogue of exhibition at Alisan Gallery, Hong Kong (2001).

'Xiang Wai Zhi Xiang in Chinese Landscape Painting and the Impact of Western Art'. *In Studies on 20th-Century Shanshuihua* (Shanghai, 2006).

Since 2001, Michael Sullivan has contributed the following forewords to artists' exhibition catalogues:
2003 Yang Yanping (Michael Goedhuis, New York); 2004 Wang Jia'nan (Michael Goedhuis, New York); Ju Ming (National Museum of Art, Singapore); Wan Qingli (Hong Kong); 2005 Qu Leilei (Ashmolean Museum, Oxford); Wang Huaiqing (National Museum of Art, Beijing); 2006 Shao Fei (Beihai Park Treasure House, Beijing); 2008–9 Wang Keping (10 Chancery Lane Gallery, Hong Kong and Galerie Jacques Barrère, Paris); 2009 Chen Cheng-hsiung (Chelsea Art Museum, New York); Huang Chun-pi (National Art Museum, Beijing). Liu Zhengcheng (Beijing, 2009).